Saved by Titanic

Saved by Titanic

by Samantha Maise

Charleston, SC
www.PalmettoPublishing.com

Saved by Titanic

First Edition

Hardcover ISBN: 979-8-8229-0415-6
Paperback ISBN: 979-8-8229-0416-3
eBook ISBN: 979-8-8229-0417-0

For Terry.

Thanks for giving me the magic back even when I thought I had lost it.

Chapter One

Soft hands. Warm touches. The joy of a loving marriage. All of the things Genevieve Charlotte Williams didn't have. She felt a pang of envy as she watched a happy family walk through the streets of Southampton. She realized that could have been her life, if her body had not failed her and her husband, Clyde Williams. Maybe then they would have still been happy together.

She gasped in pain as her husband appeared, grabbing her wrist. "What the hell are yer looking at?" he slurred with alcohol on his breath.

"Nothing, my dear. I was just waiting for you," Genevieve said to soothe him.

Her husband had been an impressive businessman back in the States. Clyde had come from nothing and created a substantial business that had employed many people in times of economic downturn. Genevieve's brother had been one of the first to go into business with him. At that point she had caught Clyde's eye.

They had gotten engaged when she was nineteen. Her mother had cried happy tears, proclaiming she had been afraid her daughter would turn into an "old maid." They had married when Genevieve was twenty, right before Clyde's business branched across the pond to England. Her parents had been heartbroken, but they had accepted that it was the best thing for their daughter and her new husband. "We will see you soon!" her mother had said as she hugged

Genevieve tightly. That had been five years ago. The business had tanked for a variety of reasons, but mostly due to Clyde's drinking.

After they had settled into their one-story cottage, they had discovered she was expecting a child. They had both been excited, with Clyde being so supportive and protective of her during that time, but the baby had been stillborn. Genevieve had mourned, but Clyde had almost taken it personally. He had started drinking, never stopping. He had taken to pubs and private bottle collections at home, paying less attention to Genevieve and the company. Investors had jumped ship as soon as they could, with businesses closing everywhere. This had destroyed whatever growth her hometown had garnered.

She couldn't be sure since she hadn't returned home since she had come to this godforsaken place. Since Clyde used whatever money he could get his hands on for alcohol, whatever money Genevieve could get was used for groceries. She would never beg her parents for money. They probably had enough problems. Adding another mouth to feed did not have to be the next one.

This was her problem; she had to take care of it herself. It was a lonely and terrible life, but it was the one she had been dealt.

There was no help for her. As Genevieve and Clyde walked home, she noticed men laughing at Clyde—not that he would notice. He was too drunk to care about anything. Some women gave Genevieve a pitiful look, like always, but they never gave her assistance, hope. If somebody was going to help her, they would have done so already. Until she had enough funds to go home and live on her terms, she was stuck in this life.

They came to their home, which used to be an adorable cottage with a garden. Clyde had bought it knowing Genevieve would love it. It had been charming and elegant when he had carried her over the threshold. Now it was dilapidated, crumbling before her eyes. Whatever money didn't go to groceries went to repairs so the cottage wouldn't kill them before her great escape. The only thing that had survived the joyful bliss was the garden. It was how Genevieve had been able to keep food on the table.

She unlocked the door, leading Clyde to his reclining chair. He was out in seconds. She grabbed the mail and put the keys away in a safe location, away

from Clyde. He had lost them once on one of his bangers; thankfully Genevieve was slim and had been able to get in through an open window.

She looked at the mail with disinterest. Every day it was more of the same: bills, bills, bills. This translated to money, money, money. She had more interest in a flyer that was promoting an "unsinkable ship." Unsinkable, she thought. How could a ship be unsinkable? There was no way a ship could boast that. As her thoughts were interrupted by Clyde's loud snoring, she realized she'd rather be on that ship.

As if. Even if she could afford the lowest-class ticket, she still couldn't carry herself when she got home. She was considering seeing if they were hiring for this trip when she gasped and dropped all the mail at the sight of a letter addressed to her from Nana Wilson. Before Clyde could wake up to investigate, she scooped all the mail up and discarded it on the table, locking herself in the bedroom. Tears came to her eyes as she opened the letter from her beloved Nana. Genevieve missed her the most out of all her family members. She opened the letter, reading what she didn't know at the time was her salvation:

Dearest Genevieve,

I miss you dearly but am happy to report I am coming to Southampton. It has been far too long since I have seen you and your darling husband. I bring news of your family. I will be there at the end of March and cannot wait to see you.

Nana Wilson, 25 February 1912

So many emotions and thoughts ran through her mind: joy, elation, fear. How would she explain to Nana that she was living in squalor, her husband drinking them both to death? Where would Nana stay? If the outside was crumbling, the inside was in even greater disrepair. Genevieve used to keep it beautiful in case Clyde ever did leave her, so that she could sell the cabin for money, but in the end, she had lost hope. He wasn't leaving her, ever. *A nice gift from life,* she thought sourly.

Genevieve walked out to the kitchen to spot the time. Seeing that she had enough time to send a letter via the post office, she checked Clyde, seeing he was still passed out. She shook her head distastefully while she put her cloak on, grabbing some money, hoping she had enough to afford a stamp.

She ran as fast as she could to the post office. "Good evening," the postman said. "What can I do for you?"

"I need to send a letter to America, as fast as I can," she gulped out.

"That can be fast, depending on where you are sending it," he said.

"New York," Genevieve said as her breathing came back to normal.

"Good news: you are just in time," he explained. "The mail boat came here early. As long as I have the post and payment before five p.m., it can go out to-day. It can be there as early as next week."

"Thank you," Genevieve said.

She grabbed some paper, writing to Nana that she was overjoyed to see her but that there was no room in her house. If she didn't object to staying at a hotel in town, then she would be able to accommodate her. She finished the letter by saying that she hoped to see her at the end of March. Having paid for a stamp and having left the letter with the postman, she rushed back home to Clyde. He was awake and indifferent when she entered the house.

"Where the hell have yer been?" he asked.

"I sent a post to my grandmother," Genevieve said. "She is coming to Southampton at the end of March. I was answering some questions."

Clyde grunted in response but made no other comment. She sighed in relief. She had been afraid that Clyde would refuse her what little freedom she had.

She made them dinner (Clyde used to do the honors, but he had almost burned up the whole place once after he had begun drinking heavily), but her mind was on Nana's visit. Genevieve had last seen her before the move. This gave Genevieve what she had lost a long time ago: hope.

Now when she walked through town, she wasn't ashamed. Nana would help her figure something out. She would help her to escape the hell she had been living in. Hopefully, answers would come sooner rather than later; indeed, she would soon learn how cruel Clyde's temper was becoming.

Genevieve had entered the house after coming home from the market with some choice meats for dinner. She was humming a lively tune when Clyde swung open their bedroom door with a snarl. "What the hell is this?" He was holding Nana's letter.

"My Nana is coming to Southampton," she explained. "Surely you remember I went to town and sent a post to her a couple of weeks ago."

"Well, she ain't staying here!" he yelled.

"Of course not, darling. She is staying at a hotel nearby," Genevieve said, thinking, At least I hope so.

"You better hope so, or you'll be sleeping in the streets!" he yelled while going out the door.

"Won't you stay, Clyde? I'm making dinner!" Genevieve jumped as the front door slammed so hard it rattled the whole cottage. Tears appeared in her eyes as she thought of how bad Clyde was becoming. At least he wasn't abusive—yet.

The thought made her turn the stove off, and she went to pack items that were nonessential to her life as of now, so as not to alarm Clyde of her plans, in a small bag. This contingency plan could save her if it turned ugly before Nana came. But Genevieve had to be careful where she hid her packing. Although he was drunk and clueless most of the time, obviously Clyde wasn't blind.

Genevieve returned to the kitchen, resuming her dinner preparation. She had no idea when Clyde was returning, so she would keep a plate warm for him. She lost all hope when it turned ten thirty. She threw the dinner out in the trash, supposing he would eat food some other time. She turned into bed and entered into a dreamless slumber.

When she woke, she found that Clyde hadn't joined her in bed.

A glance inside the living room showed he had been there. His clothes were all over the house. As Genevieve picked them up to bring some semblance of order back to her cottage, she also looked for Clyde. She found him outside, puking his guts out.

"Where have you been, Clyde?" she asked after returning with a wet towel to wipe his lips off.

"All over town!" He cackled. "Over here, over there..."

"All right, let's get you into bed," Genevieve said, guiding him. She helped him lie down, taking his shoes off.

After making sure Clyde was secure in bed, Genevieve made her way to the kitchen table. She sighed as she sifted through the mail, knowing that she should eat breakfast but ultimately feeling defeated. She perked up after seeing a return letter from Nana. It was a short letter, only acknowledging that she was fine with Genevieve's plans, but it was all she needed to get up and start breakfast.

Let Clyde do his worst to her. She was going to survive and become a proper lady once more.

But as the days ticked down to Nana's visit, Genevieve became more paranoid, even when completing the simplest of tasks. She was so afraid that Clyde would know something was amiss, and it made her even more clumsy. She wasn't sure how long she could keep this ruse up. If Clyde knew she was hoping to leave with Nana, he would hurt her—or worse. Genevieve was banking everything on Nana. If her grandmother couldn't help her, then she was as good as dead. She just hoped it wouldn't get to that point.

There was one day left before Nana's planned arrival. Genevieve couldn't eat; she couldn't sleep. All she could think of was the promise of tomorrow. But she was worried. What if the boat was late? What if the boat had sunk? She couldn't bear to think of it. The past month had been hell for her; she couldn't stand one more delay. She would go insane if she lived with Clyde any longer than she had to.

That night, as she lay in bed with Clyde—hopefully one of her last nights spent in this way—she wondered about the first thing she would do. Would she rejoin her family, or could she move in with Nana? But there was the fear of Clyde. Would he retaliate against her or her family if she left? Maybe she'd

run somewhere, live alone, make sure that Clyde couldn't hurt anyone close to her. She needed out of this situation, but she wouldn't risk anyone being hurt because of her.

Because of her tumultuous situation, Genevieve barely got any sleep. She was quite disoriented, but that didn't deter her from going about her day. Today was the day Nana was coming. At midday her salvation would be here. It didn't matter how long it took to get back to the States; she would fight every day to escape from Clyde. She would no longer be subject to his abuses. From this day forward, she would become stronger. No more bending over backward for Clyde or his drinking. If he wanted to become a drunken slob, fine by her, as long as she wasn't there anymore.

Genevieve cooked breakfast, then ate it fast. She knew rushing through her day wouldn't speed things up, but she couldn't help it. She wanted to run into her Nana's arms, never letting go. She would no longer take for granted the people in her life. She had let herself be taken away from her family; more importantly, she had let someone take away her value and self-worth. No more.

Genevieve made herself stay at home for as long as possible. If she left too early, she would just drive herself crazy. When she did leave, she walked as slowly as possible. No reason to seem like a crazed person. She couldn't help but quicken her pace when she saw the docks. She looked around for Nana's boat. No luck. I am probably too early anyway, she thought.

So Genevieve found a bench to sit on to bide her time, waiting. She waited some more. She feared something was amiss when the boat finally pulled up to the dock. But excitement coursed through her as her Nana finally appeared. Nana had always been a fashionable woman, a widow too young with money to spare, but all those years later, with her white hair, she was even more elegant. She stood tall and proud, with all the assurance of old money. But that didn't stop her from embracing her excited granddaughter.

"I've missed you, Genevieve," Nana said with great restraint. Truth be told, she wanted to sob at the sight of her granddaughter. They had been close before Clyde had taken Genevieve away from her.

"I've missed you so much, Nana!" Genevieve whispered. "How was your trip?"

"It was fine, dear. Not many passengers, many like me," Nana said, "wanting to come across the ocean to meet with loved ones."

"I'm so glad," Genevieve said.

"Let's find my hotel, then we'll visit at your home," Nana said.

"That sounds perfect, Nana," Genevieve said. "I have so much to tell you."

They walked to the hotel and went to the front desk. "Hello, ma'am," the hotel clerk said. "How may I help you?"

"I need one room for five days," Nana said.

"Of course, ma'am," the hotel clerk said. "Here is the key; what is your form of transportation after you leave?"

"That new ship that has her maiden voyage on April tenth," Nana said. "It's supposed to be the safest ship to sail on."

"Yes, ma'am. Many of her passengers are here at the hotel," the clerk informed them.

"Wonderful! Well, thank you for your help. Now, my dear, it is high time that we chat after all these long years." Nana took Genevieve's hand before they walked arm in arm to the house.

It was invigorating for Genevieve to see the change in the townspeople's attitudes as they walked through town. With Clyde, Genevieve had been the town joke; now men tipped their hats at the pair, and the women smiled politely. Genevieve smiled at Nana. This could be how I was treated always, she thought.

As they walked closer to the house, Genevieve was concerned. What would Clyde be doing right now? Would he be tearing the house apart, or would he be drinking himself to death? She was startled from her thoughts as Nana congratulated her on her beautiful garden, with green broccoli, red apples and strawberries, and yellow forget-me-nots. She was pleased to know she had made her Nana proud, but as they entered the house, her jaw dropped.

The house was spotless, with no sign of abuse or neglect in sight, and there before them was Clyde, clean and spotless, with no sign that he had swindled her money out from under her. Genevieve wanted to unleash on him, but she knew that would only make her look bad in front of Nana. Why would Nana believe anything was amiss? It looked as if he had never touched a drop in his life.

"It is so good to see you," Clyde said, opening his arms to her. "We were so overjoyed to receive your letter. As you can see, my Genevieve is always making this her patch of heaven; that is why we have no room. We wouldn't want you to hurt yourself."

There it was: his first veiled threat against her loved ones. She knew that this was just a charade, not a new turn for Clyde. Even though she had been careful in her planning, he had still been able to figure her out. It was unnerving how he knew every little step in her repertoire. She tried to think about how Clyde had known of her plan. Had it been the suitcase or her nervousness? She tried to think that maybe he was just scared that Nana would go back and tell her family of any neglect or abuse, but she knew Clyde better. This charade was all for her.

"I'm just glad I get to see you both!" Nana said. "It's been far too long."

"We are so glad you could make it," Clyde said as they both embraced.

"Any chance you two will come back to the States?" Nana asked.

Genevieve silently cheered. Anything Clyde could be caught on was good for her. Any loose question, he would be tossed away and she back home.

"Life has been rough for us, but I have new projects coming up," Clyde answered. "I can't tell you, but I have hope they will be great for us."

You smooth bastard, Genevieve thought. She should have seen this gaslighting coming. This past month had all been a play of his design. Clyde had wanted her to believe that he was so drunk out of his mind that he couldn't do anything by himself. Instead, he was masterminding his way of getting into Nana's good graces. If Nana believed he was looking for new employment in Southampton, there was no way she would believe that Genevieve was looking for safe passage out of here.

Once again Genevieve was stuck in a horrible situation. Maybe she could get Nana alone, but she highly doubted that this toxic asshole was going to let that happen. No doubt he had a plan for everything. She had been good, but he was better. He was going to take away her only chance of redemption.

"That's wonderful!" Nana said. "You two are going to have the best years of your life ahead of you."

"It's all I ever wanted," Clyde said.

"Isn't he the best?" Nana asked. Genevieve forced a smile.

"He sure is," she said, defeated.

"Why don't I make us dinner?" Clyde asked smugly.

It wouldn't last the whole time; she knew it. No matter what had motivated him to do this, he would always need alcohol to get through the day. If he didn't get alcohol soon, he would be off the rails. She had no idea how he thought he would get through this next week.

"That would be wonderful. I had a good ship, but no matter where you sail to, they never have enough food," Nana said. "The food on my return ship is supposed to be divine, though."

"I can't promise divine, but I'll try. For now, you two catch up," Clyde said as he gave Genevieve a pointed look. She knew what that look meant. She had to be careful about what she said.

"Yes, how is everyone back at home?" Genevieve asked.

"Everyone is fine, dear. Your brother is married with two children. He started up a business on his own, so the town is booming once more," Nana said. "He made your father a partner in the firm, so he and your mother have more than enough money to spare."

For the second time that day, Genevieve's jaw dropped to the floor. When Clyde had been coherent, he had told her—no, he had bragged to her—that the town had gone downhill, that everyone had lost their money. It was why she had never told her parents what had been happening to her.

"It's a true miracle," Genevieve said.

"How has everything been with you, my dear?" Nana asked.

"I couldn't imagine being anywhere else. It's something else," she lied.

"I am so glad that you love it here, the both of you," Nana said. "It pleases my heart that you both are strong and making this marriage work, even in a strange place."

"That means a lot," Clyde said.

"It's up to the both of you to be there for one another," Nana advised.

"That's the plan," Clyde said dangerously. "Dinner is ready. I'll show you to the table."

"I'm so glad you have such a supporting husband," Nana said. "I can trust you are safe here with him."

Genevieve forced a smile. She hated to lie to Nana, but she hated it even more that Clyde had put her in this horrible situation. It wasn't enough that he was destroying her reputation; now he was taking away her free will. Nana believed he was a good husband. Unless Genevieve found a way to tell her the truth, there was to be no salvation for her. She would die alone among strangers, never seeing her family again.

"This looks amazing!" Nana said, looking at the food on the table.

"Thank you. It's not much, but I like to help out as much as possible," Clyde said.

"You should see him on a regular occasion," Genevieve said.

Clyde coughed as he choked on a piece of meat.

"Unfortunately, I'm not here for too long," Nana said, missing their pokes at one another. "I heard about the new ship, and I thought it was a good opportunity to see you again. You know that I don't always like to be away from home for so long."

"I know, Nana. I'm just so grateful to see you again," Genevieve said. "Even just one day would be good enough for me."

"Me too, dear. But let's think about the future. April tenth is a long way away for us if we treasure each moment we have with each other," Nana said tenderly.

"Yes, it's so long away," Clyde grumbled.

Genevieve smiled at the thought of Clyde not being able to be his true self for so long. How refreshing to be in control of the narrative, even for a short time.

"You're right, Nana. We will have a marvelous time with one another," Genevieve said with a strength she thought she had lost.

The two women spent the rest of the evening talking, but Clyde was still in ear's distance. There was no way to tell Nana the awful truth. When Nana wanted to return to her hotel to rest, Genevieve thought she would escort her, but Clyde, ever the gentleman, decided that he should walk her there due to the lateness of the hour. She shouldn't have been surprised. Clyde would probably be around both of them the whole time Nana was there. She decided the best plan was to write a letter, placing it in Nana's purse when she had a chance.

The best-case scenario was that Nana would see it and be able to help her while she was still in Southampton. The worst-case scenario was she would see it back in the States and send the cavalry for her. But she had to be careful. If Clyde saw the letter, he would no doubt hurt her or Nana. Genevieve was not going to let that happen. Clyde was done destroying people's lives. He had hurt so many people, even if indirectly.

Genevieve had written the letter and hidden it before Clyde came home. They didn't speak to one another that evening or in the morning once they woke up. It was as if this event had led them both to discover what the other thought. No matter what happened after Nana's trip, there was no going back to the charade they had maintained for so long.

Over the next three days, Genevieve and Nana made up for lost time, all under the watchful eye of Clyde, of course. But that didn't matter to Genevieve. For a glorious week, Clyde couldn't drink so he could keep up the ploy of being a loving husband. What she would give to have that level of control over him all of the time. A mere dream that would end too soon. But for now she had the hope that she could give Nana the letter detailing everything that had happened. Thankfully, she found the chance that third night.

They had decided to enjoy dinner outside, seeing as it was a beautiful evening. Genevieve went into the house to grab Nana's purse while she and Clyde continued talking outside. She rushed in and grabbed the letter before putting it securely into the purse, walking out, giving it to Nana.

"Thank you, dear," Nana said affectionately. "Until tomorrow."

"Good night, Nana," Genevieve said, hugging her tight before waving Nana and Clyde away. She was getting to be a good actress, but hopefully it could end soon.

She cleaned up outside and was just getting to washing the dishes when the front door banged the wall so hard it shook the whole house. She turned to the front door to investigate, and she found Clyde beet red, angrier than she had ever seen him since they had moved to Southampton.

"Clyde, what's wrong?" Genevieve asked cautiously. When he stalked closer to her, she instinctively backed up until she hit the wall. "Clyde, please!"

He grabbed her shoulders and rammed her against the wall, throwing something in her face. Through dazed eyes, she saw that it was her letter to Nana.

"You think you can just leave me?" he yelled, kicking both of her shins.

"What did you do to Nana?" Genevieve gasped. Tears flooded her eyes as he punched her in the stomach.

"You wouldn't want to know what I would have done if she had found the letter," Clyde said as he wrenched her to the bedroom. She cried out in pain as he almost dislocated her shoulder from her arm. "But the old broad didn't see it. Even if she's a pain, that doesn't mean I have to hurt her."

Thank God, Genevieve thought. Her one fear had been that if she messed up, Clyde would hurt those closest to her, but if he hadn't hurt Nana, maybe he wouldn't hurt them. Only time would tell.

Meanwhile, Genevieve was punching at Clyde's arms—anything she could do to loosen his grip, even for a second. If it didn't succeed, she could very well die. She was not going to be so close to freedom with nothing to show for it. She was going to fight harder than she ever had. Luckily the arm that was being dragged on the floor found a random block of wood that had no doubt been left behind from Clyde's reconstruction job to impress Nana. Ironic.

As a girl, she had never had the chance to play baseball, but there was a first for everything. Although in an awkward position, she twisted her body, whacking him as hard as she could. While it didn't knock him out, Clyde howled in pain, dropping his grip on her. Genevieve stood up, ready to give him retribution for everything he had done to her.

With a growl, Clyde stood up, shielding the part of his face that Genevieve had whacked. "You sure you want to do this?" he asked.

"You've given me no choice," Genevieve said. "You might have taken me away from my family, but the day you put your hands on me is the day I say, 'No more.'"

"I'm not letting you leave." Clyde sneered.

"I'm not asking for your permission," Genevieve said.

If Clyde had been angry before, he was livid now. He rushed forward to her, and she whacked him again. It wasn't enough to disable him, though. He wrenched the board out of her hands, smacking her. She yelped as she dropped

to the floor. She didn't stay down for long, though. She knew she had to keep moving to survive this attack.

Genevieve ran to the front door, hoping to exit the house. If she was able to scream, then maybe someone would be able to help her. No such luck as Clyde grabbed her in the kitchen. She screamed in surprise, hoping she was loud enough so someone outside could hear her. Clyde clamped his hands over her mouth, and she bit his hand. He howled in pain. He let go of her long enough for Genevieve to get to the counter. She hadn't had time to clean and put away the steak knife. This was it. No going back.

Genevieve spun around to see Clyde going for her again. She dashed out of the way while he crashed into the counter. She held up the knife.

"Stay away!" she yelled.

He only laughed in response. "You're not going to use that on me!"

He was still laughing when she stepped forward, plunging the knife toward him. She was aiming for his stomach, but when he noticed what she was doing, he jumped up on the counter. He howled in pain when the knife hit home in his leg. Genevieve tried to take the knife out, but it was stuck, so she pushed him over the edge of the counter. He landed on the floor; when she peered over, his eyes were closed. She thought maybe she should check his pulse, get help for him, but then she thought about what he had done to her. Better get out of Dodge before he wakes up and does something I never recover from, she thought.

Genevieve grabbed her bag out from beneath her bed, then ran as far away as she could. When she felt that she was far enough away from the house and was confident Clyde wasn't following her, she allowed herself to breathe. She put her face in her hands, screaming in agony. In all her years on Earth, she had never considered being in a position to hurt somebody so she could save herself.

She raised her head, wiping the tears from her eyes. It was time to tell Nana what was going on in her life. She knew that she wouldn't be disappointing Nana with how her life had turned out; she knew Nana would just be angry at Clyde. Nana had given him such high praise, and now he would lose her trust forever. Genevieve just wished she didn't have to tell Nana about the physical abuse she had just endured.

Genevieve made it to Nana's hotel and went up to her room. She had hoped she didn't look too bad, but when the night clerk's jaw dropped to the floor, she knew it wasn't pretty. She knocked lightly on the door, hoping she wasn't waking her poor Nana up. Nana opened the door with a smile before she gasped in concern. "Genevieve, dear, what happened?" she asked, putting a hand on Genevieve's shoulder.

"Clyde did this to me!" Genevieve whispered.

"Come in." Nana ushered her into the room before closing and locking the door. "Why would he ever do this to you?"

"Clyde was lying to you the whole time, Nana," she said. "He was never looking for work. He's been a drunk this whole time. He lost our money. I would have written home, but he made it seem like everyone back home was poor. I wrote a letter to you, but he found it. He wasn't going to let me leave."

"If I had known, I never would have left you there," Nana said, embracing her. "It's OK. I'm here, darling."

"What am I going to do?" Genevieve sniffled.

"I'll tell you what you are going to do, dear," Nana said. "You are going to take my ticket, then go home. There isn't a reason in the world you should stay here any longer than you have to."

"Oh, but Nana, you've already been here long enough. You don't like being away from home for so long..." Genevieve stuttered.

"Nonsense, dear!" Nana exclaimed. "I can always see if there are any cancellations for this trip. If there aren't, then I'll just take the next voyage when it returns. Trust me—I would do anything for you, dear."

"Oh, Nana. I don't know what to say." Genevieve hugged her tight for fear of crying right then and there. It may have been over, but she was still traumatized by the whole event. She was sure she would have nightmares for the rest of her life.

"Let me see your bag. Oh, not much! Seeing how you didn't have much time, I'm not surprised," Nana said. "You get some sleep. Tomorrow we'll get you some first class clothing for the voyage."

"I don't mean to be a bother," Genevieve said, knowing how expensive this all would be.

"Think nothing of it. I've been saving money for you and your brother ever since you were born. I brought some money for you that I was going to present to you on my last night here," Nana said.

Genevieve giggled, then began to laugh. Clyde would never know that he had lost out on a big payday for alcohol.

Genevieve was frightened of sleeping, but as soon as she sank into bed, she instantly fell asleep. It was not peaceful, though. Images ran through her head, but she wouldn't consider them nightmares. They were flashbacks of her previous trauma. As if she needed more of a hell on earth. Once she awoke, she lay there awhile, not wanting to go anywhere.

But she got up eventually. Nana was so kind to her, she wanted to return the favor. She hoped that there would be a cancellation. She couldn't go through this trip all alone. This wasn't her life; it was Nana's. She got dressed in one of her better dresses before joining Nana in the dining room for breakfast. When Nana gave her a sympathetic smile, she realized it had been so long since someone had cared for her.

"I would ask how you slept, but I know it must have been a difficult night," Nana said.

Genevieve sat across from her, mirroring her movements. "It was hard, but I'm glad it's passed now," she said, before getting to business. "What's our plan for today?"

"Getting dresses for you, then I would love to teach you the ways of first class life," Nana said. "I want to be there with you, but I can't be sure that there will be a cancellation."

"I'll be happy to learn from the best," Genevieve said.

"Spoken like a true first class lady." Nana smiled approvingly.

They ate their breakfast in peace before going to the shop to buy Genevieve the best dresses and fur coats for the trip. Genevieve tried on many dresses, the kind that would showcase her first class life. Nana took control of everything, telling the attendant all the specifications of what she wanted to see Genevieve in. Genevieve couldn't believe the change to her battered body she saw in the mirror. It had been a long time since she had felt beautiful.

She knew that Nana had brought her money, but she was still glad to leave the transaction to her grandmother. She didn't want to think of how much money was going to these trivial, earthly things. But as they walked out of the shop and back to the hotel, she knew that her life was turning around. She was going to survive; she couldn't have been happier.

"I can't believe I only have three more days here," Genevieve said as they returned to Nana's hotel. "I feel like I've been here so long, I was never going to escape."

"And escape you will, but first things first: time for your lessons," Nana said as they put their purchases down. "Never fear if you don't get it all right at the start. There was a cancellation, I've just heard, and we will go home together."

"I am so glad," Genevieve said with a smile.

The next three days flew by. Genevieve couldn't wait to get on the ship, to leave this portion of her life behind. She hadn't seen Clyde or heard any chatter about a murder, but she couldn't be sure if Clyde had survived or not. He was a wily character; if he wanted to come for her, he would. But once she was on the boat, she could breathe, if only for a short time. Besides, she had to be mindful of Nana's advice. She wanted to make a good impression on her future.

Once she woke on the morning of the voyage, it was a flurry of activity. While the boat wouldn't depart until noon, there was packing to do, and she had to make sure nothing would be left behind. Genevieve was certain that she wouldn't return to this wretched place again. She dressed in a light-blue empire dress—the height of fashion, her grandmother had called it. Her brunette hair had been swept back into a tight bun, with a stylish black hat to accessorize. Nana nodded her head once she saw the finished look.

"You'll look as good as them, if not better than the lot of them," Nana said, wearing a classic dress that reminded her of Victorian times.

"I hope I don't make people jealous, then." Genevieve smirked.

"We'll have to see about that. Come, it's time," Nana said, walking down to the carriages that were parked out front for guests.

The pair of them sat while their luggage was put inside another carriage before being transported to the docks.

Once Genevieve was outside the carriage, she looked around at the crowds, those people wanting a glimpse of the unsinkable wonder, wishing they had been lucky enough to secure a ticket for the maiden voyage. A pair of girls looked at Genevieve in her new dress, watching her with awe. When she gave a wave to them, they waved back before giggling at one another, feeling lucky that Genevieve had paid attention to them.

With a grateful smile, she followed behind Nana, walking up the gangplank. Nana handed the valet both of their tickets; he inspected them before murmuring something to an attendant and smiling at them both. "Welcome to the RMS *Titanic*," he said.

"Thank you." Genevieve smiled.

They had only been on the ship for a couple of seconds, but she already felt more secure than she had in five years.

Chapter Two

"You're not going to use that on me!" His brain helpfully reminded him of the phrase as his eyes fluttered open. He sat up and groaned, seeing a knife sticking out of his leg. How exactly had he gotten here? He pondered that question as he thought about what to do about the knife. No one would mistake him for a doctor, but he still thought he would have heard about it if there were arteries in the leg. Well, there probably were; he just couldn't remember, either from not drinking for a week or being pushed over a counter.

Lucky for him, he found a towel near him. He would pull out the knife and then wrap it in this makeshift bandage. If he was fortunate, he would walk away—no pun intended—without much of a scratch. If it had nicked an artery, well, no one can live forever. He only wished for one last opportunity to terrorize Genevieve. That bitch. He let his anger for her wash through him as he took the knife out. He yelled in pain, feeling the steel leave his body, concentrating on securing the towel around his wound. Only then did he entertain the thought of passing out. He wasn't dead yet, but he decided to make the prognosis only when he opened his eyes. If he saw the horns of the devil or the pearly white gates, then his wife was a stronger woman than he had given her credit for.

But the hours passed by. He smiled once he opened his eyes, his mouth dry beyond all repair. It was time to test the leg, making sure the bandage was doing

its job. He sat up once more, pleased to see that it was not soaked in blood, meaning his leg was clotting. Did that mean he was out of the woods? No, sir, doctor. It was fine now, but who knew whether it would need to be amputated down the line, not to mention blood poisoning, which could happen slowly but surely. That much he did know about legs. He didn't know how to stand up without upsetting the wound any more than he already had.

He slid across to a chair that had not been disturbed during the fight. Since it was early morning and he did not hear anyone else in this godforsaken cottage, he assumed that Genevieve had left. Little did he know his wife had run to her Nana a mere six hours before. His eyelids dropped down, and he almost fell asleep at that moment before he opened his eyes violently. One step at a time: drink now, Genevieve later. He grunted as he slid across to the chair and started to stand up before collapsing into the seat. It wasn't much, but it was enough to get him to a bottle of beer. He reached for it before his hand grasped a flier. What is this?

He smiled as he read the flier, knowing without a doubt that this was the ship Geraldine Wilson was going on; since Clyde was brilliant—oh, he was oh so bright—he knew that she would get her precious granddaughter on the ship. Since she was rich, it would be doable. Even if he could get a ticket, he was sure he didn't have enough for a third-class passage. He took the bottle of beer, lifting it to his lips to take a thoughtful drink before he grinned, throwing the glass behind him, hearing the satisfying crunch of the bottle breaking.

He hadn't drunk in so long; it would be a nice pick-me-up after being left for dead, but he needed to keep this ruse up a little longer. He was going to get on that ship one way or another. He didn't need to worry about paying for a ticket—he knew a man who could get him what he needed, and he needed this. He looked at the flier once more, seeing that he had three days before the ship was going to leave. If he didn't get on it, he would never get his chance at revenge.

He stood up, his leg roaring in protest at the thought, and reached for some water. He drank his fill, knowing he had much to do and not a lot of time to do it. Then he took a basin of water and went into the bedroom, stripping naked so he could wash off the night before. His torso was OK—nothing anyone would notice—but what to do about his leg? He took off the bandage, looking

at it carefully. The wound was clotting; that much was true. He was 50 percent certain he did not have blood poisoning—a welcome sign in light of his plans. He put on a clean bandage, then carefully put on clothes, hoping he wouldn't exacerbate his wound any further.

All set, he gathered some extra clothes in a knapsack, laughing, realizing this was how this whole thing had started. Contrary to what Genevieve thought, he hadn't known she was thinking of leaving until he had seen her bag hidden in the corner. Now he was taking his things and leaving. He wondered if she had had any sadness about going away from this place, or if she had just hurried away, worried that he would wake at any time. He walked away slowly, looking back at the cabin one last time before walking to town, keeping away from people. He knew where he was going. He would not let anybody deter him from his destination. He walked to the door, looked around, then knocked. He waited nervously until the door opened.

"Clyde, my friend! It's been a while." Louis grinned, inviting him in. "You look horrible."

"I feel it. My wife has flown the coop. I know where she is—more correctly, where she is going," he said.

"She's not here, so get on out there, get her back!" Louis said.

"It's not that easy. This time she had help, but so do I. I need your help to get on that big ship that's leaving Wednesday. You think you can do that?" Clyde asked. Louis cocked his head.

"She's heading back to America without you? That's horrible." He shook his head.

"Yes, Louis, it is. So you think you can do that? It would be a big favor, so I would no doubt owe you for all time, but you would be doing me a huge favor," Clyde said.

"For my oldest friend? Nothing is too big. I think I could get tickets for the both of us," Louis said. Clyde raised his eyebrows.

"Both of us?" he asked.

"I mean, come on, man. I could help you. Plus, what are your plans after you get her back? Are you returning?" Louis asked.

Clyde hadn't thought too much about that point. He smiled. Why couldn't Louis come along?

"You know what, you make that two tickets, Louis—third-class. I don't want to spook Genevieve by being too close to her. Low profile for a while before I approach her," he said.

Louis whooped. "Third-class tickets on the *Titanic* coming up! You stay here; I'll speak with my contact. Have all the drinks you want." He grinned.

"Would that I could, Louis, but if I want to be low profile, I should make sure I'm nice and sober," Clyde said.

Louis smiled, putting a finger to his head. "Smart, very smart! I'll be back, then we'll get started on our plans for getting your girl back," Louis said before running out.

Clyde smiled. Louis was a good friend, always so ready to help someone in need. How could he think of getting on a ship and grabbing Genevieve without Louis's help? It was folly to believe that he could survive without him. But now everything was going his way. He would get Genevieve back, maybe even get rid of that old hag. And no matter how it shook out, he would have Louis with him. He could get out of anything with Louis by his side.

The days before they were to leave for America were busy ones. Louis got his debts paid in full; while not wealthy, Clyde put some money in their pot. Louis said he was more than happy to finance their trip, but Clyde hated to feel like a cheapskate. This trip had been his idea; he would have done anything to pay Louis back for everything he had done. But Clyde also did some recon before the big day.

He stood in front of the hotel when he could do so unnoticed, looking in on Genevieve and her Nana from time to time. He noticed that Genevieve was looking more sophisticated, dressing more resplendently. He shook his head. Did they honestly think they could disguise the fact that she came from trash, would always be trash? He went back to Louis's but didn't tell him what he had just seen. He didn't feel like being cheered up by Louis right then.

He went to bed that night knowing that the next day they would set sail. Tomorrow would get more real than his little recon had been. They would be in tighter quarters; he could be discovered at any time. Two respectable first class women's version of events would be taken more seriously than that of a lowly third-class man. If he wasn't careful, he could be apprehended, then Genevieve could get away from him for all time. He couldn't let that happen. Never again.

He felt like he had just gone to sleep when he was shaken awake by Louis. "Time to go, buddy. You ready?" he asked, that famous grin of his welcoming Clyde into the world of the living.

"Yep. Not much left for me here," Clyde said, getting up. He did not want to get left behind.

"I know how you feel. Let's get out of this country," Louis said.

"You did get everything set, right? We can both get on, no questions asked?" Clyde asked, a little anxious.

"We'll be all good. My contact will let us on, and on to America!" Louis said. Clyde grinned at his excitement. This wasn't a social voyage, but he wouldn't spoil this for Louis; he was why Clyde was even getting on the boat, so if he was excited to go to America, then three cheers to all.

The two men hurried to the docks; Clyde's jaw dropped as he saw the huge crowds around the ship. He knew this new ship boasted of being unsinkable, but holy cow, was the whole city going on it? He looked around, seething when he saw Genevieve and her precious Nana about to walk up the gangplank, Genevieve waving to two little girls. They giggled at the attention. He rolled his eyes at the sight. Louis snagged his shirtsleeve, gesturing with his head that they should keep moving.

"Come on. Let's get on further down here. Can't let the first class snobs see us. We might scare the ladies." He grinned.

"All right. Let's go," Clyde said.

They walked past the crowds looking at the massive ship. The two men walked up to a steward, who nodded at Louis. There was an enormous door in the cargo hold that was open so they could sneak on. Clyde looked in, seeing various pets, even an automobile. He looked back at the steward. "A car?"

"We do everything for our first class passengers, sir," the steward said sarcastically.

"Thanks, Jerry," Louis said.

"Remember, I don't know you; you don't know me," the steward said before leaving.

"You ready to get settled?" Louis asked.

"Yeah, let's do this," Clyde said.

It was going to be a good week; he would make sure of that.

Chapter Three

Genevieve and Nana followed the attendant to their rooms, which thankfully weren't far away from one another. Genevieve was in room A-11; she looked around the cabin with a smile. It was larger than her cottage had been, not to mention more fashionable. She smiled in delight at the pink carnation—a nice touch for this maiden voyage—on her wicker table. The bed looked luxurious, yet she appreciated the simplicity of the cabin. She was certain other rooms were more opulent than hers, but after five years of hell, she was happy with what she could get. She made sure her luggage was secure before locking her door, then met Nana outside of her room.

"This is the most impressive ship I've been on," Nana remarked. "Let's go topside; we can wave goodbye to the people."

"Not that there's anyone here I'll miss, but I don't mind the idea of waving away this time of my life," Genevieve said.

They joined an impressive number of passengers already waving goodbye to the crowd, no doubt many to family and friends they were leaving. Genevieve found a good vantage point and waved. She was delighted when she saw the two girls from before. They, too, were excited when she waved to them once again. She smiled sincerely when she looked one last time at the city that had been her downfall; never again would she put herself in a position that could ruin her

life. She gave one last wave to the girls before she and Nana walked back inside the ship. The ship's engines started up; the propellers started moving; they were finally leaving this cursed land.

Genevieve sighed contentedly before they stopped so abruptly that she squealed, falling head over heels. A steward gave her a hand up; she thanked him before checking on Nana. "What was that?" she asked out loud.

"I'm not sure, miss. Are you all right?" the steward asked.

"Yes, I am. Thank you," she said. He bowed before leaving.

"Are you all right, Nana?" she asked.

"I'm all right, as long as we don't make it a habit of that," Nana joked.

"Don't worry, ma'am. The New York broke loose of its rope while heading toward us. We'll have everything back up and running soon. We have no intentions of doing that again," an officer said when he heard her concern. "I'd say give us a half hour or so, and we'll get on our way."

"Thank you for the information," Nana said before he headed off. "Unsinkable or not, I'm glad they were on their toes with that close call. Come, we have some time to explore before lunch. If the ship looks empty, don't worry. We're sailing to Cherbourg, in France, to pick up some more passengers. I'm sure we'll have some good company."

They explored the areas they could, keeping out of the way of attendants and officers. Since Genevieve hadn't been in this life long, she didn't know many of the passengers they came across, but Nana knew a few, giving them polite salutations, but it was clear she wasn't close friends with the lot at this point.

Having gone on deck to look at the view now that they were away from Southampton, they then returned inside the ship, where Nana stopped before smiling at a man. He noticed her, smiling broadly at the sight of her. He was tall and imposing but in a friendly way. He walked over, kissing the top of her hand.

"Geraldine, I had no idea you'd be on this ship," he said.

"Likewise, Archibald. I was on a trip to Southampton to see my granddaughter. Thankfully I get to bring her home with me," Nana said with a smile at Genevieve.

"How magnificent!" he said.

"This is Colonel Archibald Gracie," Nana said to Genevieve. "This is my granddaughter, Genevieve Wilson."

"It's a pleasure to meet you, Colonel Gracie," Genevieve said, using her first class charm.

"The pleasure is all mine, Miss Wilson," he said. "Are you two all by yourselves?"

"Yes, we are. My maids, cook, and driver are all where they do their best work: home," Nana said as they continued walking inside the comfort of warmth.

"Well, I am offering protection to four other ladies, if you need any help," Colonel Gracie said.

"Colonel Gracie, you might have too much on your hands," Genevieve teased.

He laughed. "What can I say? I want to make sure everyone is protected during this voyage."

"As much as I appreciate that, Gracie, we don't want your hands too full. Besides, I've never felt safer," Nana said.

"If you need anything, please inform me. I'm in room C-Fifty-One. I hope we get to share a meal soon," Colonel Gracie said before letting them enjoy more of the ship.

"He seems like a good man," Genevieve said.

"He is. I already feel safer," Nana said. "Come, it must be close to lunchtime."

They got to an elevator, riding down to D deck, where some passengers were lounging on wicker tables by the Grand Staircase: wood paneling with a beautiful clock and statues. Genevieve sighed at the sight of it; it was indeed beautiful. Her attention was diverted to someone playing the bugle, and she saw that all of the passengers were getting up to enter the dining saloon.

"You'll hear him play that bugle for all three meals. I hope you don't mind the sound," Nana whispered to Genevieve. Genevieve giggled softly before following Nana in. The sight took her breath away.

It was exquisite; she noticed many Victorian details. The detailed oak wall, which was painted white, was a stark contrast to her last five years of life. Genevieve couldn't help but look back at the door, a beautiful mahogany with grillwork to once again call to detail the magnificence of first class life. But she

found even more magnificence as she looked down at the floor, an intricate gold, red, and blue that dazzled her. The glass windows on either side of the room were breathtaking. She thanked the attendant who pulled her chair out for her—a gorgeous polished oak, with rich green leather for the cushions and the backrest—as the two of them were seated at a small table. She would later be told that an impressive 554 people could be seated in this room at one time. When asked what she wanted to drink, she requested hot tea, which was placed before her immediately.

"Would you like the traditional lunch, or would you like to serve yourselves at the buffet?" a waiter asked.

"First class ladies don't serve themselves," Nana said with a twinkle in her eye.

The waiter smiled. "As you wish, ma'am," he said, giving them menus.

Genevieve looked lost at all the options. "I haven't had a chance to eat this much in years," she said.

Nana looked at her sympathetically. "I know this will be a hard trip for you, but you will get through it."

Genevieve nodded and looked back at the menu. There was so much food, and it all seemed so decadent: loin chops, a rich stew called hodgepodge, lobster, shrimp, and beef. There were also potatoes and dessert items. Genevieve couldn't even imagine eating dessert after such decadent meats and stews. But she did eat some good food, at which point she realized how much her body had been craving actual substance, not just the meager meals she had been able to put together.

After they had finished eating, she and Nana went back to exploring new areas of the ship. Genevieve could safely say that she had never seen such beauty or opulence in one place before. There was a squash court, gymnasium, and swimming pools; additionally, there were à la carte restaurants, the Café Parisian, the Verandah Café, and a grill, all complementing the meals served in the dining saloon and all with their beautiful styles. Genevieve was impressed, to say the least.

"There will be more time to explore, but I suggest we go back to our rooms. I think it's high time we get everything unpacked for this week," Nana said as they circled back to an elevator. Genevieve agreed.

After they made their way to A deck, they both went their separate ways to their rooms. Genevieve looked down at the floor in front of her room, picking up a pamphlet a steward had no doubt put there: "List of First class Passengers." She giggled as she unlocked the door, thinking that she had never thought she would make it onto such a list. She made sure to securely lock her door while she mused about her life. While she knew that Clyde wasn't—couldn't—be there, it was better to be safe than sorry. She unpacked her clothing, feeling at peace.

Then she made her way out of the room with a smile—before seeing the blankets next to her door with a note written in a hand that she recognized, that she had become familiar with over the past five years: "Keep warm." She looked up and down the hallway, and her attention was drawn to a dark figure at the end of the hall. She ran after them, hoping to get some answers.

Fear racked her brain. There was no way Clyde could have known she would be here and gotten on the ship. Or could he have? Was he about to make her life a living hell once more? She was not about to let that happen. She kept running after the figure, but she could never overtake them. She was so close to catching them when she ran into someone coming out of their room.

Genevieve gasped in terror at the man whose arms she had fallen into. She relaxed once she saw no anger on his face, only gentle concern. She could tell he worked with his hands by how rough they were on her arms, but that fact had in no way destroyed his face. She could tell he was middle aged, but his face was still smooth. His brown hair was professionally combed and styled. He was all the things Clyde wasn't.

"I—I..." she mumbled as he gazed inquisitively at her.

"Are you all right?" he asked in a British accent.

Once he had spoken, she snapped out of her reverie.

"I thought someone was stalking me," Genevieve said.

"That would be most troubling on a ship," he said. "What makes you think that?"

"I was going to rejoin my grandmother in her room when I found a pair of blankets with a note attached to them," she explained.

"Show me these blankets," the stranger said sharply, releasing his hands from her arms. He didn't say it with anger, though. He seemed concerned about her well-being.

"It's this way," Genevieve said as they made their way in the right direction. "I saw a shadowy figure. I was trying to catch up to them. That's why I ran into you. I'm sorry."

"No, I'm the one who is sorry. If I had gotten out of my room sooner, we could have caught the culprit, known what the meaning of this is." He stepped in front of her, putting his hands on her shoulder. "I want you to promise me that if this happens again, you will come to me for help."

A million questions raced through her head. Who was he? Why did he care? Should she trust him? Despite all these unanswered questions, she assented. "I will," she said.

"Good. Let's go," he said as they continued walking to her room. Once he saw the blankets and note, he chuckled to himself before turning to her. "Well, miss, this seems nothing more than a steward making sure you are warm. Perhaps he was meant to give you them before you boarded, so he ran away in case he was caught."

"Well, thank you anyway," Genevieve said. "It was mighty foolish of me to run after someone I didn't know anything about. I won't waste any more of your time."

"Wait," he said as she turned to leave, "might I escort you to your grand-mother's room? It wouldn't be kind of me to leave you all alone after this."

"Thank you. That would be most appreciated, Mr...." she trailed off. She realized that she had been in this man's presence without knowing his name.

"Thomas Andrews," he said as he extended a hand to hers in greeting. "I built this ship."

"I'm Genevieve Wilson," she said. "It's a pleasure to make your acquaintance. This ship is quite a marvelous creation."

"It's nothing but the best for the White Star Company; as I'm sure you've heard, this is the strongest ship ever built," he said as they made their way to Nana's room. "They wanted big and grand as no one had ever seen before. It was to be opulent for all classes but affordable as well. I only hope it is good enough."

"I'm impressed so far," Genevieve said, looking around at all the detail again with new eyes.

"I would be happy to give you a tour of the ship," Mr. Andrews said as he glanced at her. He could tell she was entranced by the ship, as if she was seeing this type of splendor for the first time. He didn't know how he knew, but he suspected that there was some level of trauma in her past.

"If it's not too much," Genevieve said. "I would hate to take you away from all this. I'm sure people will want to talk to you for the whole trip."

"Trust me, I'm in more of a behind-the-scenes role," Thomas said. "I don't want to take away all the glory from Bruce Ismay or the *Titanic*. And while it is unusual for the shipbuilder to be on board, it would be my pleasure to give you a tour."

"I would love that, then. Here is my grandmother's room," Genevieve said before knocking on the door. Nana opened the door, looking surprised at the pair. "Grandmother, might I introduce Thomas Andrews?"

"Hello, Mr. Andrews. It's nice to meet you. How did you two get acquainted?" Nana asked him.

"Miss Wilson had some blankets outside her bedroom that she was concerned about," Thomas explained. He didn't say anything about her running after the figure, for which she was grateful. It was not first class etiquette to run after someone, especially for an unchaperoned woman. "She mentioned that she was headed to your room, so I decided it best if I escorted her."

"Nothing the matter with the blankets, I hope?" Nana asked.

"None, ma'am. As I told your granddaughter, it was a steward who had no doubt forgotten to do his job before passengers boarded," he said.

"Of course. Thank you for escorting her; it was very kind of you," Nana said.

"Yes, thank you, Mr. Andrews," Genevieve said. "I hope to see you around."

"I'm sure you will. If either of you needs anything, please don't hesitate to bring it to my attention," Thomas said before returning to his room.

"A nice man," Nana remarked.

Genevieve looked at his retreating back, smiling. "Yes, very kind. But I have a more pressing problem." She went into Nana's room, showing her the note. "It's written in Clyde's hand; I know it."

"This is a serious problem, then," Nana said, looking at the note. "Is it possible it could be from someone else? I'm sure many people have this sort of handwriting. Besides, he couldn't know we are on this ship."

"Part of me believes that I could just be overreacting, but...Nana, I have a bad feeling about this," Genevieve said.

"It does seem troubling, indeed." Nana frowned. "We'll have to be on a clear lookout at all times. Is your door locked?"

"Yes, of course," Genevieve said.

"Good. We shouldn't attract too much attention to ourselves, but we should also make sure you are protected at all times," Nana said. "I wonder if I was too hasty in declining Gracie's invitation for protection."

"Nonsense, Nana. Plus, he is already protecting four other ladies; it's better not to overload him with a crazed, alcoholic lunatic. I'll have to be careful not to be by myself at any point. Mr. Andrews's room isn't too far from mine. If I ever needed help, he would be there immediately," Genevieve said.

"Spoken like a true lady," Nana said. "In that spirit, let's walk to the main deck. We should be able to see Cherbourg at this point."

They walked to the deck, seeing Colonel Gracie among those gathered. He noticed them, beaming. "How has your trip been thus far?" he asked once they joined him.

"Wonderful, Colonel. How about yours?" Nana asked.

"Wonderful. I wonder how many of our friends will come aboard?" he wondered out loud.

"I wonder myself," Nana said.

They had sights on Cherbourg, where a boat was on the coastline.

"Another boat?" Genevieve asked.

"Yes, they'll ferry people on board. Don't worry; it won't be like the *New York*," Colonel Gracie said, referring to the terrifying incident between *Titanic* and the *New York* that had transpired soon after they had boarded. True to the officer's word, it had taken about a half hour before they had been able to set sail.

The trio watched as the boat received all its passengers before setting sail for the *Titanic*. Once it finally reached them, more passengers began to come

aboard. Nana and Colonel Gracie remarked on people they knew or didn't know among them. Genevieve was just happy to be a spectator when she noticed a young man, maybe a year younger than her, come aboard, guiding a pair of stewards and a young maid to his room. His brown eyes met her blue eyes; the world seemed to stop for a glorious second, and she couldn't help but smile at him. His face softened into a beautiful smile back at her before he left for his room. She sighed, falling gently against a column. How long it had been since a man had enticed her with just a simple look! Genevieve turned to Nana, her curiosity growing. "Who was that, Nana?" she asked.

"I'll be! That's Victor Giglio," Colonel Gracie said.

"Who is he?" she asked.

"Benjamin Guggenheim's personal assistant," Nana said. Nana and Colonel Gracie shared a look. Genevieve decided there was more to the story. "Speaking of which, there he is. Benjamin!"

"A sight for sore eyes, Geraldine." He had blond hair. A woman with brunette hair and a very sophisticated style of dress was on his arm. "You know Miss Leontine Aubart?"

"Know of her," Nana said.

"Ah, would you be the French cabaret singer?" Colonel Gracie said.

"Oui," Miss Aubart said.

"And this is my granddaughter, Genevieve Wilson," Nana said, introducing her to the pair.

"It's a pleasure to meet the both of you," Genevieve said.

"Likewise, Miss Wilson. We will have to see each other again soon, but we should go to our rooms, make sure Victor has everything in order," Benjamin said before he and Miss Aubart were off.

The trio turned back to the offloading passengers to see if there was anyone else they knew.

"Margaret! Jack!" Nana exclaimed. Genevieve followed after her excited grandmother, seeing a pair of three people with their respective maids and servants following them. "I had no idea you would be here."

"Neither did I, until a couple of days ago." A middle-aged woman grinned. She had brown hair, swept up into a bun, with a jaunty hat, dressed not

unlike Nana. "My grandson has fallen ill, so I decided to get the first voyage I could, which turned out to be this beauty. Glad to know we'll have some good company."

"Genevieve, this is Margaret Brown, and this is John Jacob Astor and his wife, Madeleine Astor," Nana said, introducing her to the trio. "This is my granddaughter, Genevieve Wilson."

"It's a pleasure to meet you," Genevieve said with a blush.

She had read up on Colonel Astor while she had been stuck in Southampton. He owned many hotels and skyscrapers in Manhattan. He was one of the most impressive men she had ever heard of. But the pictures she had seen of him had done him no justice. He was handsome, with dark hair and a dark mustache; he looked imposing, yet he could also look kind. His wife wore something quite similar to Genevieve, as she was closer to her in age than any of the other women she had seen on the voyage thus far. She was gorgeous. In short, they made a handsome couple.

"Colonel Astor, if you don't mind. The pleasure is all ours. It's high time we got to meet Geraldine's granddaughter after all this time," Colonel Astor explained.

"Yes, it is. What brings you onto this ship?" Margaret asked.

"I can finally bring her home," Nana said fondly.

"Wonderful! We must have a party once we get home," Colonel Astor said before turning to his wife and their servants. "Come, let's get everything situated in our room before we explore this beauty of a ship."

"I'm glad to see you all here. I'll see you all later," Colonel Gracie said with a nod to Nana and Genevieve.

"I too need to unpack before composing a letter to my son. This trip isn't all pleasure," Margaret said.

"Until the next time, Margaret," Nana said. She turned to Genevieve with a smile. "Looks like this trip will be a good one."

"I hope so," Genevieve said.

She felt less scared seeing all the friends Nana had on board. Between them and Thomas, there was a chance she could survive this trip after all. They explored more of the ship, ending with the library. Genevieve had never seen so

many books in her life, including *Anne of Green Gables*, *The Merry Adventures of Robin Hood*, and *The Virginian*. It was an excellent room. They exchanged nods with Colonel Gracie once more. As Genevieve was exploring the titles of all the books, she heard someone behind her.

"Hello," he said. She turned to see the young man from before. Victor Giglio, her grandmother had called him. He was tall and dark; even if she would never admit it out loud to anyone else, he was quite handsome. He stood proud, and seeing as he was the personal assistant of Mr. Guggenheim, she could see why. She blushed, remembering the magnetic moment they had shared before and his beautiful smile.

"Hello," she said, allowing him to kiss the back of her hand.

"Mr. Guggenheim wanted me to introduce myself to you. He says you're the granddaughter of one of his friends," he said. "I'm Victor Giglio, miss."

"I'm Genevieve Wilson. It's nice to meet you, Mr. Giglio," she said.

Victor smiled subtly. "Please, Miss Wilson. It's just Victor," he said.

"Then I insist that you call me Genevieve," she said. He looked at her surprised before smiling broadly.

"As you insist, Genevieve. But only if we're not around Mr. Guggenheim. He's a good man, but he would insist that I not be so familiar with other guests," Victor said.

"I wouldn't want you to get in trouble because of me," Genevieve said. She looked around at the people in the library before leaning toward Victor. "Just between us, though, I'm not used to this kind of life."

"I refuse to believe that," Victor said.

She pulled back in surprise. "What do you mean?" she asked.

He offered her an arm, which she accepted, before they walked away from the library and prying ears.

"On the contrary, I think this is the life you want but not the life you've been given," Victor said.

He could see right through her. How many other people could see right through her? Why would he want to continue talking with her if he knew the whole story of her life? He lifted her chin, and she met his eyes once more. They both paused at the contact before he smiled sadly.

"*Tsavt tanem.* It means, 'I take away your pain.'" Victor explained. "Don't let yourself be ashamed because of what someone did to you."

"Thank you," Genevieve whispered. He released her chin, and they continued walking at a nice pace. "What are your plans once the *Titanic* reaches New York?"

"Mr. Guggenheim is going home to his wife," Victor said.

She frowned at him. "But Miss Aubart..." she said.

Victor laughed; she looked confused.

"Excuse my laughter. As you said, you aren't in this life. Mr. Guggenheim and Miss Aubart aren't married," he said. Genevieve blushed. "I'm sorry to surprise you. It seems like so many people know. It's hard to say who doesn't."

"Maybe this is a lesson to not presume anything about anyone," Genevieve said.

"I hope you don't think less of Mr. Guggenheim. He's a good employer, but I've found that love in the higher class is hard," Victor said.

"Love is hard in general," Genevieve thought out loud.

Victor looked at her with a pained smile. "Maybe that's why I chose to become a personal assistant to the fifth richest man in the world, instead of settling down, marrying in Liverpool," he said.

"Maybe you're smarter than I was," Genevieve said as if it were a great realization. Had she been so desperate for marriage that she had destroyed her whole life?

"I think there's more to your story that you're not willing to tell people. But you shouldn't trap yourself in your story. You are so much more than your past, Genevieve," Victor said.

She looked at him with a sad smile. He had been nothing but kind, but she wasn't going to trap him with her tale.

"What if I told you something so horrible, you could never look at me the same way?" she asked.

"Nothing you say would horrify me, Genevieve," he said.

She sighed, pondering his words. Just then they came upon Mr. Guggenheim and Miss Aubart, and they had to go back to their formalities.

"There you are, Victor. How is the trip going for you, Miss Wilson?" Mr. Guggenheim asked her.

"Very well, Mr. Guggenheim." She smiled.

"Ben, please. I trust my assistant is treating you well?" he asked.

"He's been nothing but a perfect gentleman," Genevieve said.

"I'm glad to hear that! You two keep enjoying your walk. We'll see you at dinner, Miss Wilson," Ben said before he and Miss Aubart continued their walk.

"Have you ever dined on first class food before, Genevieve?" Victor asked.

"I'm afraid lunch was my first proper first class meal," she said. "What should I expect?"

"Rich foods," he answered with a grin. "I do believe that it will be a small, intimate gathering for dinner, or else I would warn you about people who aren't exactly the best of first class society—rather, they take the most extreme approach to first class society and don't appreciate people whom they call 'new money.'"

"I suppose I'll have to take care when I do meet such people," she said.

"I hope you do. I would hate you to lose that beautiful smile you give me," he said.

They stopped walking, looking at one another with understanding. While Nana's lessons had been essential, he had given her the most important lesson of all: that she shouldn't destroy her morals just because she was living a first class life.

"Don't worry, Victor. I wouldn't stop smiling at you," she said.

He smiled subtly before Nana and Margaret came across them.

"There you are, Genevieve. Thank you, Victor, for escorting my grand-daughter, but might I borrow her back?" Nana asked.

Victor turned to her with a smile. "Until dinner, Miss Wilson," he said.

"Until then, Mr. Giglio," she said, watching as he disappeared. She turned to Nana with a smile.

"I'm glad you took my advice about finding an escort. I think you and Margaret should talk. I think she'll be able to help you with your situation," Nana said.

Genevieve turned to Margaret with a sigh.

"It might help you," Margaret said.

Genevieve nodded. "All right," she said.

They walked to the outer deck, away from people, then sat down in the wicker chairs. Genevieve proceeded to tell Margaret everything about the past five years of her life—sans the baby—before falling back into her chair. It was exhausting telling people about her abuse. But she also sensed a small part of her relax after letting it go once more.

"It's a hard life that women lead," Margaret said after Genevieve fell silent. "I don't envy you one bit."

"Not much I can do about it, though," Genevieve said.

"Nonsense. You can survive, keep on living, show the world that you can take a punch. That's why you're on this ship," Margaret said. "How do you feel after telling me all this?"

"Lighter," Genevieve said.

"That's your mind telling you to release all of the bad in your life," Margaret said lightly. Genevieve smiled at the sentiment before she heard a bugle play. "That means dinner is in an hour. Change into your dinner dress. Believe that you deserve this life; you've earned it."

Genevieve took that to heart as she and Nana returned to her room to change for her first big dinner. This event could make or break her. Nana helped her fasten her corset before helping her into her dinner dress. It was the most opulent dress she had ever worn. Nana had told her the fashion was beads and laces; Genevieve knew this dress was full of all that and more.

The dress was a burnt amber, with plenty of beads. It was cut just above her hip, with a layer of satin to cover the rest of her leg. Her dark hair was once again swept up into a bun, this time with a silver pin to keep it in place. As she put her elbow-length white gloves on, she couldn't believe the change she saw in the mirror. She thought about what Victor and Margaret had said. Perhaps I do deserve this, she thought as she applied her rouge.

She heard a knock; she opened the door, expecting Nana, but was surprised to find Victor. "Your grandmother asked me to escort you to dinner," he said, holding out a white rose for her.

She smiled at the flower. "Thank you," she said.

She locked her door, placing her key safely in her clutch purse. He offered her an arm, which she accepted, as they walked toward her first dinner.

"You look beautiful, Genevieve," Victor said.

"Thank you. You look handsome as well," Genevieve said.

"Remember, I have Mr. Guggenheim's influence to thank," he said.

They descended the grand staircase, where Genevieve looked at all the people already gathered below. She noticed quite a few people look up at them; many of the women looked at each other, whispering into one another's ears. One woman even took a fan out and began to wave it elegantly to calm herself.

"Are they all looking at us?" she asked.

"No. I'm sure all they see is you," Victor said.

She blushed at the sentiment. They made their way to their party, which consisted of Nana, Ben, Miss Aubart, and Margaret.

"Beautiful," Nana whispered to her. "Ready to go in with the wolves?"

"Yes," Genevieve said decidedly.

As long as Nana and Victor were there, she would survive. They were soon permitted into the dining saloon, and there was a swirl of color from all the women's dresses. Everyone seemed to know each other. Genevieve kept a tight grip on Victor's arm, not wanting to be separated in the sea of people. The party made their way to a table, where hors d'oeuvres and champagne were set before them.

"Miss Wilson, what brings you back to New York?" Ben asked, making small talk.

She looked at Nana, who nodded her head in support. "My husband's business went over to London, but he died not too long ago. Nana was gracious enough to help me find my way back."

"I'm so sorry for your loss, Miss Wilson, truly," Ben said. "I couldn't imagine losing my spouse just like that."

"I hope you never do," Genevieve said before the waiter took away the plate before them, continuing with the courses.

There was consommé Réjane, various meats, vegetables, potatoes, and chicken à la Stanley. As if all the courses they had devoured weren't enough, there were also decadent desserts. While Victor and Nana preferred to taste the

pudding Sans Souci, Genevieve and Ben tried the charlotte à la Colville, a cake with layers of cream and custard, with fruits on top. After she was done eating, Genevieve didn't know if she would ever be hungry again.

"Now that is what you call first class," Ben said after they finished. "It was a long day. Ninette and I would love to walk around the deck before we retire, but we should attend a concert in the first class lounge before the voyage is over."

"I would like that," Genevieve said.

"That's the spirit, Miss Wilson! We shall see all of you tomorrow," Ben said before he and Miss Aubart left the saloon.

"It is late. Not surprising since dinner had to be pushed back a half hour," Nana said. "Until tomorrow, Margaret. Genevieve, if you want to spend more time out and about, that's fine, if you have an escort. I will bid you good night, though."

"I wouldn't be opposed to not ending this wonderful day," Genevieve said, with a look at Victor, who smiled at her. "Good night, Nana. Thank you so much for everything."

"Oh, my dear. It is I who should give thanks to you. You've given me a breath of fresh air. I've missed you so," Nana said as they hugged.

"I will escort Miss Wilson, of course, but I don't think it's good etiquette to not escort you to your room, ma'am," Victor said.

"Nonsense, my good man. Allow me to escort her while you two young ones explore the night," Colonel Gracie said as he wandered over to their table.

"Ah, there you are, Gracie," Nana said. "Good night, you two."

"Good night to you both," Genevieve said before the pair wandered off.

"I've been having a wonderful time with the Strauses..." she heard Colonel Gracie say as they disappeared to Nana's room.

"I am sorry about your husband, Genevieve. I can see now why you seem sad, feel undeserving of this life," Victor said as they linked arms. "But I think your husband would want you to better yourself after losing him."

"You're too kind, Victor." He didn't realize that was quite the opposite of the truth.

"If I have overstepped in any way, I'm sorry," he said.

"You haven't. You're a good man who's looking out for someone," Genevieve said.

He gave her a pained smile. "More from your past?" he asked.

She smiled gently. "I didn't think anyone in the first class life would understand, but you do," she said.

"Like I said: love in first class life is hard," he said. "Where would you like to explore? We can listen to the orchestra, or we could walk outside on the deck."

"What would you do if we were just two people on a ship, with no expectations on them?" she asked.

He thought about it before smiling beautifully. "Follow me," he said. They walked to the library, where they breathed in the scent of books. "In the absence of expectations, this is where I would be. I used to love reading with my mother when I lived in Liverpool. Her influence on my life was instrumental—before Mr. Guggenheim, at least. Since commencing this job, though, my reading has become somewhat lax."

"My reading has also become a bit lax," Genevieve said, looking at the titles in the room. While the room wasn't huge, the collection of books was extensive. She turned to Victor with a smile.

"What is one book you'd want to read right now?" she asked.

He pondered the question before smiling. "One of my mother's favorite stories to read to me was *The Adventures of Tom Sawyer*. But she never got the sequel, then we never got the chance to read it before I was employed by Mr. Guggenheim." He frowned.

She smiled at the memory, browsing the titles, finally finding what she was looking for. "*The Adventures of Huckleberry Finn*. Shall we?" she asked, then found a cozy little corner they could have to themselves.

"My mother was always the one to read," he said quietly.

She grabbed his hand in support before opening the book and reading out loud.

"'You don't know about me without you have read a book by the name of *The Adventures of Tom Sawyer*; but that ain't no matter,'" she began. It was incredible how easy it was to be open with him, to be vulnerable with a man. Clyde wasn't the reading type, to start with; he wouldn't be enjoying this book

as much as Victor was. Once she yawned, though, he took the book away from her, marking their spot.

"Perhaps we should finish this later," he said. "I seem to have kept you up past your bedtime."

"But Huck and Jim!" she said before yawning again. "Perhaps you are right. But I hope we can come back to enjoy this book again."

"That is my hope as well," Victor said.

They linked arms as he escorted her back to her room, and she smiled as she realized this was the best evening she had had in quite some time. Nothing against Nana, or the last few days they had shared in Southampton, but this was the first night she had not feared Clyde or his wrath, and she had been able to share it with a man who was kind and compassionate, a man who enjoyed their time immersed in a book. This first day of the voyage had been transformational for her. They came upon her door; she turned to him with a smile.

"Good night, Victor," she said.

"Good night, Genevieve," he said, kissing the back of her hand.

She smiled as she watched him leave before entering her room. As she undressed, she thought about the kindness among the people she had met today. She would only survive this trip if she relied on them. She got into her nightgown; even though she knew it was probably futile, she lay in bed; against her will, she fell asleep on the softest mattress she had ever experienced. Thank you, Thomas, she thought before she drifted off.

But as Genevieve learned that night, killing someone, even in self-defense, would still give her nightmares. She dreamed she was back in Southampton with Clyde. He had chained her up and was openly torturing her, with no means of escape. It felt like hell.

Every weapon she could have used to disarm Clyde was used against her. To be so close to death but not able to die was the cruelest dream she could have ever imagined. Genevieve had to pull herself awake from the nightmare. Needless to say, she was covered in sweat when she sat upright in bed. She made her way to the bathroom, splashing water on her face. She then dried her body off, going back to bed for a couple more hours of fitful rest. It was anything but peaceful. When morning came, she had to pull herself away from the bed.

Genevieve got herself presentable for the day, going for a red day dress. It was what she felt like wearing after the nightmare. She knew she looked the part for the day before making her way out of her room. She remembered the room number and went to the cabin, hoping for help. She didn't know if she could survive this trip without it. She knocked on the door; it opened to reveal Margaret, who grinned at Genevieve. "Nice dress. You sleep well?" she asked.

Genevieve tried not to cry as a wave of memories of the nightmare washed over her. She looked up into Margaret's eyes with a sigh. "I need your help."

Chapter Four

"All right. Ready to get to our cabin?" Louis asked.

"No time like the present," Clyde said. It had gone exceedingly well so far, with Genevieve and her "precious" Nana up in first class for the start of the maiden voyage. They were now safely located in third-class, with no steward or officer having apprehended them or thrown them off the ship. Step one was done. He just had to think of what would come next.

"It's third-class, so the room isn't big. Plus, we'll be sharing with other people," Louis said nervously.

Clyde looked at him with a grunt. "I'm trying to get my wench of a wife back. I'm not expecting the Waldorf-Astoria," he said.

Louis cracked a grin. "I didn't know what your plans were for this week; also, this was very last minute. I just wanted to let you know that I did my best," he said.

"I appreciate it more than you can realize," Clyde said, with no more being said on the subject.

They entered their cabin, which was small, but he could make do with what he had. Two other men were bunking with them, and they couldn't speak English. It was good fortune for his plans. Louis could speak many languages, so he could converse with them if need be. He and Louis took one side of the

cabin, Louis opting for the bottom bunk. Another stroke of good fortune for him. This week he had plans; he didn't want their bunkmates to see anything and tip off the stewards.

Clyde looked around the floor, seeing what he could do to scare his wife. She must have thought him dead by now; even if she didn't, she would assume he was still in Southampton. He saw a steward come out of a room before leaving to another floor. He looked into the empty room, seeing spare outfits for the stewards. How lucky he was to have all of these resources at hand. He grabbed his size, then spotted some blankets. He grinned as a plan formed in his head. He grabbed a few, returning to his room. Louis looked up at him from his bunk, frowning.

"What are you up to?" he asked. Clyde held up the uniform, grinning.

"As a third-class passenger, I can't go to the other classes. But, as a steward, I can," he said.

Louis's face lit up at the implication. "Is this how you're going to get your wife back?" he asked.

"I can't go too fast with this. I'll give her a sign to know I'm still alive, looking for her," Clyde said.

"What's the first step?" Louis asked.

Clyde thought a minute before he put a finger up. "Easy. I'll leave this at her door with a note. She should know my handwriting after five years," he said, writing a note on a piece of paper.

"You'd think. The problem is, do you know where her room is?" Louis asked.

Clyde frowned as he put the uniform on. "No, but knowing them, they'll be in first class. It should be easy," he said. He posed in front of Louis, his outfit now complete. "What do you think?"

"Sharp! Get on out there," Louis said with a grin.

"I'll be back unless some first class wench thinks I'm the real deal and has me do chores for her," Clyde joked before the ship stopped suddenly, making him hit his head across the beam. "Bugger!"

"What in tarnation?" Louis asked. The two men stepped out of their rooms, looking for an excuse. He called out to a steward.

"What was that?" Clyde asked.

"We almost crashed into another ship. We're all good, though. Going to get everything set again, so you can get back to your duties," the steward said.

"What? Oh! Yes, of course. My duties," Clyde said, turning to Louis with a wink. "If that's all you need, good sir, got to get these blankets to a dame in distress."

"Thank you. You've been most helpful," Louis said with a chuckle.

He reentered the cabin while Clyde went up through the various decks. He decided to start at the top before working his way down. He was turning a corner on A deck when he saw Genevieve enter a room. He hid behind the wall, straining to hear if she had caught sight of him. He heard the door close before being locked. He sighed. If she had thought he was a threat, she would have raised an alarm. He peered back to make sure she was in the room. Too close a call, he thought.

He stepped softly over to her door, putting the blankets right next to it. He wondered if he was acting too nice, leaving her blankets, but it was too late to do anything else. He stepped away, making his way back the way he had come, then he heard the door open. He decided to take off running. If she lost sight of him, how could she raise an alarm?

He cleared his head, picking up speed, hearing her get closer to him. The jig would have been up if she had caught him. He heard a door open after he passed, no doubt in response to Genevieve's shocked gasps. He got down further, hiding between a corridor, sneaking a peek back, seeing Genevieve in the arms of a smartly dressed man. Fury rose within him; he almost went back to raise holy hell out of the man, then he stopped. This was what he wanted. He wanted Genevieve to fall for a man because it meant she honestly thought he was dead—he could then snatch this new life away from her. He slowly backed away, smiling. He ran down to his cabin, fortunately not encountering anyone else. He cackled as he changed back into his civilian clothes.

"Everything work out?" Louis asked.

"More than you know. I got to be more careful, though. Almost got caught," Clyde said.

"But you made it back in one piece, so cheers." Louis grinned. "How was it up there?"

"Way too clean and elegant for our tastes," Clyde said.

"You think your wife got the message?" Louis asked. Ah, Louis. Always thinking of other people.

"You bet. She's the one who almost caught me. Thankfully this man stepped out of his room in front of her. Last I saw, she was in his arms, petrified," Clyde said.

Louis frowned thoughtfully. "How is this going to help you get her back?" he asked.

"Oh, that's the beauty of this plan! I want her to feel safe and secure with all of those snobs up in first class, then bam, I'm back again, sweetheart," Clyde said.

"If this is how you feel, maybe it's better to just let her leave. She doesn't deserve you if she's so willing to go into someone else's arms," Louis said quietly.

Clyde sighed, revealing his leg to him. "This is what Genevieve did to me the last time I saw her. This is a matter of pride, Louis, a matter of letting her know I will never let her go—for better or for worse," he said.

Louis considered his words before nodding. "OK. But this is all so you can get her back, right? This isn't revenge?" he asked nervously.

"I'll take it one step at a time," Clyde said.

Louis had been so kind to get him on this ship; he wouldn't tell him that he would get Genevieve back, or he would kill her and anyone who got in his way.

"You're right. One step at a time will get your wife back," Louis said, nodding, back with the plan. Clyde sighed, knowing he couldn't lose Louis. He was his only lifeline on this rotten ship.

Louis opted for a quick jaunt around the third-class area, while Clyde decided to develop more plans for the week ahead. Genevieve was where he wanted her, but he also knew that he had to plan to make sure that he could get under her skin. Only time would tell if he went too far, but so far, it had been fun. And to think, he wasn't even under the influence of alcohol! He cackled at a high pitch, thinking that he might be a sociopath after all. Then he shook his head, clearing it of the thought before deciding to join Louis. It might do some good

to get a breather from all this, he thought. He didn't have to go so hard so fast with his wife. He just needed to spook her a little to keep her under tabs.

He joined Louis, who was conversing with two men in a different language than that of their bunkmates. Clyde looked at him curiously after he was done talking. "How do you learn all these languages, much less keep them sane in your brain?" he asked.

Louis laughed. "When you grow up on the street needing food, you learn a lot of things. I guess I never found the need to stop talking to everyone," he said.

"The streets, eh? That sounds rough," Clyde said.

"I found a life where I could be on top of the ladder, in my way, with money and food. Now I'm on this ship, I know where my meals are coming from for a week. All thanks to you, my friend!" Louis said.

Clyde felt ashamed at that, if only for a minute. "If it wasn't for Genevieve..." he said.

"Nah, Clyde. If I know one thing about you, it's that you would be on this ship one way or another. Southampton was getting to you, as it does everyone who lives there. Here's to a new chance at life!" Louis said.

Clyde smiled at that. "You're right. There was no life there for men like us," he said, feeling once again like the hero of the story.

When they returned to the cabin, one of their bunkmates spoke in his language to Louis, who broke into a smile after hearing him out.

"He said he saw your wound; he said he's got ointment for you," Louis said.

Clyde smiled. Once again, his luck was turning around. "Tell him thank you, I guess," he said. Louis did before handing Clyde the ointment. Clyde went up to the top bunk and rubbed some on the wound, sighing in relief at the feeling.

"He also said you don't have blood poisoning, so you should live." Louis grinned. "Too bad—it would have meant more food for me."

"You wouldn't be here without me, remember?" Clyde said, throwing his pillow down at him. "But if it makes you feel any better, I can give you some of my rations. Just so I don't have to be concerned you might smoosh me to death with a pillow."

"Nah, I'd get too lonely," Louis said, throwing his pillow back up at him.

"Oh, thank goodness," Clyde said, rolling his eyes.

"What's your next plan?" Louis asked.

Clyde considered the question. "Nothing too dramatic, at least not yet. I'll keep an eye on her, but I don't think I'll make contact just yet. When we get closer, I will—maybe just before we dock in New York," he said.

"When we reach New York, if you two want to go on alone, I understand. I'll find somewhere to hole up," Louis said.

Clyde looked down at him as if he were a moron. "Are you insane? You and I went on this trip together; we'll come out of this together. Plus, I still have no idea if Genevieve will go quietly in the night," he said.

"Oh, good." Louis breathed out. Clyde smiled to himself. He knew that Louis wouldn't want to be alone in a strange country. "Let's get to dinner!"

"Yeah," Clyde said. He knew that it would be hard to get Genevieve back if she ate good food up in first class. No matter how many clandestine trips he took up there, he would never see—much less eat—any of her fare, but he knew it was supposed to be good. The old bat had said as much.

"Mmm," Louis said as he dug into their meager portions.

That's when Clyde felt a flash of anger toward Genevieve and everyone else up in first class. They had more than enough food and riches to last years, and yet people like Louis had to go through starvation half of their lives, being content with what they had before them. But he knew that Louis wasn't faking his satisfaction with the food. Besides the fact there was no one here to impress, Clyde never knew him to lie to anyone about the good things in life.

Dinner seemed to end almost as soon as it started. Clyde knew that everyone in third-class had eaten their fill. No need for fancy dinners with extravagance. They were here for a better life, not for what idiots like his wife were doing: traveling just because they could. As they headed back to their cabin, he didn't know what he wanted to do with Genevieve anymore.

"Listen, I'm sorry. I guess I never realized that so many people needed food, that you needed food," Clyde said.

Louis shrugged. "Only the people with golden spoons realize. They make sure we don't get any higher," he said.

"Still, Louis..." Clyde said, struggling to think about what to say.

Louis clapped him on his back. "You were one of my most valuable customers before we left. If anything, it's because of you I was lucky to get food when I could," he said.

"See, that's why we got to stick together," Clyde said.

Louis laughed before nodding. "Deal. Want to play some cards before we hit the hay?" he asked.

"Why not?" Clyde asked, shuffling a deck of cards after Louis handed him a pair.

His mind was distracted, though. If Genevieve wanted to play this charade of being a first class lady, why not let her go through with it? Now that he wasn't under the influence of alcohol, he felt more levelheaded, realizing that a part of him didn't love her anymore. Was it because she had lost the baby? Was it because she had stabbed him before leaving him for dead? Who knew, but maybe instead of winning her back—or breaking her—he and Louis could strike out somewhere, perhaps even Canada, living their own life. He smiled; yes, that did sound like a good plan.

He wouldn't be too hasty, though. He would still be on the lookout, still terrorize Genevieve just a little bit. After all, she had left him for dead, and she deserved some grief; it would be good fun for him. He wouldn't kill her or her old bat of a grandmother. Hell, if he was under the influence of alcohol, he knew he would kill anyone who showed her the good graces of life. But he wasn't, so he would leave her little friendships alive. He smiled at Louis after he won another round. Even he had a good friend.

Later, Clyde climbed into his bunk, smiling up at the ceiling. He finally had a plan in mind. He wouldn't have to worry whether Genevieve was uncooperative or not. She wouldn't have to worry about him either. This plan was terrific.

He slept soundly into the morning, feeling great until he woke up, screaming his head off. Louis got up, trying to speak to him, but he couldn't hear him over the pain in his head.

Chapter Five

Genevieve told Margaret everything about the nightmare she had experienced. Margaret was patient, listening intently to what she said; she never interrupted Genevieve. Once she had finished, lying back wearily in her chair, Margaret gently took her hand, stroking her head. "You know I'm a tough woman. I have to be, but I've never been through such abuses," Margaret said gently. "You should never apologize for what any man does to you. He should be apologizing to you."

"He can't, though," Genevieve whispered.

"You had to do what you had to do to survive," Margaret said. "I know it weighs on you deeply, for all time maybe, but every day you are alive is a victory. He no longer holds terror in your heart. No longer will he abuse you."

"But I don't know if he died," Genevieve said. "I have no idea whether he was able to survive what I did to him."

"Even if he survived, there's no way he could be on the *Titanic* right now," Margaret said gently. "The ship was sold out. The only reason your grandmother is here is a fluke cancellation. He's gone for now; that's all that matters! You'll feel safer once you are home."

Margaret was right, of course. She had been foolish to think that he had put the blankets in front of her door. She was safe, for now, until she had to worry

about any more attacks from Clyde. But now that she had told Margaret everything, she wondered, Should she tell any of her new friends?

"Victor said he wouldn't look at me in horror, but what if he's wrong, then all he sees is a monster?" Genevieve wondered out loud.

"I know Victor Giglio; he's right. He wouldn't look at you in horror. Clyde, though, he might consider a monster. But there's no right answer," Margaret said. "Is honesty the best policy when you are escaping from an abusive husband? Would they understand? I think it can be our little secret if you want. No one else has to know."

"Thank you, Margaret," Genevieve whispered.

A rush of relief went through her. She didn't want to keep telling her tale of woe. Having people look at her with pity—or worse, hate—was the most awful thing she could think of. She also didn't want to lose the few friends she had in this life. Not reliving her tale of woe was the only way she knew to move on from the traumatic memories of her past.

Genevieve made her way to Nana's room, feeling lighter already. She knocked on the door, smiling as Nana made her way out. "Sleep well, Nana?" she asked.

"Very well, thank you. How about you?" Nana asked as they made their way down to the dining saloon.

"I've had better nights, but I'm getting there," Genevieve said.

"I'm glad."

Nana gestured for them to order their breakfast. After it had arrived, Genevieve smiled down at her omelet, not believing that not so long ago, she hadn't been able to predict where her next meal would come from.

"I almost forgot to tell you: Thomas Andrews popped by my room when you were out. He said if you wanted a tour of the ship, he would have time today to give you one," Nana said.

"How marvelous!" Genevieve said.

"I've seen enough ships in my time. I think Margaret and I will have time together today," Nana said.

"She's a good person. I'm happy she's here," Genevieve said.

"That makes two of us," Nana said.

After they had finished breakfast, they went their separate ways. Genevieve went to her room to await Thomas's knock. She closed her eyes as she leaned against the door, taking a breath. She wasn't afraid of him; she knew that none of the first class men she had met would ever hurt her. But she was still afraid she would slip up at some point. If she didn't get decent sleep every night, she was sure that would happen.

She opened her eyes when she heard a knock on the door. She opened it, becoming alarmed when no one was there. She looked around to see if anyone had seen anything. She saw a gentleman and said, "Excuse me, sir, did you see anyone knock on my door?"

"No, but I have heard others express the same concerns. I will make sure to tell the stewards to be more careful," he said stiffly before turning away.

"Oh, thank you!" she said, but he had already walked away.

Who was he? At least she hadn't run into him yesterday. That wouldn't have improved his mood! *He must be powerful to be able to tell the stewards orders at his whim,* thought Genevieve. That did answer the question of the blankets yesterday. If they were all new to this line of work, being clumsy, then Genevieve expected more of their hijinks rather than Clyde. She was so relieved at the thought.

But as she looked in the mirror one last time, she wondered how much longer it would take before she no longer feared Clyde would show up to abuse her. Did it all go away one day, or would this haunt her for all time? She thought back to the time before her engagement. Had she been so eager to get married that she had compromised all her morals? Had she been the one who had led to her abusive marriage? Had she overlooked some warning sign?

All of Genevieve's concerns were dismissed once the proper gentleman knocked on her door. "Good morning, Thomas," she said as she opened it.

"Good morning, Genevieve. How did you sleep?" he asked.

She struggled with an answer as she locked her door. "It was the comfiest mattress I have ever slept on," Genevieve answered truthfully.

"I'm pleased to hear that," he said. "Shall we?"

She accepted the proffered arm before they set off on his tour of the ship. While they walked, they passed the first class deck, where Thomas explained

how every class had the same amount of private space they would if each were on a separate cruise. "Another ingenuity of White Star Lines and Bruce Ismay. Perhaps we could share a meal with him sometime," he added.

"I'd love to!" Genevieve said. She was sure that Nana would be thrilled she had managed to secure a meal with the chairman of White Star Lines himself.

"I will see to it. He is a very busy man, though. It might not happen if he is too busy," Thomas said.

Genevieve chuckled. "Why is it that you businessmen can never enjoy the fruits of your labor?" she asked.

Thomas grinned. "We have to think of the future. I do wish we could just stay in the present," he said. "Just so I could stay with my family more than a couple of weeks during the year."

"I wish you could. I haven't seen my family in five years," Genevieve said. "I can't even imagine being away from a loving husband."

"Not married, then?" he asked.

"I was, but he died suddenly. That's why I'm moving back home," she said.

"I am so sorry, Genevieve," Thomas said. "I hope that going home will bring you peace."

"I'm sure it will," Genevieve said.

"How much of the ship have you explored?" Thomas asked.

Genevieve thought for a minute. "The first class deck, the dining saloon, the library," Genevieve said.

"Want to look behind the scenes?" he asked.

"Will I even be allowed?" Genevieve asked. She didn't want to get anyone in trouble, least of all Thomas.

"It'll be all right. We'll stay out of the way. Plus, we're going to be seeing a good friend of mine." He assured her. He guided her into the dining saloon, then through a doorway. "This is the first- and second-class kitchen."

Chefs and assistants were busy getting everything together for the rest of the meals. There was a flurry of activity; Genevieve did not want to get in their way. They all worked as a team. "This is magnificent. It's breathtaking."

"That's the plan. Not only are they working all the meals for all the classes, but there is also a special à la carte restaurant in first class for those who prefer

to see up close what the chefs are making. There's also a special kosher chef," Thomas told her as they looked around. "What was your favorite from last night's dinner?" the head chef asked her.

"There was so much food, but I think the chicken à la Stanley. I also loved the charlotte Coville," she said.

"I'm glad to hear it, miss! I hope we can meet your expectations for today," he said.

"Any chance for duck this voyage?" she asked.

He and Thomas smiled at one another. "Oh, yes, miss. I do believe we will meet your expectations before the trip is over," he said before returning to his task.

Genevieve and Thomas went back to the central part of the ship.

"Duck is a personal favorite of mine. You really should try it with—" he said before a rush of footsteps interrupted him. It was a steward, who handed him a note after a bow to Genevieve. Thomas frowned as he read it. "I'm sorry, Miss Wilson. Something's come up. I have to attend to an important matter."

"Of course, Mr. Andrews," Genevieve said formally.

He hurried away; she hoped whatever was calling him away wasn't too serious. She realized with a start she was without a chaperone. Thankfully she heard a familiar voice behind her.

"Miss Wilson, I'm surprised to see you here," Colonel Astor said with a twinkle in his eye as she turned around to face him. "Is the cooking not to your standards?"

"Hardly." Genevieve laughed before accepting the proffered arm. "Mr. Andrews was giving me a tour of the ship. He got called away on important business."

"Ah, of course. Maiden voyage—I'm sure it won't be his last call," Colonel Astor said. "I wonder if you might help me with something, Miss Wilson."

"Anything," she said.

"You know of my darling wife, Madeleine. She is good friends with Margaret, as anyone would be, but there's not anyone on this trip near her age group. I wonder if you might become friends with her. At least try to become friends. I know not everyone gets along in first class, even if we do try to put on that

front for the world," he said. "After our wedding last year, many of her friends turned their backs on her. On us, really, with me divorcing my wife, Ava, and then marrying Madeleine soon after. I love my wife. I want the best for her and our baby—hence this ship. I know it would do good for her soul to have a true friend. Who better than the granddaughter of a good friend of mine?"

"I would love to become friends with Madeleine, if she wants that," Genevieve said. She knew what it was like. Besides Nana, Margaret, and Victor, she didn't have any close friends of her own on this trip—or any friends from the last five years of her life, for that matter.

"Wonderful," Colonel Astor said.

They came upon Nana and Margaret as they walked along. He left Genevieve in their graces.

"How was the tour?" Nana asked.

"Cut short, unfortunately. Mr. Andrews had important business to attend to," Genevieve said. "How about your morning?"

"Margaret and I have been catching up. It's truly been a wonderful time so far," Nana said. Genevieve smiled.

"I'm glad," she said.

The trio walked some more before the bugle blasted for lunchtime. They met more of their friends before they saw Ben, Victor, and Miss Aubart. Genevieve greeted Ben and Miss Aubart before smiling at Victor.

"How is your morning going, Miss Wilson?" he asked her.

"Well, thank you. I was fortunate enough to get a tour of some of the ship," Genevieve said.

"Sounds wonderful," Victor said.

She noticed Colonel Astor and Madeleine had joined them; she smiled at Madeleine, remembering Colonel Astor's wish. Madeleine noticed her, perking up when she saw the smile.

"Hello. I never got a chance to speak with you yesterday," she said to Genevieve.

"It was a busy day. I'm Genevieve Wilson," she replied.

"It's nice to see another young woman like myself," Madeleine said. "Usually I'm just in Jack's shadow. Don't mistake that I somehow don't love my husband;

I do. I just don't have good friendships most of the time. The older women think I'm some harlot who will steal their husbands."

"Perhaps if they got to know you, they would see it wasn't true," Genevieve said.

"*You* don't know me," Madeleine teased.

"Trust me. I've become good at sensing people's true intentions over the last five years. Also, you wouldn't want to steal my husband." Genevieve lowered her voice so only Madeleine could hear her.

"It was bad?" Madeline asked sympathetically. Genevieve nodded her head. "I'm sorry."

"It's better now," Genevieve said. Madeleine smiled; they made a silent pact to protect each other at that moment. They turned as the dining saloon doors finally opened so they could be seated for lunch.

"We must talk later," Madeleine said before taking the arm of her husband. While Genevieve and Nana would be eating with Margaret, and Victor would be sitting at Ben's table, Victor still escorted her to her table, pulling her chair out for her. She waved goodbye before turning to her party.

"Looks like you and Madeleine got along pretty well," Nana said.

"I think we did. Colonel Astor was kind to suggest I should get to know her," Genevieve said before digging into lunch.

"It's more than kindness. I think he's just worried that she won't find meaningful friendship with anyone, not after the scandal from their wedding and her being pregnant at such a young age," Margaret said. "I'm fond of her, but I look more like her mother than a close friend. Plus, I think she would be good for you."

"She already is," Genevieve said.

They continued with the meal, talking about their hopes after the *Titanic* got to New York. After the meal had ended, Nana wanted to rest a bit, while Margaret was going to walk. Nana permitted Genevieve to get fresh air on the first class deck without a chaperone.

"Since it's not dark, I think you'll be safe. Just be careful," Nana said.

"I will, thank you," Genevieve said.

Once she had reached the outside deck, she breathed in the fresh air. She could hardly believe this was her life. A week ago she had had no hope. Now she was on the grandest ship in the world, with friends she had not had before.

She sat in one of the deck chairs, watching the water as the ship pulled forward. She shivered as it was frigid in the afternoon hours. She would have to remember to wear some of her fur coats. Hopefully Nana would help her out with matching clothing. Her attention was diverted as a toy ball bounced against the leg of her chair. She picked it up, walking in the direction it had come from. "Hello?" she asked. A small child with a coat came up with longing eyes. She bent down, offering the ball to him.

"Thank you," he said before running off. She smiled at the interaction before turning to see that two women had also walked onto the deck.

"So you're the newcomer everyone has been talking about," the new woman said. The women Genevieve had met thus far had been kind, compassionate. Genevieve saw none of those qualities in this woman. "What's your name, child?"

"Genevieve Wilson, ma'am," she answered, though she would have loved nothing more than to have just left the conversation.

"My name is Lady Duff-Gordon," the woman replied, although Genevieve was unsure whether she was giving her name or correcting Genevieve's use of "ma'am."

"Of course, Lady Duff-Gordon," she said to appease her new companion.

"That's better. I don't usually call attention to myself, but I'm glad we are getting a chance to talk." Genevieve found that statement preposterous. It hadn't even been five minutes; the conversation had been all around Lady Duff-Gordon. "I wanted to talk to you about your companions."

"What about them?" Genevieve asked.

"Well, Madeleine is a fine companion, especially for one as young as yourself. She can give you good lessons on finding a man with a pocketbook as tall as his suit. It's your other companions you need to be afraid of," Lady Duff-Gordon said.

"What?" Genevieve sputtered. She couldn't believe the disrespect implied in Lady Duff-Gordon's last statement, yet her interlocutor was too oblivious to understand her question.

"Margaret is too new money. People love her, of course, but it's the same as one's love for a puppy. Cute until it vomits, then ruins the place," she said with contempt in her voice. "Giglio—well, he's nothing more than a common servant. If you want real influence in life, you should spend your days with more worthwhile affiliations. If I were you, I would get a better escort on the ship. I appreciate a woman who understands that escorts are important, but you need to make sure they are the best of society, not the outcasts of society."

"I beg your pardon, ma'am," Genevieve said with a snarl. "I don't make affiliations. I make friends. And even if Margaret and *Victor* were affiliations, as you say, the fact would remain that they, not you, were there for me yesterday. I would be more concerned about what kind of affiliation you would be, though. Victor warned me about people like you. I'm happy to report to him that you are nothing of importance. Good day, ma'am!"

Genevieve swept away from Lady Duff-Gordon with a huff, then stormed back into the ship's interior. She leaned against the door, sighing heavily with her eyes closed. "I say, what a performance!" Ben chuckled near her. "I haven't seen Lady Duff-Gordon silent for so long."

"I don't know what came over me," Genevieve said, glancing back out, seeing Ben was correct. She did seem frozen in the spot with a nasty face after Genevieve had left her. "She said so many hateful things, especially about Victor, that I just snapped."

"She could use a lesson in civility. Any of her friends will tell you that," Ben said. "But I heard what you said about Victor. It was very kind of you. I know he'll appreciate it as well."

"It was true what I said. All of it," Genevieve said.

"I know," Ben said with a smile. "It's just nice to know that I'm not the only one who appreciates him for who he is."

"I'm glad to know Victor is right about you being a good employer," Genevieve said softly. Ben nodded before the two went their separate ways. Genevieve made her way to the library to see if any of her friends were there, to see if perhaps Victor wanted to revisit the book; she ran into Madeleine.

"I was looking for you after lunch. Oh, you look cold." Madeleine frowned at the sight of her.

"I went out on the deck. It was peaceful but frigid," Genevieve said.

"Come, let's go to the Verandah Café," Madeleine said.

Genevieve followed her, then beheld the most beautiful restaurant she had ever seen. Trellises covered in ivy ran up and down the walls, with narrow arched windows. She joined Madeleine at a table, sitting in a wicker chair. "Two coffees, please."

Genevieve took a sip of coffee, already feeling warmer. "This was a good idea; thank you, Madeleine."

"Of course. I find coffee is better with friends," Madeleine said. Genevieve smiled at the thought. She remembered what Lady Duff-Gordon had said about Madeleine, how she had said Madeleine could help her "find a man with a pocketbook as tall as his suit." She felt more anger at the older lady.

"I'm glad we're friends. I met someone else on deck this afternoon. She wasn't charming," he told Madeleine.

"Lady Duff-Gordon, no doubt." Madeleine shook her head. "You mustn't care what that woman says about anything."

"I might've snapped at her for what she said," Genevieve said.

"What did you say?" Madeleine asked. Genevieve told her everything; Madeleine laughed. "Well, she'll get over it—eventually."

"I hope," Genevieve said. She saw Margaret pass by; she waved to her.

"How are you two?" she asked the two girls.

"Genevieve took down none other than Lady Duff-Gordon," Madeleine said with a smirk.

"Really? I'm surprised you lived to tell the tale," Margaret said.

"Ben was sure I had left her frozen on the deck," Genevieve confided to them both.

"A new statue. France gave us Lady Liberty, Sodom and Gomorrah gave us Lot's wife, while *Titanic* will give White Star Line Lady Duff-Gordon," Margaret quipped. Madeleine and Genevieve broke off into a fit of giggles. They stifled the giggles when Lady Duff-Gordon walked by them, giving them a withering glare. They all broke into laughter after she was out of view. "It won't be a good gift."

"That was the best time I've had in a while," Madeleine said.

"It's usually a good time if you can laugh," Margaret said.

"It's more than that. You're the first ladies who have accepted me as an equal. Most people just see me as a child, not worthy of conversation. And women think of me as a minx who stole Jack away from his wife. I value you both very much," Madeleine said.

Genevieve was touched by this sentiment. After leaving Clyde, she had been afraid she would fade into the background, not finding anyone to care about her. Her worry had been unfounded, it seemed. "I'm glad I could be on this trip. It was very last minute," she said. "I don't know if I could survive this trip without all the friends I've made so far."

"Give yourself credit, Genevieve. Something tells me you could do this by yourself if you had to," Madeleine said.

Genevieve smiled at her, knowing she was right but also knowing she wouldn't want to be alone. She was navigating first class with help, but she was able to do it by herself. She made new friends while also making an enemy. Although it did seem as if everyone was only friends with Lady Duff-Gordon because of the advantages that came with it. *It was a lonely life to live*, she thought bitterly. And yet she couldn't forgive Lady Duff-Gordon for thinking so lowly of her new friends, especially Victor.

"She called him by his last name! As if since he's a personal assistant, his first name isn't important," she told Margaret after Madeleine had left for her stateroom and they were walking to theirs. "I knew first class life was different, but I didn't think it would be like this."

"You want to know why she reacted that way while Ben was happy to give him a first class ticket of his own?" Margaret asked. Genevieve shook her head. "Because he values Victor. Lady Duff-Gordon only values people who can elevate her status. Now that you're in this life, you get to choose the kind of person you'll become and the kind of people you let in. Never forget that."

"I won't," Genevieve said. After Margaret went to her cabin, Genevieve went to Nana's cabin. She knocked on the door, waiting for Nana.

"You look like you've had a day," Nana remarked, opening the door wider so she could come in. The stateroom wasn't much different than Genevieve's—just as opulent. Genevieve sat down in a chair, sighing.

"I have," Genevieve said. "I met Lady Duff-Gordon."

"I see," Nana said. "How did that go?"

"I don't think we'll be friends anytime soon," Genevieve answered.

"Spoken like a true Wilson." Nana smiled. "Have you seen any more of Madeleine?"

"I have. She's a good person. I think we understand each other," Genevieve said.

"I knew she would be good for you," Nana said. Genevieve smiled.

She knew her grandmother was always looking out for her, no matter how long they had been separated.

They walked to Genevieve's room, where Nana helped her into her dinner dress—dark red with beads running down its length. Genevieve was putting on her gloves, making sure she looked presentable, when she heard a knock on the door. She opened it, smiling when she saw Victor. "Good evening!" she said pleasantly.

"Good evening, Genevieve. You look beautiful," he said.

"Thank you," she said.

"I wanted to talk to you about something important," Victor said. "Can we talk out on the deck?"

"Of course," Genevieve said. She grabbed a fur coat, following him out. She hoped nothing was the matter. They made their way out, and Genevieve faced Victor, waiting for him to explain.

"I've waited for this moment all day; now that I'm here, I'm almost scared." Victor laughed before sighing. "Genevieve, you are unlike anyone I've ever met. You see me—not a valet for Mr. Guggenheim or someone beneath your status, but the real me. I heard what you said to Lady Duff-Gordon. No one has ever done that for me."

"What she said was wrong. Anyone would defend you. I told you I wouldn't listen to people like her," she said. Victor shook his head.

"Not anyone would stick up for me. At least not anyone who matters," he said, taking her hands in his. She looked down at their hands before looking into his eyes, frozen at this moment. "I care for you, Genevieve Wilson. I know you just lost your husband, and I'm a valet, but when I see myself happy, I see myself with you. If you'll have me, of course."

"Victor..." she whispered, flabbergasted. "I don't know what to say."

"Don't say anything. Think about it, please. At least for a day. If you don't feel the same, I won't be mad," he said.

She looked down, processing what he had just told her. "I will think about it, Victor," she promised him.

He smiled, kissing the back of her hand for a long moment before offering her his arm. "Then I would be happy to escort you to dinner, Miss Wilson," he said.

She smiled. "I was hoping you would say that," she replied.

Genevieve thought of Victor's proposition as they made their way back to Nana's cabin, then down to the dining saloon. He was a good man; she did not doubt that. Her problem with the whole affair was that Clyde would eventually show up. She would never be naïve again to believe that she killed him by simply pushing him off the counter. He might not be on this ship, but he would survive and one day find her. If he didn't kill her, he would kill Victor to get back at her. She couldn't let that happen.

As she ate dinner with their party of Ben, Miss Aubart, Victor, Nana, and Margaret, she wondered whom she could go to for advice. She couldn't just turn her back on a good man because of her fears. If only she had a buffer, someone who could help her with this big decision. As she laughed at something Ben was saying at the table, she finally knew whom she could turn to. She was a person who knew her well enough but didn't know her whole story.

After dinner ended, they all attended a concert, and the orchestra helped calm down her racing thoughts. She set herself in the present, not thinking about any decisions that could end a friendship or start a new romance. She sat next to Victor, feeling Lady Duff-Gordon's eyes on her. Genevieve snuck a peek but didn't see anger on the older woman's face, only sadness. With a rush, she realized that Lady Duff-Gordon didn't hate Victor or even Genevieve, for that matter. Rather, she was jealous they were happy with one another.

If she had stayed with Clyde, would she have turned into the same bitter woman Lady Duff-Gordon was? Once again, it proved Nana was a lifesaver. She would never want her heart poisoned by a man she wasn't meant for. After the concert was over and they had clapped for the musicians, she looked at Victor, wanting to say yes, but she also wanted to get a second opinion.

"I know I gave you a lot to think about tonight, Miss Wilson. If you'd rather put our story aside tonight, I completely understand," he said.

"It was a lot to think about," she said with a sigh. "I do want to consider your proposition properly. Perhaps tomorrow, we can revisit the story. I promise you I will give you an answer soon."

"That's all I ask for," he said with a smile.

After Victor escorted her to her cabin, she took her heels off, sighing. She was considering soaking her feet while she thought about what to do when she heard a knock on the door. She opened it to see a steward. "Letter from Mrs. Astor, ma'am," he said with a bow.

"Thank you," she said before he left.

She opened the letter, seeing that Madeleine requested her presence in her room if Genevieve was not otherwise preoccupied. Genevieve smiled at the good luck of the letter. If she didn't tell her what happened tonight, she might go insane.

She put her shoes on again, locking her door, checking to make sure it was fastened. Satisfied that her room was secured, she went two floors down to the Astors' room. She knocked on the door, realizing she hadn't lived a life like this in a long time. No one had written to her to come over for five years. She smiled when Madeleine opened the door. "Thank you for coming. Please come in, Genevieve," she said.

"Nothing the matter, I hope?" Genevieve asked before she looked around the suite. It was massive and more prominently situated than her cabin. Madeleine laughed at the expression on her face.

"It's just like Jack to buy the biggest room he can. I just thought with him in the men's lounge, we could have time to ourselves to talk," Madeleine explained.

"That sounds wonderful. I did want to talk to you about something," Genevieve said.

"Anything," Madeleine said, motioning to an empty chair. Genevieve sat down, telling the younger woman everything that had transpired that day between her and Victor. Madeleine was silent, listening to Genevieve, enraptured by her tale. Finally, Genevieve fell back, finished with her story.

"I don't see what the problem is, Genevieve."

"You want to know why I came to you first?" Genevieve asked. Madeleine shook her head. "Because you don't know my whole story. If you did, you probably would advise me to tell Victor no."

"There's your answer!" Madeleine laughed. Genevieve looked confused at her. "You want to say yes; that's why you came to me. If you wanted to say no, you wouldn't be here right now."

"You're right," Genevieve whispered.

She hadn't been attracted to Victor only because he was one of the first men to treat her right this trip; he had also been thoughtful toward her. He had been the first to introduce himself; he had always been a gentleman around her. And the moments they had shared reading the night before had been some of the most memorable moments in her life. While he had said he loved her, he had also said he wouldn't be mad at her if she said no. It was a rare quality in a man, no matter what his class. She looked at Madeleine with a broad smile. "I'm in love."

"I know you are! What are you still doing here with me? Go to Victor, tell him the happy news," Madeleine said, chiding her.

"I really should tell my grandmother about this before I spring it on her. Plus, we're on a ship. It's not like he's going anywhere," Genevieve said.

"That's all very true," Madeleine said. "You must tell me once you've said yes to him."

"I will," Genevieve said. The two women continued talking before Colonel Astor came back.

"Good evening, Miss Wilson. I trust you are having a good night?" he asked. Genevieve smiled at Madeleine.

"The best night. Since you're back, I will bid you two a good evening," Genevieve said to him. She turned to Madeleine with a smile. "Perhaps it would be too rash to let him go through the night without an answer."

"Good luck!" Madeleine embraced her before she left.

As Genevieve walked upstairs to see Victor, she realized she was happy. She finally felt comfortable in her skin. Clyde's grasp on her was finally loosening. She was no longer afraid. When she came upon their shared set of rooms, though, she found chaos. A maid and a group of stewards were searching the room with intensity. "Nothing the matter, I hope?" she asked.

"None, miss. We just had an unlocked door. Miss Aubart is having a fit," a steward said.

"Did you need anything, Miss Wilson?" the maid asked.

Genevieve racked her brain for the maid's name before remembering. "No, Emma. I'll let this all sort out. I'll find Victor in the morning," she said.

She was disappointed that she couldn't share her happiness with Victor that night but recognized that safety came first. If she had been in Miss Aubart's shoes, she too would have been frightened of the implications. Genevieve hoped that someone had forgotten to lock the door, that nothing was truly amiss.

She decided to go back to her room, reaching her door as she heard Thomas approach behind her. "I am so sorry, Genevieve. One thing after another. An eventful maiden voyage, it seems."

"It's quite fine. I had a bit of an eventful day myself." She smiled.

"Ship crumbling around you as well?" Thomas joked.

She laughed. "Hardly. No, I just received some unexpected news, which..." Genevieve trailed off as her door opened all by itself.

"Are you all right?" Thomas asked. She didn't know how to answer him; she felt frozen. She started shaking, backing away from the door. "Genevieve, what's wrong?"

"I—I locked...I locked my door," she said in shock. "I locked it. I know I did. I checked it twice. It can't...it shouldn't have opened."

"All right. You stay out here; I'll check your room. If you hear a commotion, get help," he said. "Don't come in unless I say so. Can you do that?"

Genevieve couldn't answer; she couldn't even move. She didn't know how, but she knew somehow, someway, Clyde had done this. Clyde had broken into her room, quite possibly Miss Aubart's room as well. He would kill Genevieve; if Thomas went into her room, he would be killed as well. If Clyde was furious at her, as he no doubt was, he would probably try to kill the whole ship in retaliation. The friends she had made were all in trouble. She had brought this all on them. How could she have done that, especially to Victor?

"Genevieve!" Thomas yelled, getting her attention. "I can't help you unless you help me, OK?"

"I—yes, I can help you," she said. "Just be careful."

"Don't worry," he said before going into the room. She tried to stay calm, to listen for anything that might be going wrong, but it was hard to hear over the pounding of her ears. She tensed when she saw a shadow at the door, then jumped when Thomas came out. "Good news. There's no one in your room. Come on in; make sure nothing has been taken."

"OK." Genevieve breathed out. She walked into her room, seeing nothing missing or out of place. "Everything's still here."

"I'll make sure to note the need to make repairs to your door. It must simply be a mechanical error in your door," Thomas said.

"I'm sorry I made this trip harder," Genevieve said, looking down, ashamed. She had overreacted again. Clyde wasn't there.

"It's not a problem. It helps in the future if I knew what's broken now," he said.

She nodded, hugging herself tight. Thomas went over to the bed, grabbing her coat to put it over her arms. She frowned at him. "What are you doing?" she asked.

"Come on," he said.

She gave him a look before putting it on, then followed him out of her room while she made sure to lock her door. She wasn't sure if it had been a mechanical error, as Thomas said, but as she followed him, she knew it had not been Clyde. She had to quit relating everything to her fear of him. It had made her paranoid, which had almost made her say no to a good man. They made their way out onto the deck.

"Are you trying to make me forget about my door opening by freezing it out of my mind?" she asked.

He gave her a patient smile. "Just look up," he said.

"What am I supposed to see?" she asked before complying. "Oh, my word."

The stars were brighter than she had ever seen them—pristine and beautiful. The cold disappeared because all she felt and focused on were the stars. Thomas laughed at her expression. "Are you happy you came out now?"

"Oh, yes. Very much so," she whispered. "I've never seen stars like this before."

"Neither have I," he said. "I'm just glad this cheers you up. I'm sorry your door malfunctioned. I hope it doesn't scare you the rest of this trip."

"Thank you," Genevieve said, in awe of the scene before her. They made their way to a bench so they could sit, looking at the sight before them.

"Genevieve, we didn't get much of a chance to talk today. I know you told me that your husband died, that your grandmother helped you get on this ship, but I want to know more about you," Thomas said. "I'm sure it will help you to talk."

Genevieve almost broke; she nearly decided to tell him about Clyde, to tell him everything that had happened so far. If she did, he would no doubt go to every level on this ship to figure out at once if Clyde was actually on board. But what if he thought she was a monster? She closed her eyes, deciding to bury the horrible truth once again. "Five years ago, I was betrothed to my husband, Clyde, when his business boomed, and we were transferred to London—Southampton, to be exact. He died suddenly."

"Did you have any children?" Thomas asked. Genevieve closed her eyes at the memory. "I'm sorry. I shouldn't have asked that."

"No, it's fine. I want to tell you," she said.

"All right," he said softly.

"I got pregnant right before we left for Southampton, but we didn't know it until after we left," Genevieve said. "Clyde—he wanted to be a father. I was as young as Madeleine is now, so I don't know if I was excited or just knew it was my duty as a wife to make children. But the day I gave birth, the baby was stillborn."

"Oh, Genevieve," Thomas whispered, grasping her hand.

"I couldn't understand how a baby that had been moving in me could die so suddenly. I didn't feel any grief, only confusion. But Clyde was devastated. He was never the same after that," she said.

"Let me guess—he escaped into his work?" Thomas said.

If drinking were work. "Something like that," Genevieve said. "It was a lonely couple of years."

"So no chance of any children?" Thomas asked.

"No." She shook her head.

"Happy or sad?" he asked hesitantly.

She considered his question. "Both," she said. Maybe if the baby had survived, Clyde wouldn't have turned to alcohol, and he would still love her. But each day, as she moved further away from the woman she had been while married to Clyde, she realized that what they had shared wasn't love, not even in the slightest. So, in a way, she was happy that she hadn't brought a child into Clyde's world. Maybe it wouldn't have mattered anyway if the baby had survived. Perhaps, in the end, he would have returned to drinking no matter what. "Does that make me a bad person?"

"No, I don't think so. He was the one who chose to push you away. You deserved more," Thomas whispered. She closed her eyes, and a tear fell. He wiped it away with a sigh, hugging her tight. "I shouldn't have pushed you."

"It's not that. I've never told anyone this before," she said. "It's so freeing to let go of something that traumatic. I never realized how much it affected me still."

"I'm honored you told me. I promise I won't divulge your secret to anyone," Thomas said.

Genevieve smiled. "I know," she said.

"Let's get inside," Thomas said. "I'm sure you're quite frozen now."

"That's the great thing about talking with a friend—you don't notice the cold," Genevieve said.

"I'm glad I can be that for you." Thomas smiled as they walked back inside.

Now that they were inside, though, she could feel the difference in temperature. She started shaking.

"Maybe it was in fact freezing outside," she shivered.

"One last stop before you go back to your room," Thomas said.

Genevieve followed him without complaint. It may have been too cold for her to speak, but she would follow him again since his first idea had worked out so well. He came upon the kitchen. She gave him a look but didn't say anything. He disappeared before reappearing with two cups. She took one, taking a sip before smiling at him.

"Hot cocoa?" she asked.

"Aye. It's good for warming up after telling your troubles to someone," he said.

"It's delicious. I don't know how to repay you for your kindness," Genevieve said.

"That's the thing about friendship—you don't need to repay," Thomas said.

"I will keep that in mind," Genevieve said.

"Let me walk to your room. The waitstaff can pick up your mug tomorrow," Thomas said.

They walked back to her room in comfortable silence. She thought about what he had said about friends not needing to repay one another. She had been alone for so long, she wasn't sure how to be friends with anyone. But she would take Thomas's advice when it came to them. They came to her door, and she turned to him.

"Maybe it was a good thing my door messed up tonight," she said. "It meant a lot to tell you my story. I think I'll sleep a lot better tonight. Plus, it helped me with a big decision about my future."

"I'm glad I could help," Thomas said, jiggling her doorknob, making sure it was still locked, with a smile. "It looks like you're safe for the evening, Miss Wilson. I hope you have a pleasant sleep. I will make sure to get your door fixed tomorrow."

"Thank you, Mr. Andrews. Have a pleasant evening," she said, adopting a formal tone. She closed, then locked her door and finally took off her heels for the night.

As she drifted off to sleep, she knew she had been right when she had said she was sad she didn't have any children but glad she didn't have children with Clyde. If he had had any sense of love in his heart, then he wouldn't have turned to alcohol when she had lost their baby. He would have been the strong one. But if everything worked out tomorrow with Victor, he would be a compassionate man. He would help her turn her life over. With that thought, she fell into a deep sleep, the most comfortable she had experienced in a long time. If she hadn't already known that she would say yes to Victor, she did now because the thought of him gave her peace. It was something she didn't have for five years; it was comforting to know that she had good people in her life once again.

They were the reason she was able to get out of bed in the morning with a smile on her face and hope in her heart.

Chapter Six

"Come on, Clyde! Talk to me," Louis said. Clyde had scared him out of his bunk in the early morning of the second day of the voyage.

Nothing would stop Clyde's screams, though. His bunkmates, who spoke Italian, asked him what was wrong. Louis wasn't sure. Clyde had put the cream on his wound last night; it hadn't looked terrible. Of course, any knife wound was going to have some kind of pain associated with it, but Clyde had been managing it quite well over the past few days. Louis finally snapped his fingers, knowing what was wrong.

"Alcohol! He's been off the deep end for over a week. I'm not exactly sure where I can come up with some on this ship, though," he said. One of his bunkmates, Horace, held out a canister of liquid, motioning to Clyde. Louis took off the top, smelling it, breathing out when the smell of alcohol hit his nostrils. He stood on a chair to tilt Clyde's head up, letting the alcohol do its job. Clyde finally stopped yelling. Louis breathed out. He gave Horace his bottle back, along with a nod of thanks.

"What happened?" Clyde asked weakly.

"I know you wanted to go through this trip without alcohol, but it was too much for you, man. The only way I could stop you screaming was to give you a hit," Louis said.

Clyde groaned. "Whatever you gave me stopped the pain, so thank you. You're always saving my life," he said.

"You'd do the same for me. Now let's get you some food. It should help," Louis said.

"All right," Clyde said, sliding off the top bunk.

The two of them had breakfast. Louis couldn't believe his good luck once again: there was so much food! He had never been guaranteed three meals a day, even when business was good, so it was a relief to finally be in a position to know when his next meal was. He didn't even care what he ate; he would not let any food go to waste, even if he hated it. He turned to Clyde, hoping he had done the right thing by giving him the alcohol.

"How are you feeling now?" he asked. Clyde considered the question as he ate some gruel.

"My headache is gone; I don't feel as weak. The alcohol with food helped," he said. Louis was pleased to know he was just more than a pretty face who could translate languages.

"What are your plans for today?" he asked, always ready to help his friend.

"Rest, I think. I've been pushing myself so hard, I think today showed. Don't worry about it; I'll figure something out later. For now I think I need to catch a few more winks of sleep. I don't want to keel over later," Clyde responded.

"Yeah, you rest. Don't worry. We'll get your wife back," Louis said softly, thinking of a plan to help.

He snapped his fingers, a method forming in his mind. He made sure that Clyde was sleeping comfortably before changing into Clyde's steward outfit. He didn't know where Genevieve was, but he knew she was in first class, so it couldn't be that hard, could it?

He was dead wrong. Holy tarnation, was it easy to get lost in the maze of rooms spread across the various levels. How could he find Genevieve when he didn't even know where he was? But luck was on his side as he saw the woman enter her room. Louis was impressed; she had dressed up well. Not that he'd tell Clyde that, though. He was already in a world of pain; Louis didn't want him to think he was hitting on Genevieve. He walked over carefully to her door, looked around to ensure he wasn't arousing suspicion, and knocked on

the door before running around the corner. He heard her door open, wishing he could see her face.

"Excuse me, sir, but did you see who knocked on my door?" he heard Genevieve ask.

"No, but I have heard similar concerns recently. I will make sure the stewards are more careful." He heard a gentleman tell her. The gentleman was so stiff; Louis had tasted hard alcohol that was lighter.

"Oh, thank you!" he heard Genevieve call after him. Louis rolled his eyes. Whoever that guy was sounded like an ass. Louis was turning back to go down to third-class quarters when he ran into a man coming out of his stateroom. He looked tall, official; he also didn't look stiff. Louis tensed as he walked past him, hoping he wouldn't be discovered.

"You, there!" he heard the man call after him. Louis turned back to him with a nervous face. "You're a third-class steward, aren't you? What are you doing up here?"

"Uh..." Louis said, wondering what he could say to save his hide. "Man in charge of us wanted to get the chairman's opinion on something, but he's busy making sure first class stewards stop knocking on people's doors up here. It sounds like a lot of people up here are being bothered by careless stewards."

"Oh?" the gentleman asked.

"Yes...sir. A woman just around the corner asked him about it, and he said he'd look into it, so I guess he'll be pretty busy making sure she isn't disturbed again," Louis said.

The gentleman looked thoughtful at that. "Yes, I do believe he will be busy. Thank you for the information. If you find yourself in any trouble down there, tell them Thomas Andrews said you did your best," he said.

Louis nodded his head. "Thank you, sir," he said before strolling back down.

He didn't want this man to think that he was up to something by running away. But Louis chuckled as he thought about it. This Thomas trusted him completely. He was the perfect undercover agent.

Louis made it back to his cabin, stripping back into his civvies. Clyde looked at him curiously as he sat up, rested from a morning nap. "What is this all about?" he asked.

"I know you wanted to rest, so I helped you out with Genevieve," Louis said. Clyde's eyes opened wide. Louis was afraid he had gone too far.

"What did you do?" Clyde asked.

"You said you wanted to terrorize her, so all I did was knock on her door. She didn't see me. Plus, the man in charge even thought the random knock was because of the first class stewards," Louis said.

Clyde considered this. "And you weren't seen?" he asked.

"Well, I did run into a man. But my disguise was foolproof! He accepted I was a third-class servant, sent me on my way. He even gave me a name," Louis said.

Clyde looked surprised. "A name?" he asked.

"Thomas Andrews. A good thing the other guy didn't see me. He was a stiff," Louis said before looking at Clyde. "Are we good?"

"As long as nobody saw you, we're square. I just don't want you to get in trouble because of me," Clyde said.

"No trouble! I cross my heart, hope to die—well, you know what I mean," Louis said.

"Yes, I do know," Clyde said.

"You all good?" Louis asked.

"My headache is gone; I'm thinking smart for the first time in a long time. In fact, I wanted to talk to you about something," Clyde said, climbing down from the top bunk.

"Go ahead," Louis said.

"I wanted to be on this ship to get Genevieve back because I'm her husband; she doesn't hold the reins on when she is done with me. But after yesterday, hearing about how you always needed food, I realized that maybe I could be done with her. She goes willingly to those first class snobs, even though they all know people like you need food?" Clyde said. "Perhaps this is one fight I can lose."

"What would we do, then?" Louis countered.

"We're going to America. It's a big place. If you don't like it, it should be easy to get to Canada or Mexico," Clyde said.

Louis considered that with a smile. "Mexico. I prefer senoritas to maple syrup," he said. Clyde laughed when he heard that. "Mexico, then. Tonight I'll say my goodbyes to her," he said.

Louis cocked his head. "You're going to see her?" he asked.

"No, that would ruin everything. I'll steal a pair of keys to sneak into her room. It's the idea of her I want to say goodbye to," Clyde said.

"I understand. I'm proud of you, though, for letting her go. Not everybody would be so brave," Louis said, awed.

"Yeah, well, you've opened my eyes to what the world needs," Clyde said. "Lunch?"

"You know I could always go for food," Louis said, hiding his smile. He had never had a friend like Clyde; he was sure he would never have another like him. He was one in a million.

Clyde had been scared when Louis said he paid Genevieve a visit, but only because he didn't want Louis to get into trouble. But Louis had come through once again. He was calm, relaxed, even collected under pressure. He shouldn't have been surprised Louis had gotten himself out of the dilemma. Now they were on the same page, heading to Mexico. If Genevieve wanted this life, then all the power to her and her conniving grandmother. To hell with the both of them.

But he did want to pay her room one last visit—well, maybe more than one visit, but he would be done with her by the time they all docked in New York. Pretty soon he would never have to worry about seeing her, which meant she would never have to worry about seeing him. It would all work out. It was great, he kept telling himself. It would be great.

He and Louis settled into dinner, but his mind was only half on the food. Could he do this? Could he let Genevieve go willingly? This was all lunacy. He needed to control Genevieve, terrorize her for everything she had done to him!

But as he watched Louis converse with a little boy who was refusing to eat his food, he knew he had to let go of the control he so craved or he could very

well lose his friend. "If you don't eat your food, I will." Louis teased the boy. The boy's mother whacked his hand, and the boy started to eat stealthily. The mother beamed at Louis in appreciation for his help. He turned to Clyde with a smile. "A shame she doesn't realize I would eat his food!"

"You can have some of mine. It's the least I can do for you," Clyde said, pushing some food onto Louis's plate.

"I don't need food," he said, but Clyde held up a hand.

"You've done so much for me this trip; today you did me a solid. It's the least I can do," he said.

"Thank you," Louis said, digging in.

Clyde settled into silence, taking a long swig of beer. After this morning's events, he didn't want to wake up screaming. Plus, he wasn't sure how much alcohol Horace was willing to share before he just killed him. But he made sure not to overdo it, just enough to take the edge off.

"So what's the plan exactly? I'm sure Genevieve will have her door locked," Louis said wisely.

"You had your plans this morning. I had my plans this afternoon," Clyde said, holding up a pair of keys he had stolen off a steward. Louis brightened up at that.

"Bloody hell! What if you get caught, though? You'll be in more trouble than ever before," he said.

"I appreciate the concern, but I think I'll be fine. I heard the old bat suggest attending some odd event, so I'll have some time to sneak in," Clyde said. Louis nodded.

"I know you need this, so I wish you good luck," he said.

Clyde smiled before changing into his steward's outfit and heading up to first class. He only got a little turned around but found Genevieve's door. He unlocked the door and walked in, breathing out before looking confused. These weren't her things.

"Bugger!" he exclaimed before running out of the room. This wasn't Genevieve's room at all. Think, Clyde, think! Where was her door? He hit his forehead with his palm. "Imbecile!"

He hadn't been on the right floor to begin with. Genevieve was on A deck; he was on B deck. He was going to find a staircase when, whoa! Who is that? Clyde asked himself as he saw a very sophisticated woman come out of a stateroom on the arm of a distinguished gentleman. Clyde sighed as he looked her up and down, admiring the view, hearing her speak French. Merci, woman, he thought, before he continued with his quest.

He finally located the correct room, hiding behind the corner again as another steward delivered a letter to Genevieve, already back from her prior engagements. The time had passed for him to say his goodbyes. But a lick of good fortune came to him as she exited her room once more. He waited to make sure she didn't double back before entering her room.

He sat in the chair, seeing everything she had done for herself in these past few days. Was this the end of their marriage? Perhaps it should have ended over five years ago. Her mother had always sold her to him, but as he thought about it, he had never wanted to be a husband, much less a father. He had started drinking when he had realized that this was the life he was supposed to lead.

It wasn't all too bad, though. That was how he had met Louis. Now, as he looked around one last time, he said goodbye to the life they had once shared. In this new life he and Louis would begin, he could control someone or something else. He exited the room when he heard Genevieve and another man conversing. He hid behind the corner—his new position when people came—to listen to them. It was nothing more than idle prattle, but then he heard her gasp when her door swung open. It brought him so much joy to know that he still held fear in her heart even if he planned to leave her behind. It was all the control he needed.

Clyde felt lighter as he walked back to his cabin. He smiled at Louis as he stripped down once again.

"How'd it go?" Louis asked.

"It went well. I feel lighter already," Clyde said.

"So are you done with the steward's outfit now?" Louis asked.

Clyde hesitated. "Not yet. You never know when it could be useful. But I will give you the keys. I don't need to visit Genevieve anymore this trip," he said.

Louis sighed in relief. Clyde could see it was a relief to the old sport to know he wouldn't get into any more trouble.

"Shall we sleep?" Louis asked.

"Yes. Let's wash this day away. Tomorrow we can start planning our trip." Clyde wiggled his hips around.

Louis laughed a wholesome laugh. "Si, si, my friend. Life is going to be good for these two bachelors!" he said.

Clyde smiled. "Yes, it will."

Chapter Seven

When Genevieve woke up in the morning, she felt more comfortable than she had in years. No nightmares, no stress, just peace. As she got dressed for her day, she decided that honesty was the best policy. She would keep the truth as to how Clyde had died a secret for now, but last night had proven that keeping secrets only hurt her. She heard a knock on the door and went over to admit the person. She saw a waiter bent over a rolling cart, obscuring his face.

"Breakfast, ma'am," he said in an exaggeratedly accented voice.

"How did you know I'd be up so early?" she asked him, a playful smile on her face.

Thomas looked up with a cheery smile on his face. "I figured you would be up to see your day. It seemed like you had a big decision you had to see through," he said. "Plus, I thought you'd want to personally see your door being fixed once and for all."

"I would like that," Genevieve said thoughtfully before thoroughly looking at him. "Where'd you get a waiter's uniform?"

"I told you I was good friends with the chef," Thomas said with a twinkle in his eyes as he put a tray on a table in her room. "Enjoy your breakfast. I'll hopefully fix your door."

Genevieve sat down to tea with fresh fruit, saving the oranges to share with Victor, while Thomas got to work on the door. "I found the problem. This door-knob is broken," he said. Genevieve frowned. "How is that?" she asked.

"Come see," he said, motioning for her to join him. She walked over, and he showed her by turning the doorknob several times. It became loose after a few turns.

"Is that why my door opened for no reason?" Genevieve asked.

"It could be. It means that it needs to be replaced. Unfortunately, it can't be replaced until the return trip, so it won't help you or the next party to occupy this room," Thomas said.

"At least you tried." Genevieve smiled. She would just have to get used to the fact that her door could open at any time during the rest of the voyage.

"Just be careful through the rest of the trip. If you'll excuse me, Mr. Ismay will want to know about this immediately," Thomas said.

"Have a good day, then. Thank you again," Genevieve said.

She decided it was high time to talk to Nana about yesterday. She walked to Nana's door, knocking brightly. Nana opened the door, laughing at the sight of her.

"Don't you look chipper! What has got you into such a happy mood?" she asked Genevieve.

"Something wonderful happened yesterday," Genevieve said as she swept into Nana's room. She proceeded to tell Nana about what Victor had told her.

"What did you say?" Nana asked.

"He told me to think about it, and I have. But I wanted to know what you thought, Nana. Your opinion matters so much to me," Genevieve said.

Nana scoffed. "My opinion on your love life doesn't matter. If you truly have feelings for him, go to him, tell him," she said.

Genevieve smiled as she embraced her grandmother. "Good, because if I had had my way last night, I would have told him then," she said sheepishly.

Nana chuckled at the statement before taking Genevieve's hands into her own. "You are more like me every day. Now get out there; get the man you truly deserve," she said with a wisdom Genevieve hoped she could one day have.

"I will, Nana." She smiled.

She checked the mirror to make sure she looked appropriate in her pink empire dress before looking for Victor. She didn't have to look far; he was approaching her door as she was leaving Nana's room. They both froze at the sight of each other before laughing and smiling at the coincidence.

"Good morning, Genevieve," Victor said. "Did you sleep well last night?"

"Good morning, Victor," Genevieve said. "I did. It was very refreshing. You?"

"Unfortunately, when I returned to our quarters, there was quite a scandal," he said. "Someone had broken into Miss Aubart's chambers."

"I know," Genevieve said.

"News travels fast on this ship. Her door was completely unlocked when Ben and Miss Aubart returned. Her maid hadn't been in the room since we had left for dinner," Victor said. "She had a pretty good alibi as well."

"My door was unlocked as well. I visited with a friend after you dropped me off," she explained as they walked to the first class deck. "Mr. Andrews, the designer of our ship, looked at the door. He found that the doorknob needs to be replaced after they return to Southampton. I hope it's the same for Miss Aubart."

"I'm sure it is as you say, but that still didn't make our night any better." Victor rolled his eyes. "Miss Aubart brought along many items on the voyage. We had to check everything. Of course, nothing was missing."

"And no indication that anyone had been inside of her room?" Genevieve asked.

"None," he said. "Still, I would care more about the fact that no one had harmed me than the fact that all of my fur coats remained in place."

"Even now?" Genevieve shivered as they made their way out on deck. "But I know what you mean. I think it takes an extraordinary act for us to realize we aren't as safe as we believe we are."

"Sounds like you are speaking from experience," Victor said softly.

"I am. I hope that no one has to learn how to live through an experience like mine," she said, turning her head toward him, stepping forward. "And I hope it's not too much for you."

"What?" He asked.

"I was headed to your room last night. That's why I knew about the unlocked door. I wanted to tell you everything. But I knew the timing was inappropriate. Safety comes first. I'm sorry I had to wait until this morning to let you know," she said.

He looked at her with a startled smile. "Does that mean..."

"Yes." She breathed out. He brought his hand up to cup her face. She closed her eyes at his touch; it was the happiest she had been for so long. She opened her eyes again, looking at him with a sigh. "But the life that I used to live, it wasn't easy."

"I would never push you, Genevieve," Victor said.

"I know," she said. Victor kissed her on her forehead; for once she felt at peace. He hugged her close; nothing else mattered. She felt so in love with him at this moment that she almost felt healed.

"I want to stay in this moment forever," he whispered.

"Me too," Genevieve said. Madeleine would be so happy for both of them.

"We can keep our relationship much the same as it has been on the trip," Victor said stoically.

She pulled away, surprised. "But, Victor, we love each other," she said.

He smiled sadly. "Trust me, you don't want to ruffle the wrong feathers. Once we both get settled home in New York, then we can establish our relationship more publicly. For now, let's just keep it private. Only people you can trust to keep a secret," he said.

Genevieve smiled. "You are so patient with me that I will go with your wishes. But just so you know, I don't care what people like Lady Duff-Gordon say. It's you, Victor. It's always been you," she said.

"I am so happy to hear you say that," Victor said.

He looked around to make sure no one was nearby before placing a chaste kiss on her lips. She shivered, now at the contact rather than the cold. He pulled away, but she put a soft hand on the back of his head, kissing him as long as they could afford. When they finally separated, their cheeks were bright red, but again, not from the cold. He offered her his arm before they stepped back into the ship's interior.

"There you are, Victor. Hello again, Miss Wilson," Ben said as they met him inside.

"Good morning, Ben. Victor was escorting me; he told me about the unfortunate news of Miss Aubart's door," Genevieve said. "It might be prudent to talk to Mr. Andrews. He found out my doorknob needs to be replaced once the ship gets back. I'm sure it will help Miss Aubart feel safer knowing that no one was snooping among her things."

"I will make sure to do just that. Now, if you don't mind, I need Victor for some business," Ben said.

"Of course," Genevieve said to him. She turned to Victor with a smile. "Until the next moment, Mr. Giglio."

"Until the next moment, Miss Wilson," he said.

"I forgot to ask you, Victor, how did that negotiation go?" Ben asked as the pair left. Victor looked back at her; she smiled at the floor, blushing.

"It went extremely well, Mr. Guggenheim. Thank you for the advice," Victor said.

Genevieve sighed happily, deciding to go see Madeleine, tell her the good news. Before she could, though, the man from the day before approached her, alongside Thomas. He had the same looks as Colonel Astor, and she knew he had to be of first class society.

"Miss Wilson, I never got to introduce myself yesterday. I am Bruce Ismay, the head of this ship. May I extend my apologies for whatever trouble your door has caused," he said. Genevieve was flabbergasted. "Now the whole ship is booked, of course, but I can see if anyone could change rooms with you."

"I would change rooms with you if it made you feel any better," Thomas said.

She was shocked that Mr. Ismay cared about her wishes, that he knew her name, but was pleased that Thomas was sympathetic to her plight. "It's completely fine, Mr. Ismay, Mr. Andrews," Genevieve assured them. "I'm OK with continuing my stay in my current cabin. It was startling last night, but now I'm more prepared for the future."

"Very well, then, Miss Wilson," Mr. Ismay said stoically. "I hope you have a pleasant rest of the trip."

"Thank you, Mr. Ismay," she said before he moved away. She smiled at Thomas. "Hello again."

"Hello, Genevieve," he said.

"A busy day for you?" she asked.

"Unfortunately. Did you hear about Mr. Guggenheim's guest?" Thomas asked. Genevieve nodded solemnly. "Miss Aubart. I ran into his assistant, Victor Giglio. They did not get a lot of sleep last night," she said as they walked together. "I told Ben to talk to you, see whether she had the same problem I did. It looks like he took my advice."

"Yes, and it was sound advice. It doesn't appear to be the same problem, though," he explained. "Whether that appeased her or not remains to be seen."

"Shame for her, good luck for you, I presume," Genevieve said.

"Exceedingly good. I would hate for her to think that I had messed her door up on purpose," Thomas said.

"I'm sure she doesn't think that," Genevieve said. "I've met Miss Aubart. While she does seem a bit concerned about her material possessions, I'm sure she understands that these things happen, especially on maiden voyages."

"One thing after another happens on this ship. It reflects badly on Mr. Ismay and the shipping line. I can't help but think it's my fault," he said bitterly.

"I'm sure it's not your fault," Genevieve said.

"I wanted an extra row of lifeboats, but the line said it would take away the aesthetic, detract from the beauty of an unsinkable ship," Thomas said. "What happens if something goes wrong and there aren't enough boats for everyone? I would never forgive myself if innocent people were hurt because I didn't do absolutely everything I could."

"Thomas, stop," Genevieve said, making sure he was looking at her. "You can't blame yourself for something that hasn't even happened—something that won't happen. One day at a time."

"You're right." He sighed. "I guess so much has happened so far, I just keep expecting the worst."

"Come," she said, finding two empty seats where they could comfortably talk. "Yesterday you helped me so much. Now I will listen to you—whatever you want to talk about, to keep your mind off your troubles. Your life."

"Not much to tell about my life. Helen is my wife; we married about four years ago. She had our daughter, Elizabeth—my Lizzie—about two years ago." He got his pocket watch out to show Genevieve the picture of his family.

"Beautiful," she said.

"They're why I'm trying to do my best in the business," Thomas said. "If this succeeds, maybe Lizzie will be proud of me. Whenever she hears the name *Titanic*, she'll think of her old pop."

"I'm sure she's proud of her father, no matter what he does or succeeds in," Genevieve said.

"She's about two, so maybe I'll wait to hear her judgment until she's older." He grinned.

She laughed at his joke. "That might be a good idea," she said. She studied him for a minute. "Feel any better?"

"Yes, thank you. It was good not to talk about the voyage," he said.

"I'm glad. Take time not to worry about anything," she said. "Then perhaps you won't be stressed all the time. Otherwise you'll be like me, imagining there's someone in your room."

"That was a real fear you had," Thomas said gently. "But I will take your advice. This is my job, but if I keep this all to myself, I might go insane."

"If you ever want to talk, please let me know," Genevieve said.

"I will, thank you. I almost forgot to ask: Did you ever make that decision?" Thomas said.

Genevieve smiled. "I did. For the first time in a long time, I'm happy," she said.

"I'm happy for you," Thomas said before he had to hurry off to attend to something else.

Genevieve continued on her quest to find Madeleine to tell her the happy news. She found her in the Verandah Café with her maid, Rosalie. Madeline perked up when she saw Genevieve, telling Rosalie she was in good hands, dismissing her for the time being.

"How are you?" Madeleine asked.

"I told Victor yes," Genevieve said simply.

Madeleine squealed. "I'm so happy for the two of you!" she exclaimed.

"He does want discretion until we get settled back in New York," Genevieve said. "He's afraid we'll ruffle too many feathers on this voyage if we go public."

"That is wise advice. I'm not sure what someone like Lady Duff-Gordon would say, much less do, if she were to see it with her own two eyes," Madeleine said.

"Last night, I was at one of the orchestral concerts after dinner. I was sitting with Victor. I knew she was looking at us. Do you know what I saw?" Genevieve asked. Madeleine shook her head no. "Jealousy. I think she says all these horrible things because she recognizes that happiness is so rare."

"Still, it is hard for some people to relearn civility. She could still make your lives a living hell while on this ship," Madeleine said.

"In any case, I don't care what someone like her would say, but Victor's being so patient with me that I won't reveal it," Genevieve said. "I know how much you wanted to know about it; I'm sure he'd be OK with me telling you."

"The highest discretion, to be sure! But once you get settled in, I will help you with whatever you need: appropriate clothing, relationship advice, marriage advice..." Madeleine trailed off seductively.

Genevieve giggled at her friend. "I am happy to be taking this one step at a time, but I will come to you if I need anything," she said before growing serious. "I thought someone had broken into my cabin last night."

"How dreadful! What happened?" Madeleine asked.

"My door swung open just as I was returning from talking with you. I knew I had locked it properly. Thankfully Mr. Andrews was there; he helped search my room, make sure no one was there," Genevieve said. "He found out that my doorknob needs to be completely replaced."

"I'm happy you are all right, then. I'm sorry that I asked you over. Your safety means everything to me," Madeleine said.

"Quite honestly, it helped me in my decision with Victor. I have been alone for far too long. It helped me realize that I shouldn't be scared about being with a great man like him," Genevieve said.

"That's an excellent point. I don't know what you went through, but if I can be of any help, please let me know," Madeleine said.

"You're a good friend; that's what I need now," Genevieve said. Madeleine smiled at the sentiment. Genevieve was glad she was on this trip for more than one reason. The two girls looked up as their beaus walked in.

"Rosalie told me you would be here, love," Colonel Astor said. "Good morning, Miss Wilson! How is the *Titanic* treating you?"

"I am so fortunate to be here for a variety of reasons," Genevieve said as she looked at her two friends with a warmth in her heart.

"I am happy to hear that. Come, my love, it's almost time for lunch," Colonel Astor said as he offered his arm to Madeleine. "We haven't had a chance to share a meal with you, Miss Wilson. We must remedy that soon."

"I would love that," Genevieve said with a grin at Madeleine. She walked arm in arm with Victor while Madeleine was with her husband. This very well could be my life in the future, she thought.

As they walked to the dining saloon, the Astors said hello to the people they knew; Genevieve did the same, though her list of acquaintances was much shorter.

"I see you have found a proper escort," Colonel Gracie said as he approached her. She smiled up at Victor before addressing the colonel.

"He is a proper gentleman. But I'm sure your ladies will also say the same about you," she said.

"Too kind as always, Miss Wilson! But that is my hope as well. It has been a good trip, hasn't it?" Colonel Gracie asked.

"Very," Genevieve said.

"I'm happy to hear that, Miss Wilson. I hope to see you again soon. My good man," Colonel Gracie said to Victor before heading off.

"How has your day been so far, Miss Wilson?" Victor asked her. Genevieve was saddened that they couldn't be honest about their feelings for one another. But she knew that one day soon they could, which would make it all the better.

"Every day on the *Titanic* is rich, filled with adventure," she said.

"I find it very much the same," he said.

Ben came up to them just as they were entering the dining saloon. "I am very sorry to interrupt the two of you, but I have a significant lunch meeting. I'd like you to be there, Victor," he said apologetically.

Victor bowed his head, kissing the back of Genevieve's hand. "Until the next moment, Miss Wilson," he whispered. Genevieve smiled at both of them before finding Nana.

"I trust you had a good morning?" Nana asked her. Genevieve shook her head, smiling at everything that had happened to her. "It looks like it's just the two of us for lunch. But Jack did invite the both of us to dinner. Madeleine said it was OK if Victor could escort you to dinner; I told her that I'm sure you would be quite pleased with that arrangement."

"It depends on how Benjamin gets along with his lunch meeting, but I would find that acceptable," Genevieve said.

As they set into their pea soup and consommé Paysanne, she asked Nana where Margaret was. She hadn't seen the older woman all day. "A touch of seasickness, poor girl. After lunch I'll check in on her, make sure she's staying hydrated, at least," Nana said.

"How unfortunate. I hope she fares better soon," Genevieve said.

After lunch had concluded, Nana checked in on Margaret while Genevieve looked to see if Victor was finished with his business. As he and Ben walked out of the saloon with another gentleman in tow, he looked over at her, shaking his head no apologetically. She nodded her head, going the opposite way, heading toward the library. Before she had made it far, though, Madeleine appeared at her side.

"I hope you got our invitation to dinner tonight," Madeleine said.

"I did; it was very kind, although Victor might not be able to make it." Genevieve lowered her voice. "He and Ben seem to be very busy."

"I just wanted to be nice. If it doesn't work out tonight, we'll have the both of you over after we get back to New York," Madeleine said. "Plus, there's so much time left on this ship! Ben can't have that much business to attend to while on board."

"You've been nothing but a wonderful friend. I thank you for that," Genevieve said. "I haven't exactly been truthful with you, though."

"You don't need to say anything. I know that you have had a hard time. I don't want to push you into revealing your past," Madeleine said.

"I appreciate that, but I want to tell you this," she said, directing them to a sitting area. She told Madeleine the story she had told Thomas. Madeleine gave her a somber look.

"I'm sorry. I couldn't even imagine," Madeleine said.

"I had no idea how much power it still had over me," Genevieve said. "I haven't slept that well in ages. So I'll try to be as truthful as I can. Hiding truths has only wearied me."

"That's a good rule to live by," Madeleine said.

They decided to join the other ladies for tea. At the same time, Genevieve felt lighter than ever. She still had to tell Madeleine the truth about Clyde—and Victor the whole thing, for that matter—but almost everything was out in the open. This was what healthy living looked like. It was refreshing to experience. They came upon Miss Aubart. She still looked distressed.

"Go on, find us a table," Genevieve said to Madeleine before turning to the other woman. "Miss Aubart?"

"Oui?" she said, bags under her eyes. Victor had been right; they hadn't slept much last night.

"I heard about your unfortunate time last night. My door malfunctioned as well," Genevieve said. "I just wanted to make sure you were OK."

"Merci, Miss Wilson. I am, as you Americans say, petrified," Miss Aubart said. "It's only for the image I come out to socialize. I fear my ruse is not working. Perhaps my appearance?"

"You do look a little tired," Genevieve said honestly. "Do you have a place to sit? I'm sure it would not be a problem for you to join our table."

"Merci. I would love that," Miss Aubart said with a smile. Genevieve led her to the table Madeleine had picked out. Madeleine looked surprised but kept quiet for introductions.

"Madeleine, may I present you to Miss Leontine Aubart? She had the unfortunate luck of her door being unlocked as well," Genevieve said as the two of them sat down.

"I'm very sorry," Madeleine said. "It's a pleasure to make your acquaintance."

"Bonjour. A pleasure to meet you as well," Miss Aubart said. "I've heard everything about your amazing wedding. The pair of you have fine, rich tastes. Very French."

"I will take the compliment—I think." Madeleine chuckled.

"I wouldn't dare insult the wife of the richest man on earth!" Miss Aubart said. "I must give thanks to you both for allowing me to sit with you. Most women here, they give me a wide berth."

"Perhaps that is this group's legacy," Genevieve said. "Women seem to give us all a wide berth."

"It's a rite of passage." She heard Margaret behind her. She turned to see her back in the world of the living.

"I'm glad to see you are better, Margaret," Genevieve said to the older woman as she sat at the table with them.

"Can't keep me down for long," Margaret said before addressing the table. "If you're sitting here with us, it means that maybe you are doing the right thing in life, even though people may not see it that way."

"Merci, then, for noticing me," Miss Aubart said. "Not many people would have cared. 'Ah, rich young thing. You brought this all on yourself.'"

"Do people say that to you?" Genevieve asked, surprised.

"Whispers on the street, but I do believe that's what they say," Miss Aubart said with a shrug.

"It's true for me as well," Madeleine said.

"I refuse to believe that. We don't bring anything on ourselves," Genevieve said. "If anything, other people bring it on us. They come at us with preconceived notions, then we just blindly go along with it. It's horrifyingly gross."

"Unfortunately, there's not much we can do," Madeleine said.

"There should be, though. When did it become acceptable for women to get the short end of life?" Genevieve asked. "We deserve better."

"I believe that as well," Margaret said.

"This is quite stimulating talk!" Miss Aubart exclaimed. "People usually only care to talk about my music or what I'm wearing. This is refreshing."

"I'm not usually this vocal." Genevieve blushed.

"It'll be good for you to be vocal. We all need to take a stand," Margaret said. "It's my hope that one day women will stand up to our abusers."

"That'll be the day," Genevieve said.

"We all have a bit of power in ourselves. I hope we're all powerful enough to use it when we need to," Margaret said, giving her a pointed look. Genevieve smiled back, knowing she had already used this power.

"It sounds like a wonderful world," Madeleine said.

"I am just OK if people don't assume I bring everything on myself," Miss Aubart said. "People probably made practical jokes on me by opening my door. Only explanation."

"I'm sorry. But I hope that won't happen again," Genevieve said.

"Merci," Miss Aubart said with a smile.

They continued with their tea, with Miss Aubart telling them of her life in France. Teatime seemed to be over almost as soon as it started. "I know you're all about French sophistication, so you no doubt have a plan for dinner attire, but please, let us help you with your rouge," Madeleine said to Miss Aubart.

"I will accept your kind offer," Miss Aubart said. "I still feel exhausted."

"Hopefully a good night's sleep will help you," Genevieve said.

"I don't know if I feel comfortable in my room without the protection of Ben," Miss Aubart said. "Might we use your room, Genevieve? I hear you are quite close with Mr. Andrews; he would no doubt keep us all safe."

"Oh! Of course," Genevieve said, touched by Miss Aubart's trust in her. They had almost reached her room when they ran into Thomas. "Good afternoon, Mr. Andrews. I trust you are faring well."

"Good afternoon, ladies," he said with a crisp bow. "Another busy afternoon that is getting away from me."

"What did I tell you this morning?" Genevieve chided.

"One day at a time, only what I can control," he said.

Genevieve smiled. "That's better," she said.

"What are you ladies up to?" Thomas asked.

"Getting ourselves presentable for another glorious dinner party," Genevieve said.

"I will leave you all to it, then," Thomas said before taking off.

"He's a nice man, but is it normal to have a shipbuilder on a voyage?" Miss Aubart asked.

"I don't exactly know, but he's been a great help ever since I met him," Genevieve said as she unlocked her door.

"How did you two meet? I never asked," Madeline said.

"The first day of the voyage, I found some blankets near my door; I saw someone running away from my door. I ran after them to see what the meaning was, but I ran into Thomas instead," Genevieve explained, locking her door after they all entered the room.

"Quite dramatic! It is, as the French say, *le destin*. 'Destiny,' you would say," Miss Aubart said as she sat down for Madeleine to transform her. "Of course, *le destin* could also apply to you and Victor."

"Victor?" Margaret asked.

Genevieve blushed. "I never got a chance to tell you, but yesterday, Victor told me that he cared about me. And we've decided to start a proper relationship once we reach New York. I asked for Madeleine and Nana's advice, but I never got to hear yours," she said.

"Why should it matter what I say?" Margaret asked.

"You're an important person to me. You've given me good insight on this trip," Genevieve said.

"You know what I said when I married my husband?" Margaret asked. Genevieve shook her head. "I'd rather marry a poor man whom I love than a rich man whom I don't. As long as you truly love Victor, that's all that matters."

"I do." Genevieve smiled.

"Ben is very happy for the both of you," Miss Aubart said. She now looked resplendent, with no sign of any tiredness under her eyes.

"He is?" Genevieve asked.

"Oui. He understands more than most people how Victor needs love; plus, when Victor talks with you—or even about you—he's the happiest either of us has seen him," Miss Aubart said. "Ben said Victor should talk to you about his feelings. I'm delighted it worked out the way you both wanted."

"You look beautiful!" Madeleine exclaimed after she was done with Miss Aubart's rouge.

"Merci," Miss Aubart said. "Please sit down; let me repay you for your kindness."

As Madeleine sat down so Miss Aubart could apply her rouge, Genevieve thought about what Miss Aubart and Ben had done for her and Victor. She knew that if Victor had been employed by anyone else, the arrangement likely would not have been feasible. It was very thoughtful of Miss Aubart to say she was happy for the two of them. She knew that if it had been any other woman—Lady Duff-Gordon came to mind—they might have turned their nose down at the pairing. They were genuinely different from any people she had met thus far. She turned to Margaret after her musings.

"I'm not good at applying rouge, but I could try to help you, Margaret," Genevieve said.

"I'm good, thank you," Margaret said. "You young girls do your thing. I'll just sit back and relax for a minute."

"I see I'm not the only one who isn't used to this busy schedule," Genevieve said.

"It's more than that. I've been sluggish for a while," Margaret said. "Hopefully, once I get back on solid land with my son to care for my grandson, I will feel better."

"I hope so," Genevieve said.

"Good thing we are on this ship. I've had worse seasickness." Miss Aubart sniffed.

"It's been a good ship so far. Unfortunately, my body doesn't agree," Margaret said. "I'll be fine, though. It just means I might be moving slower."

"As long as it's easy sailing," Genevieve said. She was startled by a knock on her door, then went over to open it. She smiled when she saw who it was. "Hello, Ben."

"Good afternoon, Miss Wilson. I hear you have quite the party in here," he said. "Ninette, are you ready, my dear?"

"Almost." Miss Aubart took a step away from Madeleine. "Perfect!"

"Thank you, Miss Aubart," Madeleine said.

"Until next time, Miss Wilson. It should also please you to know that Victor is free to escort you to dinner. That is, if you would like him to." He winked at her as he and Miss Aubart left. Genevieve shut the door before turning to her companions.

"Silence," she said, flopping on her bed. Madeleine giggled, then joined her.

"Trust me, it's never quiet," she said. "It looks like you and your beau will join me for a meal after all. Come, let me do your rouge."

"OK," Genevieve said. She sat in a chair in front of the mirror as she let Madeleine make her beautiful.

"I must help you find a beautiful dress for the night!" Madeleine exclaimed after she finished with Genevieve's rouge.

"You are too good of a friend for me," Genevieve said.

Madeleine looked at her, surprised. "Don't ever say that. I am just the kind of friend you need during this time of life. Plus, you are too good of a friend to me," she said.

"I mean it, though. Your helping me find my true feelings for Victor, listening to me, just being there for me are unlike anything I've experienced in a friendship," Genevieve said.

"Maybe you haven't had the best of friends in life," Madeleine said gently.

"That's unfortunately true," Genevieve said. She smiled at Madeleine's choice of dress. Fewer beads this time, but it was pale pink; it brightened the mood in the room. "It's lovely. Thank you."

"He's sure to love it," Madeleine said. "I'll see you two soon."

After her friends left to change into their evening attire, Genevieve looked at herself in the mirror. She finally saw a woman in love, with friends to help carry her through anything that happened. It was quite the transformation from being married to Clyde. She turned to the door when it was knocked on, then opened it and smiled as Nana walked into the room. "You look gorgeous," Nana said.

"Thank you. It was Madeleine's idea. She said Victor is sure to love it," Genevieve said.

"I do not doubt that. I take it dinner with him is back on?" Nana asked.

"Ben came over earlier to pick up Miss Aubart. He assured me so," Genevieve said. "Margaret came over while Madeleine, Miss Aubart, and I were getting tea earlier. She seemed a bit better."

"A bit better, yes. Hopefully, once we reach land, she will get a clean bill of health," Nana said. "But don't you worry your head over that. Tonight, it will be a grand dinner."

"I hope so," Genevieve said. "Miss Aubart said that Ben advised Victor to confess his feelings to me. I think the two of them are happy for us."

"A rare person that Benjamin Guggenheim is. But I agree with their sentiments. It's high time you found happiness, my love—Victor too," Nana said.

"Thank you, Nana, for everything. I know that this trip is not what you expected," Genevieve said.

"True, but I am happy to get my granddaughter back." Nana smiled.

Genevieve hugged her tightly before hearing a knock and going to open the door to reveal Victor. He looked at her before smiling broadly.

"You look beautiful," he said.

"Thank you, Victor. I'm glad you could escort us to dinner," Genevieve said.

"It was very fortunate indeed. Good evening, ma'am," he said to Nana.

"Good to see you again, young man," Nana said before he presented an arm to them both, escorting them to dinner.

As they walked to dinner down the grand staircase, Genevieve wondered what all these people would do if they found out that she and Victor were together. She knew that if Lady Duff-Gordon found out, she would have a fit. While she knew Victor had his concerns about ruffling any feathers, she hoped he knew that she didn't care about any of that. She loved him, and she didn't care who knew about it.

They made their way to Madeleine and Colonel Astor, with Madeleine winking at her before embracing her. "Did he love it?" she asked Genevieve.

"Yes," she whispered. Madeleine giggled before they sat down for another glorious dinner. Somewhere around the fourth or fifth course, Colonel Astor asked her what had brought her aboard the *Titanic*.

"My husband died recently; my grandmother was kind enough to help me home," Genevieve said.

It was the edited version of what had happened, the version she had told so many times on this trip, but this time she was ashamed to tell it. She peeked at Victor, who looked away as she told the tale. If she couldn't tell him the whole thing, she at least had to tell him that it wasn't a happy marriage, that her feelings for him were real.

"My condolences, Miss Wilson. I'm truly sorry," Colonel Astor said quietly. "But you are quite a lifesaver, Geraldine! I'm happy you were able to be there for your granddaughter when she needed it."

"I'm glad as well," Nana said.

"What about you, Colonel Astor? What plans do the two of you have once you reach land?" Genevieve asked, hoping to perk up this dinner.

"Parenthood," Colonel Astor said with a smile to Madeleine. "We wanted to make sure the baby was born in America. I thought, Why not the best for my bride?"

"Sounds wonderful," Genevieve said.

After they finished their meal and Genevieve made a promise to Madeleine to see her tomorrow, she knew she had to talk to Victor. They dropped Nana off at her cabin, then she turned to him. "We should talk about what I said at dinner," she said.

Victor shook his head as they continued to her cabin. "You don't have to explain anything. I knew that your husband died; I know we all grieve in different ways," he said. There was a tension between them that Genevieve couldn't stand. She rushed forward, blocking his way so he could look into her eyes.

"But you deserve the truth! You deserve to know everything that happened," Genevieve said. Victor placed his hands on her hip, and they both froze at the contact. Genevieve hesitatingly put her hands on his shoulder before their lips met sweetly, then with more passion. Victor pulled away first with a smile on his face.

"You don't have to tell me anything because I know you'll tell me what happened when you're ready. I told you I would never push you," he said.

She placed her head on his chest as he wrapped her in a hug. "You're too good for me," she whispered. He kissed the top of her head; she felt healed by his embrace.

"Come, let's revisit our dear friends Huck and Jim," he said.

She pulled away, smiling. They settled into her room after making sure no one had seen Victor accompany her, then finished the tale of Huckleberry Finn. She closed the book, smiling up at him. He took it gently from her hands, placing it on the table. He cupped her cheek before they kissed with a burning

passion. She was lost in that kiss; she didn't want it to end. But after what felt like hours, Victor pulled away with a groan.

"I should get back to my room," he said.

"I suppose I have been selfish with you," she said even as she continued kissing him.

He pulled away, smiling beautifully at her. "Oh no, my love. It is I who has been selfish with you. I will never apologize for it, because you make me so happy. Do I make you happy?" he asked.

She couldn't believe he had to ask. "I've never been happier in my life. You never have to worry about that. I now know what true love feels like," she said.

He smiled as he made his way to the door. "I never knew how good this ship could be to me. I wouldn't want to be anywhere else right now," he said.

She came up to him just before he left, giving him one last kiss. Then she locked her door, leaning against it, smiling up at the ceiling. Victor was right: she didn't want to be anywhere else. She decided to soak her feet in a basin of water. They weren't used to these kinds of shoes. She smiled, though, thinking about his kisses. She had never felt a love like this, not even in her marriage to Clyde.

After a considerable amount of time, Genevieve dressed in a robe, deciding to check her door. It was silent outside, but there was a steaming cup of hot cocoa outside her door. Before, she would have been afraid Clyde had left it, but it must have been Thomas. He had no doubt come by, and she hadn't heard him. "Good night, Thomas," she whispered.

She sat in a chair, enjoying her drink. It was quite welcome, as each night seemed to get progressively colder. It also helped her feel sleepier. She expected a warm night's sleep, like last night, but instead, she descended into hell.

She had just laid down in bed when she heard an urgent knocking on her door. She frowned but got up to investigate. "Hello?" she asked, not seeing anyone there. She grunted as her head swung back after a punch to the nose. Tears involuntarily came to her eyes as blood flowed from her nose, likely broken from the impact. Who could do such a thing? She started to back up when Clyde came into the room.

"No, I killed you!"

"You only thought you did." He snarled. He then punched her so hard in the stomach that she was convinced he had broken her back. He pulled her up to the wall, slapping her hard. "You listen; you listen good. The only way you get out of this alive is if you come back home to me."

"I will never let myself destroy my morals ever again!" Genevieve gasped. "Face it, Clyde—you don't love me anymore; I don't love you. Instead of hurting one another, let's let each other go. Maybe we'll be happier."

"You think I care about your happiness?" He backhanded her with murder in his eyes. "You're mine, mine to do anything I want with. You're right—I don't love you anymore. But I am not letting you go easily."

She brought her knees up to his groin. He grunted at the impact, but that didn't stop his attack. He glared at her, squeezing her throat. She fought back but couldn't get away. She felt herself grow unconscious before she launched herself up in bed, screaming. She looked at her body, touching her nose, but she couldn't find any evidence of Clyde's attack.

It felt too real to be a dream, but there wasn't any blood or bruises. She looked up at the door as someone frantically knocked. Could this have been a repeating dream, a dream within a dream? She gasped as she heard a key come into the lock. Dream or not, someone was coming into her room.

"Genevieve, what happened?" he asked.

"Please don't hurt me," she whispered.

"Sweetheart, why would I ever hurt you?" Victor said.

Chapter Eight

*C*lyde woke up feeling peaceful. He was heading on a new adventure with a friend, and he would never have to worry about people's expectations of him or the prospect of marriage. Would he have a few flings here or there? Of course. But they would only involve sexual escapades. That was the kind of life he wanted to lead. He headed down from the top bunk as he heard Louis groan.

"Let's get up, sleepyhead," he said.

Louis responded by smashing his pillow over his face. "Five more minutes?" he asked.

"Come on, we can get coffee while it's still hot. And I've never known you to turn food down," Clyde said.

"You're right. Food now; we can sleep later," Louis said, standing up, dressing for the day. "How did you sleep?"

"For the first time in a long time, I'm free," Clyde said.

"That's great." Louis smiled.

"What about you?" Clyde asked as they searched for the ever-elusive coffee.

"I always sleep fine. I know I moan about the first class people, but I get it, man, I do. They have three meals planned for the day. They get to sleep soundly, not worrying about money. That's basically what we have here on this ship. I hate to say it, but I'll miss this when we get off," Louis mused as he took a sip of coffee.

"I know what you mean. For the first time in my life, I finally understand the good things in life. Here's to the good life, no matter when we get food," Clyde said, raising his cup to Louis.

"Cheers to that! Now, you mentioned food..." he said.

"Food is always good," Clyde said, clapping him on the back, looking for their allotted breakfast.

It wasn't always the best, but Louis had a point. Their little life down in third class was just as good as first class. Clyde laughed to himself. He had hated Genevieve for getting on the boat with a first class ticket, but if she was running away from him, he was sure she would have been thankful for any ticket at all. That's when he realized he hadn't thought of her, at least not in a hateful way, since yesterday. Perhaps saying goodbye to her had helped him out more than he had thought.

Cheers, sweetheart, he thought as he chugged the last of his coffee. He told Louis of his findings after they were away from prying ears.

"I wish I had figured out that Genevieve leaving me would be better for both of us sooner! I never wanted to marry or be a father; all of those responsibilities I thought were important wore on me. Quite honestly I don't think Genevieve wanted to marry me either," Clyde said.

"She had to be sad about the baby, though," Louis said softly.

"Confused or even shell-shocked, yes, but I think she was too young to realize the gravity of what had happened. I started drinking then because I knew we would have to go through that all over again," Clyde said.

"Then who knows how you would be faring now? Babies raise the cost of living for any parent. Keeping them alive is a miracle in itself," Louis said. "So no hard feelings between the two of you?"

"Not anymore. It's funny, I don't want to see her again, but I would like to leave her a note or something, let her know I'm not going after her anymore, that she can be with whoever she wants—as long as her mother isn't involved with the planning." Clyde rolled his eyes.

"She's not a good person?" Louis guessed.

"I don't think the two of us would have been married if her mother hadn't been involved. What a sniveling little weasel. I finally caved into her demands, but at what price?" Clyde thought out loud.

"Sounds tough. But Genevieve's with her grandmother now, right? I'm sure she'll make sure to straighten the mother out," Louis said.

"I never got the impression ole Nana cared for Genevieve's mother, so I'm sure it will work out," Clyde said. A thought came to his mind then. "We still have that steward's outfit?"

"Yeah. Why?" Louis asked nervously.

"What if I did write her a letter?" Clyde asked.

"I don't know, man. What if she thinks your faking or something?" Louis asked.

"There's always that possibility, but I'm sure it will be better than just letting her assume I'm coming after her. These close calls have been fun, I will admit, but I'm ready for this new life: you, me, some senoritas, and some Mexican beer," Clyde said. Louis looked at him, nodding.

"Will this help you move on from Genevieve?" he asked.

"Yes. This time there will be no tricks to scare her. I'll put the letter under her door when she's at dinner. I won't even need the keys this time," Clyde said.

"You write that letter, then let's get our plans together once we reach New York." Louis grinned.

"All right. A letter shouldn't be too hard," Clyde said, fetching some paper and a pen, sitting down at an unused table in the dining room.

"I'll get out of your hair. Maybe I'll explore the outside deck a bit," Louis said.

"Don't get too cold." Clyde grinned before focusing on the letter.

"Dear Genevieve..." he began.

Louis breathed out as he made his way to the third-class deck. He was proud of his friend for letting go of his past like this. Louis was never one to be tied down by a girl. He knew it was different with Clyde, though. When he was a businessman, he had been classified as a second-class man and had had expectations put on him by society. Clyde's parents had never been brought up in conversation, so Louis had never asked—as an orphan, he didn't want to break

open old wounds that could still be there. Still, if he had been able to become an impressive businessman, he no doubt had someone looking out for him—old money, probably.

Louis was a different story. He was an orphan, always would be. No one cared for orphans; they never found respectable jobs, much less money to buy more than the meager pieces of bread they could find while on the street. The only way he could get money was to lie, swindle, cheat for something to fill his stomach. It was no life for children, much less a respectable woman. Louis would undoubtedly die alone, but at least he would have a chance to get a good three meals a day with a good friend.

He knew that Clyde had warned him to stay warm, but it wasn't too bad for him. The temperature was reminiscent of Southampton—in December. All right, it was cold, but nothing he couldn't handle. He just wanted an excuse to leave Clyde with his letter alone. If this was how he could move on, all the power to him. For now Louis wanted to appreciate this ship, to appreciate what it had granted them. He breathed in the fresh air before he turned, seeing the other class's deck. Then he saw something he wished he hadn't noticed.

There, on the first class deck, was Genevieve kissing someone. He couldn't tell whom; he didn't care because he could tell it wasn't Clyde. They were hiding their kisses from prying eyes, so perhaps the man wasn't precisely first class, but he still looked well-to-do. Louis closed his eyes in defeat. Clyde had grown so much in the last few days, but would it destroy him to know that Genevieve had already moved on? He moved away from the deck slowly, knowing he would have to tell Clyde about this. If he didn't, it would be the ultimate betrayal.

He walked back to the dining room, dreading every step he took. Would he destroy his friend by letting him know that his wife had moved on so willingly? Louis reasoned with himself. Maybe Clyde would laugh it off, be glad that she had moved on. After all, it would make their next move easier. Clyde wouldn't even have to write that letter. They had said their goodbyes in their hearts; that was what mattered. He came back to Clyde, who was concentrating on his writing.

"There you are. Does it sound too egotistical if I keep writing 'me'? I feel like I've said that way too many times in this letter," he said.

"Clyde, I got to tell you something," Louis said gently.

Clyde looked up at him with a smile, a smile he had just gotten back in the last few days. "What is it?" he asked.

Louis failed to tell him what he had just seen. "Write from your heart. If she ever cared for you, she would know that this is hard for you to begin with," he said.

"Thanks, Louis. That means a lot." Clyde added a few things to the letter before he sealed it into an envelope. He breathed out. "I feel better already! I'll hide this in my bunk, then get it to her room later."

"Sounds good," Louis said without gusto.

He felt so horrible to be lying to his friend. But if everything worked out, Clyde would deliver that letter, never again having to worry about seeing Genevieve. Clyde returned, smiling at him.

"A couple of days from now, we'll be heading to Mexico," he said.

This cheered Louis up. "To Mexico," he said.

Clyde felt content as the pair of them tucked into dinner that night. He was finally going to rid himself of Genevieve. He had thought he had to kill her to do it, but that had only been the alcohol talking. He could lead a life in which he didn't have to worry about marriage or the need to have children. It would just be he and Louis hitting up Mexico in style.

He did notice a change in Louis, though. It had happened after he had come back from the outer deck. "You sure you're OK?" he asked.

Louis smiled before nodding. "It's been a whirlwind few days. I just can't wait until we can move forward with our plans," he said.

"That makes two of us. Pretty soon, it will be up, up, and away." Clyde smiled.

"Not to press, but when do you think you'll give Genevieve that letter?" Louis asked. Clyde considered the question. "Part of me wants to wait in case she raises an alarm. I don't want to be thrown in jail once we get to New York. But it felt so good writing that letter. Maybe it'll be better if I do it tonight.

Maybe she'll even want to thank me for lifting the nightmare of seeing me again," he joked.

Louis nodded. "The sooner, the better. I hear you clearly," he said.

"But if I don't get changed now, I might miss my window, so here we go," Clyde said, heading back to their cabin.

He changed into the steward's outfit one last time, took the letter, and ascended to Genevieve's cabin. He remembered her door number this night and walked confidently to her room. Then he heard the door lock, no doubt Genevieve going to bed for the night.

Clyde sighed before heading back down. When he did deliver the letter, he didn't want anyone to be there. He wanted total anonymity. Genevieve would no doubt run after him if she spotted him; this time she would no doubt catch him, then raise an alarm. Ah, well, he would have other chances. He just had to be patient.

Louis looked at him when he stepped back in, still grasping the letter.

"What happened? Did she see you?" he asked.

"Nah, she returned early. Don't worry, though; she'll get it soon," Clyde said, putting his civvies back on.

"You didn't see a man, did you?" Louis asked.

Clyde frowned. "No. Why? Should I have?" he asked.

Louis hesitated before coming up with the perfect cover. "I just don't want that first class guy to get suspicious. He's probably figured out nobody down here needed to talk to the big guy upstairs," he said.

"You're right! I almost forgot you met that guy. Good thinking. But don't worry, nobody saw me; plus, I'm nimble. Soon I'll give Genevieve that letter, then we'll be good to get on our way to the future," Clyde said.

Louis nodded. "Sweet, then," he said.

They both made their way into their bunks, Clyde feeling as light as a feather. It took Louis far longer to fall asleep, though. Tonight had been a close call in itself. He wouldn't sleep well until Clyde delivered that letter. And until then his horrible secret could come out at any minute.

Chapter Nine

"Genevieve, why would I ever hurt you?" Victor asked again. Thomas stood next to him with a somber expression.

"You're not real. You're just a dream," Genevieve whispered.

"We are real. I'm not a dream," Victor said softly. He leaned down in front of Genevieve's bed, showing her his hands. "I was coming to see if you wanted to share breakfast with me, then I heard you scream. When you didn't answer, I thought the worst."

"Why would you come by in the middle of the night?" she asked Victor before turning to Thomas. "And why would you have keys?"

"It's eight in the morning; I have keys because I'm the shipbuilder," Thomas explained gently. "Why don't you tell us what happened?"

"Eight in the morning? That can't be," she said.

"It is," Victor said. He brought up a hand to her. She winced before realizing he wasn't going to hurt her. She brought her hand up, grasped his, feeling its warmth, realizing he was real, and he wasn't going to hurt her. She started crying once she realized the dream was over. Clyde wasn't there; he wasn't hurting her. She was safe. Victor wrapped her in a protective hug, and she melted in his embrace, gladdened that he was here protecting her. "It's OK; I'm right here. I'm not leaving you."

It wasn't easy for her to stop crying. Even if it was a dream, she still felt everything: her nose being broken when Clyde had first entered her nightmare, her spine feeling like it had been fractured when he had seemingly punched her in the stomach, then him squeezing her throat into unconsciousness. This was all too much for her. Her dream of Clyde was worse than what he was in reality.

"Genevieve, please tell us what happened," Thomas said. "Did someone come into your room, hurt you?"

"No. I—I thought someone had, but it was all just a dream," Genevieve said.

"A dream? Genevieve, the way you were screaming out was like someone had killed you," Victor said.

Genevieve broke, telling them everything about Clyde, concluding with the contents of her dream. Victor rubbed her shoulders supportively throughout the tale, while Thomas had a pinched face.

"Why didn't you tell anyone? At least me!" Thomas yelled.

"I told Nana and Margaret. And I didn't tell anyone because I killed my husband—well, I'm almost certain I killed him. I didn't want anyone to hate me," Genevieve said.

Victor rubbed her shoulder, kissing the top of her head. She relaxed at his touch, thankful that he was still here, not leaving her.

"You killed him in self-defense. But you're not even sure he's dead; at the very least, you're not sure he's not on this ship," Thomas said. "We would have protected you better had we known."

"You don't hate me?" Genevieve asked. He looked at her, shocked.

"Of course not. You had to do what you had to do to survive," Thomas said.

"I told you that you would never have to explain anything to me. I meant that; I meant it when I said I cared for you," Victor said.

Her heart swelled at that. "Now, besides the blankets outside your door, has anything else suspicious happened?" Thomas asked.

"Someone knocked on my door, but Mr. Ismay was just outside, so I think that rules out Clyde," she said, trying to remember everything that had happened during the trip. "Besides my door malfunctioning, then your hot chocolate last night, there's been nothing."

"You mean when I got you the hot chocolate after our talk the other night?" he said.

"No, you left a cup outside my door last night," she said.

"Genevieve, I didn't leave anything outside your door," Thomas said.

She looked up at Victor, pleading with her eyes for him to change his answer. He shook his head slowly. "If neither of you left it outside my door, then who did?" Genevieve asked.

"I don't know, but we will figure this out," Thomas said. "Give me a description of Clyde. I'll see if any of my contacts can recognize him based on the information."

"He's medium height, about five-foot-six. He's surprisingly thin, but that's just because he mostly just drinks alcohol, only eats food if he remembers or cares. He recently shaved, so if he is trying to keep up that façade, he should be clean-shaven. He also has dark-brown hair. He should be limping if he did survive," Genevieve said, trying to remember everything she could about him.

"I'll see what I can find out. I want you two to stay here, only let people in that you trust," Thomas said.

"OK," Genevieve said. He squeezed her hand before leaving.

She knew that Victor was still there, but she started shaking after remembering everything about the dream. It felt so real; she had to know if her face reflected the punch that had occurred. Genevieve knew it was foolish to believe that her nose was broken, but it still radiated pain as if it were.

"Your nose isn't broken; I can promise you that," Victor said after she voiced her concerns.

"I need to see it myself," Genevieve said. He sighed before helping her out of bed, guiding her to the mirror. She was afraid of what she would see, but there were no bruises or blood. She sighed out in relief as she placed a hand on her stomach, realizing there was no pain there either. Victor stood next to her, unsure of how to help her. "I understand if this is too much for you."

"Nonsense, my love. If anything, this is too much for you. I'm sorry that your husband did any of this to you," Victor said. He wrapped her in a hug while she cried silent tears. He kissed the top of her head; she felt relieved that he was still there with her. "Thomas was right, though. If you had told me you thought you were in trouble, I would have protected you better."

"I didn't want to take you away from your job, though," Genevieve said.

Victor shook his head slowly at her concerns. "Mr. Guggenheim would understand if he knew I was protecting the woman I love," he said.

She was shocked at his proclamation. After everything he had witnessed on this trip, he still thought of her as the woman he loved. Genevieve broke into a smile at the thought. "You love me?" she asked. Victor nodded in affirmation. "I love you too. I didn't realize how much until now."

Victor looked at her with a loving smile before leaning his head down to give her a gentle kiss that grew. That was when she realized that maybe she wasn't afraid of Clyde hurting her; rather, she was fearful of Clyde hurting the friends she had made on this trip. If he knew what the pair of them were doing right now, he would kill Victor. She pulled away from Victor with tears in her eyes. "I'm such an idiot!"

"Genevieve, what's wrong?" Victor asked.

"Clyde would hurt you if he ever found out about this. I should've seen that sooner," Genevieve said. "We shouldn't be doing this, any of it. I can't be with you. You could die."

"That doesn't change my feelings for you," Victor said.

"I couldn't bear it if you were hurt," Genevieve said.

Victor looked at her with sad eyes. "How do you think I would feel if you were hurt?" he asked. She closed her eyes, two tears falling from them. Victor put his hands gently on her shoulders before she pulled herself closer to his body. He wrapped her in a hug, and she had a feeling that no matter what she said, he would always be there to save her.

She looked up when she heard a brisk knock on her door. Victor went over to open it; Thomas came in. Genevieve wiped some tears away. "Did you find out if Clyde is here?" she asked.

"It seems there are too many staff members who look like Clyde. And none of them are limping, according to my contacts," Thomas said with a sigh.

"And no idea how the cup got in front of my door?" Genevieve asked. This was all very queer. It was looking less like Clyde, but there was no other explanation. It was driving her mad.

"No. Show me exactly where you found the cup," Thomas said.

"It was right here, where the blankets were," Genevieve said. "No note or anything."

"Hmm, nothing suspicious to see," Thomas muttered to himself. The trio looked up when a man came upon them, stopping when he noticed them.

"Excuse me, ma'am, sirs," he said, wringing his hands together.

"Charles, what are you doing here?" Thomas asked, sounding surprised. "This is Charles Joughin. He's the baker." He turned back to Charles. "You're usually not in this area at all."

"Well, I, um..." Charles stammered.

"Did you leave that hot chocolate outside my door?" Genevieve asked.

"Charles, that is inappropriate," Thomas added.

"I'm sorry, sir! But they had me baking bread late; it gets so cold down in my chambers, I just wanted to warm up. They weren't making any more cocoa for us servants, but there was still some leftover from the à la carte restaurant," Charles said. "I was going down to my chambers, hoping no one would notice— that's why I came over here—when I was called back to the kitchen. I knew I'd get in some right trouble, so I left it here. I forgot all about it until this morning."

"It has been pretty cold. I'm sorry I took your hot chocolate," Genevieve said, grabbing the cup, giving it back to him. "If anyone questions you, you just tell them you were getting it for me. It's the least I could do."

"Oh, thank you, miss. Thank you!" Charles said before running back to the kitchen.

Genevieve turned to her protectors with a pained expression. "I don't know whether to laugh or cry," she said. "Out of all the doors, he chose mine."

"If we look at this logically, though, it's a good thing," Victor said. "It wasn't Clyde, which means he isn't here. Charles just seemed to be in the wrong place at the right time."

"I know Charles. He wouldn't hurt a fly," Thomas said to her.

"This has all been embarrassing," Genevieve said before looking down. "I should get dressed. Poor Charles may have seen more of me than he wanted."

"I will leave you to that chore," Thomas said.

"Thank you for everything," Genevieve said.

"We're here for you, Genevieve. Just ask for help; I'll be there for you," he said before leaving.

She turned back to Victor with a red face. "I feel a little ashamed at what I said," she admitted.

"Don't ever feel ashamed about what you feel," Victor said.

"You're too good for me," she whispered.

Victor smiled subtly. "Someone has to be," he said. "You should get dressed so you can get some breakfast. Don't worry; I'll be right here to protect you."

Genevieve looked at herself in the mirror as she dressed for the day. She couldn't be entirely sure what was true and what was her imagination. Was Clyde on this ship or not? But as she walked outside to Victor, who had stayed there, true to his word, she knew she couldn't let her past destroy her future. She had tried her hardest to push Victor away this morning. But he had stayed, even though he had seen the horrid bits of her life. If that wasn't true love, she had no idea what was.

As they made their way to the dining saloon, they ran into Nana. "There you are! Taking time to yourself this morning?" She smiled.

"No, Nana. Something horrible happened," Genevieve said as the trio made their way to the dining saloon.

As they ate their breakfast, she explained everything, with Victor telling the parts he could. Nana sighed.

"I'm so sorry, Genevieve. That sounds horrible," Nana said. "Perhaps I should've found some other way to keep you better protected."

"It's OK. I'll protect her from here on out," Victor said.

"Good man." Nana smiled at him. They looked up as Thomas approached the table.

"Are you feeling any better?" he asked Genevieve.

"A bit. It's good to eat food," she said.

Out of the corner of her eye, she saw Ben and Miss Aubart. Victor excused himself before following the pair, talking to Ben. Genevieve turned back to Thomas, who was frowning furiously at the table. "Thomas, what's wrong?"

"I've been looking for Clyde all morning. I thought maybe he was hiding elsewhere among the staff," he said. "I was going mad, but I kept going, knowing

you needed to find him, to stop him. I was angry at you this morning for not telling me about this, but now I realize this is how you feel all the time. And I can't imagine."

"It wasn't your fault, though," Genevieve said.

"I know, but you don't deserve all the agony you've experienced for years," Thomas said.

"I know that; I've always known that," Genevieve said. "But it's nice to hear someone else say that."

"How is it you're able to stand on two feet after all this?" he asked.

"I think I figured out I would have to save myself a long time ago. But it gets better when you have people who care about you," she said.

He nodded, smiling gently. "I'll still get back out there, make sure there's nothing amiss," he said. He left, then Victor returned.

"Nothing the matter, I hope?" Genevieve asked.

Victor shook his head. "I discreetly told Mr. Guggenheim that I thought you needed more protection, and he agreed. I'll be with you as long as you want me," he said.

"You didn't have to do that," Genevieve responded.

"I want to make sure you are safe; I won't let you go through this alone. Not anymore, at least," Victor said.

She smiled at his thoughtfulness. "Thank you," she said.

"I'm glad to know that you'll be more protected as well," Nana said. "Perhaps you'll feel better if you talk to Margaret. She'll be able to help calm your fears after a nightmare like that."

"I will, Nana," Genevieve said.

Victor escorted her to Margaret, and when they found her, Genevieve told the older woman all about the dream, ending with the cup. Margaret looked troubled at best but allowed Genevieve to tell the whole tale. After it was done, Margaret turned to Victor.

"Are you with her at all times?" she asked him.

"I am now," he said gravely.

Margaret nodded her head. "That's good. You're right; it very well could have been a dream, but now that I know about these shenanigans, I want to make sure we stop them at once," Margaret said.

"How do I stop my nightmares?" Genevieve asked.

Victor squeezed her hand in support; she smiled at his tenderness.

"That I don't know. Keep on believing that you're surviving," Margaret said. "You will get better. You're going to be OK, as long as you have people to lean on."

"You're right," Genevieve said.

The trio continued with their walk, and they eventually ran into Mr. Ismay, who talking with one of the officers. As he finished his business, he noticed them, giving a chivalrous first class bow. "I trust you are enjoying your morning, ladies?" he asked.

"We are, thank you," Margaret said.

"If you need anything, please let us know," he said before heading off.

"I'm glad we're the ones who found out about Charles, not him," Genevieve said.

"Too true," Margaret said.

But as they continued their walk, Genevieve began to dislike Mr. Ismay for another reason. He no doubt recognized Victor as Ben's assistant, yet he didn't say anything to Victor. Did he acknowledge the women alone out of chivalry, or was it because he didn't recognize Victor as an equal? Genevieve sighed, wishing that people knew what a perfect gentleman Victor was.

As they continued their walk, she noticed Margaret saying hello to many of the other passengers. Genevieve had only met a handful herself; she wondered how Margaret could recognize so many, plus remember their names. She asked Margaret, who only laughed.

"You just get to know a lot of people, take time to know them," Margaret explained. "It's just in my nature; I'm a people person. It's also a part of the social circles. If you decide to become a part of this life, you'll get used to it."

"I have no idea if I do, much less know what I want to do after I get to New York," Genevieve said. She also knew that most of the people she interacted with would accept Clyde before Victor, and she wanted no part of that situation.

"You don't have to know what you want to do. But if you do want to come into this life, I'll help you, as will Madeleine," Margaret said.

"Madeleine will help you with what?" Madeleine asked as they came upon her and her maid, Rosalie.

"Help integrate me into high society," Genevieve said.

"If she wanted to," Margaret said.

Madeleine looked shocked before smiling. "I'll help you, of course! In any way you need," she said.

"There's nothing definitive," Genevieve said.

"I'll still be here regardless. Good morning to you all; hello, Victor," Madeleine said cordially. That was the one thing Genevieve loved about her; she was accepting of Victor. "How is your morning going? I wanted some fresh air; Rosalie was kind enough to join me."

"I thought I had a stalker," Genevieve said.

"What do you mean?" Madeleine asked.

"There was a cup outside my door last night; I thought Thomas or Victor had left it, but they hadn't," Genevieve said.

"What happened?" Madeleine asked.

Genevieve told her tale of how she was wearing nothing but a robe when Charles came upon them. Madeleine started laughing. "Nothing but a robe?"

"I've never seen a man's face go whiter," Genevieve said.

"How scandalous!" Madeleine said, but that didn't stop the grin on her face. "No harm is done; at least, I hope. No offense to you, Victor."

"None was taken, Mrs. Astor," Victor said. "I'm just happy we were able to figure out the mystery for Miss Wilson's sake."

"I'm happy that the plot was discovered, that nothing nefarious was planned. Anything else happen this morning?" Madeleine asked.

"Not much else," Genevieve said.

It still felt wrong to lie to Madeleine, but there was no way she would ever tell Madeleine about the dream. Madeleine was a gentle soul; to reveal the contents of her dream might horrify her since she was already in a delicate condition. She did not need to hear about Genevieve's dream or her past marital problems.

"Well, at least you got a good laugh from the morning," Madeleine said. "I don't think I've ever had a compromising situation like that. Don't worry—we'll keep it discreet, won't we, Margaret?"

"Of course," Margaret said, knowing there was more to the story. She moved on so the younger ladies could talk further.

"I don't think Charles will tell the tale either," Genevieve said. "I'm sure he doesn't want Mr. Ismay to find out."

"Yes, that would be a good motivation," Madeleine said. "Is that why Victor is escorting you everywhere?"

"Yes, Mrs. Astor. I wanted to make sure Miss Wilson is protected after this morning. She was properly scared by the whole event," Victor said.

"I approve. I don't want my new best friend to be so petrified that she doesn't want to join my husband and me for dinners once we reach the shore." Madeleine winked at the couple.

"You're too kind, Madeleine," Genevieve said to her friend.

"Nonsense!" Madeline said.

Genevieve shook her head. "It's true. If it wasn't for you, Margaret, or Nana, I'm sure no one would approve of this. Not that I need any approval," Genevieve said to Victor. "But I would be very concerned about how to live properly after everything that's happened in my life."

"Thankfully, you don't have to worry about being alone. I understand how it is to be in a controversial relationship, but if I had listened to everybody who said it wouldn't work out between Jack and me, I wouldn't be standing here with you right now, on the grandest ship in the world, due to give birth in a couple of months," Madeleine said.

Genevieve smiled. "We are two peas in a pod, aren't we?" she said.

Madeleine laughed. "Yes, I do believe so! A good thing as well, as we get the best beaus life has to offer," she said.

Genevieve looked up at Victor, smiling. Madeleine was only too right. The promise of a life with Victor helped her imagine the possibility that Clyde could never hurt her again. It was one of the only things that helped her carry on. The trio talked for a bit before Colonel Astor came looking for Madeleine for lunch. While they already had plans for lunch, he promised to include Genevieve and Victor in a special dinner he had planned.

"Really? Any clues?" Genevieve asked.

"Just know you'll like this surprise, Miss Wilson." He smiled before he and Madeleine left for lunch, Madeleine promising Genevieve she would see her later.

Genevieve and Victor searched out Nana, so they could find a table for themselves. It was another enjoyable lunch before Thomas approached them at the end.

"Good afternoon, Thomas. Is anything the matter?" Genevieve asked.

He sat down at the table, looking around, making sure they were not being overheard. "I told Genevieve this already, but I haven't been able to find anyone matching Clyde's description on board." Thomas addressed Victor and Nana.

"We've already figured out Charles left the cup outside my door. Isn't it possible that means Clyde isn't on this ship?" Genevieve asked.

"I can't explain it, but I think too many things have happened to you on this trip," he said. "I was wrong not to take some of your concerns more seriously."

"That makes me feel safe," Genevieve said sarcastically.

"I don't say this to scare you. I just want to prepare you to be on the lookout for everyone," Thomas said. "I don't care what time of day it is; if something happens to you, come find me."

"OK," Genevieve said.

"And don't forget, you'll have me for protection as well," Victor said.

Genevieve held Victor's hand in support, smiling sadly. "I'm sorry, Victor. You shouldn't have to worry about watching out for my alcohol-crazed husband or me—any of you," she said.

"We want to help you, Genevieve," Nana said.

"We'll figure this out," Victor said.

"You're all too good for me," Genevieve said.

"Someone has to be," Thomas said. He looked around as staff was cleaning tables, getting ready for the dinner hour. "Come, let's get out of their way. Business never sleeps for them."

Genevieve followed her party out of the saloon, appreciating her friends even more. Not many people would have helped her, but they were going out on a ledge for her. She now feared for Clyde's life if he did try to come for her. She was pretty sure he would rue the day he had hurt her; they were that committed. She was happy that she had found them but even more so that they had found her.

"I never got to give you another tour of the ship," Thomas said. "To take our minds off all our troubles, how about I show you all around?"

"I would like that," Genevieve said.

"Have you ever seen a ship's bridge?" Thomas asked.

"No, I can't say that I have," Genevieve said.

"Come on, then," he said, offering his arm to Nana while Victor and Genevieve linked arms. "Now, Captain Smith might not be there. Normally his presence is required only if there's some tricky maneuvering of the ship or there's a problem. But I know many of the officers. They're good men. I'm sure they'd love to impress you ladies."

"I can't wait," Nana said as they stepped onto the bridge. Thomas held up a hand, walking over to some of the officers before smiling, waving them over.

"I'd like to introduce you all to officers Charles Lightoller, Harold Lowe, and Joseph Boxhall. They're manning the bridge now and will be relieved sometime in the night," Thomas explained. "There are also three quartermasters on the bridge with two lookouts up high. They help these men here identify anything in the *Titanic*'s way."

"I guess you don't want to hear from them," Genevieve said.

"No, miss. Don't worry. It's purely for protection," Officer Lightoller said. "I suspect we'll only need them for when we pull into New York."

"Yes, we'll get you there safely, miss," Officer Boxhall said.

"I'll be happy for that," Genevieve said, smiling up at Victor. "What is it like when the sun first comes up?"

"Beautiful, miss." Officer Lowe smiled. "How is your trip going so far?"

"No complaints from me," Nana said.

"It's the grandest ship I've ever been on," Genevieve said.

"I'm glad," Officer Lowe said before turning back to his work.

"The *Titanic* is a well-oiled machine, thanks to these men," Thomas said. "We'll let you get back to work. Thank you for letting us drop in on you."

"Yes, thank you," Genevieve said.

"Have a good day, miss," Officer Lightoller said.

"That was a great idea, Mr. Andrews," Nana said.

Genevieve agreed. It was great to see how the ship worked; plus, it kept her mind off of Clyde.

"Is there anything else we can see? Could we see the boiler room?" Genevieve asked. Thomas hesitated; she noticed the officers all look at him with unease. "Is it off-limits? I don't want to get anyone in trouble."

"They're a bit busier than the bridge. I don't think it's a good idea," Thomas said.

Genevieve saw the officers visibly sigh. She knew there was something more to this whole situation, but she didn't press them. It was something that they had under control. "OK," she said, before they made their way out of the bridge.

"I'm sorry we couldn't see everything you wanted to see, but I hope you enjoyed this," Thomas said.

"I did, thank you," Genevieve said.

"Business for me never sleeps on this trip. I'll check in again if I hear or see Clyde," Thomas said before departing their company.

"I'm glad he is looking out for you. He reminds me of Mr. Guggenheim; he seems to know everyone," Victor said.

"That he does, my love," Genevieve said discreetly.

Victor and Genevieve dropped Nana off at the library as she wished to compose a letter. They continued talking discreetly, in case any prying eyes were on them. It was so easy to laugh with Victor; it had been so long since she had laughed. It was a welcome change in her life to be around him. She realized that this was true love, not what she had shared with Clyde. If she had known what true love was, she might not have married Clyde. She couldn't change the past, but she could make sure she had the right people in her future, and she knew Victor was right for her. They looked up when Margaret came upon them. Genevieve smiled at the older woman.

"Hello, Margaret," she said.

"Hello, Genevieve, Victor. How are you?" Margaret asked.

"Very well, thank you, Mrs. Brown," Victor said.

"It's a beautiful day after a horrible morning," Genevieve said. "How about you, Margaret?"

"I can't complain. Would you like to come to tea, Genevieve? I saw Madeleine go in not too long ago," Margaret said.

"I'd love to," Genevieve said.

"Allow me to escort you two, then. It'll give me some time to talk to Mr. Guggenheim," Victor said.

Genevieve beamed at him as they walked arm in arm to the tea parlor. After he departed, promising that he would escort her after tea, Genevieve and Margaret walked in, finding Madeleine. She waved them over, which made Genevieve feel at home.

"Where have you been?" Madeleine asked.

"Thomas was so kind to offer Nana, Victor, and me a tour of the bridge," Genevieve explained before taking a sip of tea.

"Splendid! How was it?" Madeleine asked.

"It was good. We met three of the officers working; they were quite charming," Genevieve said. "How did you spend your time?"

"Resting. I woke up this morning with a groggy feeling, which I can't seem to shake. You know, because of the baby," Madeleine said with a grimace. "I figure the more I rest, the better I'll feel for Jack's surprise."

"Any chance you know what it is?" Genevieve asked.

Madeleine shook her head. "None; Jack hasn't even told me," she said. "Don't worry, though. Whatever it is, I'm sure it'll be a fun time for all."

"That sounds fair," Genevieve said.

They continued with their tea. They paused their conversation when Miss Aubart came up to their table. "Miss Aubart, how are you?" Genevieve asked.

"Well, Miss Wilson. Bonjour, everyone," she said to the table. "I heard that you need Mr. Giglio to escort you because of nefarious things. I hope you find safety with him."

"Thank you," Genevieve said. She felt it was very kind of Miss Aubart, of all people, to say that to her. She wasn't sure other women would be as kind.

"Of course," Miss Aubart said before leaving the tearoom.

"She's an interesting woman, that one," Madeleine said.

"Indeed. I'm not sure if she would have felt the same way otherwise, but after the door incident, I'm sure she recognizes that sometimes personal security isn't available to everyone," Genevieve said.

"Well, your feelings for one another no doubt help," Madeleine teased. Genevieve smiled at her friend, but Margaret was looking at her thoughtfully. She wondered what she was thinking of as they finished their tea. "I've had a lovely time, ladies. I think I'll relax a little more before dinner."

"We'll see you at dinner, then," Genevieve said. She turned to Margaret. "You looked like something was bothering you. What's wrong?"

"Last night you had that dream about Clyde?" Margaret asked her.

"Yes." Genevieve shivered. "What of it?"

"What if you had that dream because your subconscious is guilty?" Margaret asked. Genevieve frowned. "You mean even though I know I deserve better than Clyde, my subconscious is still trying to guilt me about moving on from him?" Genevieve asked.

"I think so," Margaret said. "You're scared that Clyde is still alive, here on this boat. What would happen if he knew that you had friends, especially of the male kind? Someone who loves you more than he could ever love you?"

"He'd be angry, volatile; he'd hurt me, plus anyone else he could get his hands on," Genevieve said, considering the question. "He'd react exactly as he did in my dream."

"Then I think we found your problem," Margaret said gently.

"What do I do about it?" Genevieve asked.

"You have to admit it to yourself. Clyde isn't on board; he's dead. He can't hurt you anymore," Margaret said. "You need to let your grief go."

"Clyde isn't here; he's dead," Genevieve said, although she didn't believe it. She had a gut feeling that somehow, somewhere, he was still alive. Maybe not on this ship, but somewhere, biding his time until he could find her to do his worst to her. But she didn't want to worry Margaret, and so she decided to go along with the ruse. Margaret left to take an invigorating walk while Genevieve pondered her life at the table. She looked up as Victor walked in.

"Have a good time?" he asked.

She smiled as she accepted an arm from him. "It's always a good time with friends, but it seems my brain is broken," she said.

Victor frowned. "What do you mean?" he asked. She explained what Margaret had said about her dreams and how her brain refused to let go of the past. "Your brain is not broken. It would take a lot for anybody to get over what you went through."

"That's the thing, though. It has to be broken because I know deep down that I deserve someone like you," she said. "If my brain can't see that, then maybe Clyde did break some small piece of me. Maybe he did win in his own right."

"I refuse to believe that. We're on the grandest ship in the world, and we found each other," Victor said, turning her toward him. They looked in each other's eyes; she saw a gentleness in him that she had never seen in anyone else. "You know how many people don't see me? I may have a first class ticket, but they won't see me as one of them. But you see me. You've always seen me."

"Madeleine sees you as well," Genevieve said. But she thought of that first day, when Victor got on after they had stopped at Cherbourg, how her eyes found him, then she couldn't look away.

"If we weren't serious about one another, would she care?" he asked.

She looked away as she pondered the question. "I don't know," she answered truthfully. "I don't want to know because that means we wouldn't have found one another, not in the way that matters."

"Too true, my love. Too true," he whispered.

They continued with their walk, greeting fellow passengers as they went along, steering clear of Lady Duff-Gordon. Genevieve was finally coming into her own as a first class passenger. While most talked directly to Genevieve, there were only a few who greeted Victor. She soon saw what he had meant.

"I see it now; when you asked whether Madeleine would see you if it weren't for me, our relationship. I've never seen it before, but I am so sorry. I wish people knew how good you are. You deserve more than what people think you deserve," Genevieve said.

"I don't think that will change anytime soon," Victor said.

"It should, though," she said.

Victor turned to her with a cheery smile. "I don't care. As long as I have you and my employment with Mr. Guggenheim, I don't care what other people think," Victor said.

Genevieve thought about it. "Maybe I shouldn't care what other people think, either," she said.

"You're a first class woman," Victor said. "You're supposed to care about what other people think."

"If I cared about what other people thought, I wouldn't have said yes to you. Plus, I probably would also still be in Southampton with my husband," Genevieve reminded him. Victor looked over at her, considering her words. "You're right. I'm sorry I spoke so hastily. You're not like the other women in first class," he said.

"There are a few distinctions that separate us," she teased. Victor laughed at her joke before they both fell silent.

"You are a powerful woman. I think that other first class women should be like you," Victor said after some time. "Maybe you could change their thinking about who is acceptable to them."

Genevieve thought about his words. If some woman had told her that Clyde wasn't good for her, she wouldn't have been in this situation. Genevieve thought bitterly of her mother's words—I was so afraid you'd be an old maid!—realizing one of the reasons she had married Clyde was her mother's influence. If she had known any better, she might have made a better decision. Perhaps she could change women's minds about certain men. All women deserved good men like Victor.

They came upon Nana, who smiled when she saw the pair.

"There you two are! What have you been up to?" she asked them.

"Thinking of shaking up first class thinking." Genevieve smiled at Victor.

"Spoken like a true Wilson," Nana said. "I can't believe how fast time is going! We must dress for dinner. I don't know what to expect."

Genevieve didn't either, but she did know that after her talks with her new friends, she was no longer afraid of Clyde or what he could do to her. Her past had already been stolen; no one was going to steal her future. After Victor promised to escort them to dinner later, he went back to his room to change for

the night's events while Genevieve helped Nana scour her closet for appropriate dresses. Genevieve found a beaded burnt orange number, deciding on that.

"It looks beautiful," Nana said in a hushed tone.

"Thank you, Nana," Genevieve said as she changed into it. She wanted to look beautiful tonight for a particular reason. "Today has been rough, but I'm glad I experienced it."

"In what way?" Nana asked as she helped Genevieve to fasten everything that she couldn't reach.

"I realized that I don't want to be like first class women. Don't get me wrong; the close friends I've made on this trip are wonderful. But there are some on this voyage I don't want to aspire to be like. Do you know that most people won't even acknowledge Victor?" Genevieve asked Nana.

"Unfortunately, most people won't. It can be a sad world we live in," Nana said.

"Victor said that I could be the one to take charge of the first class women, make sure they know to be with good, kind men," Genevieve said.

"If anyone can do it, it's you," Nana said after Genevieve turned around for her to examine the dress. "What's your first plan?"

"It depends on what Victor says after I ask him," Genevieve said.

It was important not to push him into anything he wouldn't want to do, but she didn't want to hide their feelings anymore. They both deserved happiness, what other people thought be damned. Nana returned to her room to change; Genevieve looked in the mirror as she thought of what she wanted to ask Victor. She remembered how Madeleine had done Miss Aubart's rouge and picked up the tools she needed.

She smiled after she had finished, examining herself in the mirror. She turned to the door once it was knocked on, smiling. It was time. She opened the door to reveal Victor, who froze once he saw her before smiling at the transformation.

"You're beautiful," he whispered.

"Victor, you've been so patient with me. I can't tell you how much it means to me. I want to be patient with you as well, but after our talk, I don't want

us to hide anymore. I want people to know that you mean the world to me," Genevieve said.

She held out a hand to him. He looked down at it, smiling before grasping it. They walked hand in hand to Nana's room. Nana smiled when she saw the pair.

"I feel a fool praising Clyde before because I see now that this is love," she said.

"Thank you, ma'am," Victor said.

She gave him an appraising look. "That's 'Nana' to you," she said.

Genevieve beamed as Victor offered an elbow to her.

"Come, let's see what Astor's surprise is," Nana said.

They walked down to the grand staircase; Nana walked down first, while Victor and Genevieve looked at one another. "Ready?" Victor asked. Genevieve smiled.

"Ready," she answered.

They started walking down the staircase hand in hand, and it seemed like everyone's eyes were on them. Genevieve kept her head held high, not meeting anyone else's gaze. They reached the bottom and were immediately met by Lady Duff-Gordon.

"What is the meaning of this?" She sniffed. "He's not good enough for you, girl."

"If anything, I'm not good enough for him," Genevieve said. Lady Duff-Gordon looked like she wanted to say something but was interrupted by Madeleine.

"Excuse me, Lady Duff-Gordon, but we have a dinner with Captain Smith that we can't be late for. Genevieve, Victor, if you're ready, we're in the à la carte restaurant," she said. Lady Duff-Gordon's face froze with indignation. The happy couple silently laughed as they followed Madeleine.

"Are we dining with the captain, or did you make that up to silence her?" Genevieve asked.

"Oh, we are dining with the captain! My sly husband was able to do that. If we had the time, I would ask how this came to be," Madeleine said, pointing to their intertwined fingers, "but I'm a very patient woman."

"It's love; why should we hide it?" Genevieve said. Victor smiled at her as they made their way into the à la carte restaurant. She saw Colonel Astor, Margaret, Nana, and the ship's captain himself: Captain Edward Smith. He was imposing but still gave the women warm smiles. He was shaking hands with Colonel Astor, who introduced Madeleine to him.

"This is Genevieve Wilson and Victor Giglio," Colonel Astor said. "From what I have gathered, it's her first time on one of your ships."

"Really? Well, I hope you're having a marvelous time so far," Captain Smith said, shaking her hand.

She curtsied, entranced by his imposing stare. "It's been amazing, sir. I've had an enjoyable time," she said.

"I'm glad, Miss Wilson. Good to see you again, Victor," Captain Smith said. "It's good to see you again, Mrs. Brown."

"Good to see you as well, Edward." Margaret grinned. "I have to admit, I didn't think this would be Astor's surprise."

"You didn't tell them, Jack? I'm surprised that you haven't been gloating about it all day," Captain Smith said.

"I didn't want to make any promises I couldn't keep," Colonel Astor said.

"Yes, the life of a captain is very unpredictable," Captain Smith said. "It's been a good voyage so far, but I can't promise that nothing will ever happen."

"We understand, Captain Smith. Thank you for sharing a meal with us," Genevieve said.

"The pleasure is all mine, Miss Wilson," Captain Smith said, pulling a chair out for her to sit in. "Were you aware that the maiden voyage of *Titanic* is to be my last as captain?"

"I did hear that," she said.

"That's one of the reasons I choose to enjoy some of my passengers' company. Trust me, I'll enjoy spending time with my family, but I will miss these trips," Captain Smith said. "That's why I'll savor this trip a little more."

"I'm glad I was able to be on this last trip with you. I hope you enjoy your time with your family," Genevieve said as the hors d'oeuvres were served.

"How do you like the food so far?" Captain Smith asked.

"It's wonderful, sir," Genevieve said.

"Good. I'll make sure to pass on that message to Ismay," he said.

"He must be pleased with how everything is going so far," Colonel Astor said.

"Exceedingly so. Although you never can tell with Ismay," Captain Smith joked. They all laughed, lightening the mood almost immediately.

They enjoyed a fine meal, Captain Smith telling them some of his adventures on his many voyages. Genevieve couldn't believe her morning had started so terribly but was ending on such a lovely note.

"I hope you all enjoy the rest of the voyage," Captain Smith said after dinner was over.

"Thank you. It was an enjoyable meal," Genevieve said.

"Have a good evening, Miss Wilson," he said. "Thank you, Jack, for arranging this."

"It was my pleasure to do so," Colonel Astor said before Captain Smith left. He turned to the group with a smile. "What a remarkable man!"

"It was a good surprise, Colonel Astor. I had a great time," Genevieve said.

"I'm glad you liked it, Miss Wilson," he said. "Look at the time! It just flew by. We should head to bed, my dear. We'll see you all in the morning for church service?"

"Yes. Have a good evening," Margaret said.

"See you in the morning," Genevieve said.

Madeleine came over, embracing her. "Don't flash random men in your robe!" she whispered. Genevieve laughed, waving her friend off.

"I'll escort you both to your rooms," Victor said to Nana and Genevieve.

"Are we sure it's safe with Lady Duff-Gordon on the prowl?" Genevieve asked.

"Don't worry; I'll protect you." Victor grinned. They dropped Nana off first before heading to Genevieve's room.

"I haven't been to church in years," Genevieve said.

"You'll remedy that tomorrow. Lady Duff-Gordon excluded, I'm glad we revealed ourselves to others. I love you, Genevieve; I don't want us to be separated because of what others think," Victor said.

Genevieve looked at him with tears in her eyes. "I love you too," she whispered.

He wiped the tears that fell. "I didn't mean to say anything improper..." he said.

She shook her head, placing his hand on her face. "It's not improper. I haven't heard anyone say that to me for so long," she said.

He rubbed his thumb against her cheek; she closed her eyes at the sensation. Then she opened them slowly, looking at his beautiful face. He leaned closer into her before placing his lips on hers for a gentle kiss. They broke away to look at one another before heightening the passion of the kiss. She wrapped her arms around his neck while he wrapped his arms around her hips. He pushed her slowly against the door; she had never felt closer to anyone.

She finally found her key, unlocking her door so they could enter. Victor placed a sweet kiss above her dress's neckline. She closed her eyes at the sensation. He pulled away before helping her out of her dress. He placed it carefully in one of the velvet chairs before coming back to her inviting lips. He pulled away again, looking her carefully in the eyes.

"Am I going too fast?" he asked. She shook her head. "You know I would never push you."

"Victor, if I had any concerns about this, about you, I wouldn't have suggested being open with our relationship," she said. She lay on the bed, motioning for him to join her. "I want this. I want you because I love you."

Victor smiled at Genevieve before coming over, sitting on the bed gently. She could tell he still had some doubts so she pushed his dinner jacket off before unbuttoning his shirt one button at a time so he would get the message. He laughed before helping her, throwing the shirt onto a nearby chair. Their lips met once more; she wrapped her arms around his neck, wanting him as close as she could get him. She could tell he felt the same way as he held her hips tight against him.

His lips trailed down her cheek to her neck; she breathed out as the sensation undid her. She hadn't been touched like this in five long years. When he took off all of her underclothing, she wasn't nervous or afraid that he would look at her body with shame. She remembered that Clyde had done that when

they had been intimate. It was almost as if he wanted someone better than her. "Thank you," she whispered.

Victor frowned at her. "For what?" he asked.

She smiled sadly. "For accepting all of me—mind, body, and soul," she said.

He kissed her softly. "I will always accept you. I'm sorry you had to be in a relationship that made you believe otherwise," he said.

"I'm grateful to be in a relationship of such acceptance," she said. He smiled, exploring her body with his hands and mouth, and the two shared a night of passion the likes of which they had never experienced before.

Chapter Ten

Clyde opened his eyes in the morning, breathing out in contentment. He hadn't slept this well in years! Why hadn't he thought of leaving Genevieve earlier? Besides the fact she had tried to kill him, she had had the right idea all along. And if he was sleeping soundly, no doubt she was in the lap of luxury. He quietly laughed. She should be thanking me! he thought.

He stayed in bed a touch longer. He no longer had to worry about people's opinions about when he should or shouldn't eat. Besides the fact that breakfast would soon disappear, at which point he would have to wait until lunch, he could relax all he wanted. How about that? he thought. It's not that different from first class life.

He lay on his back, relaxed, letting the ship lull him into relaxation. He didn't entirely fall asleep, not wanting to miss breakfast but also not wanting to get up so early; he didn't let himself think about anything. Even when they were still living in Southampton, he still felt the stress of marriage. But now he felt secure in his bachelorship, and he could be comfortable in bed.

When he had had his fill of relaxation, he jumped down from his bunk to get Louis up. He smiled, seeing his friend lying on his stomach. Louis must have been more tired than he had thought. He placed a hand gently on Louis's shoulder.

"Wake up, sleepyhead," he said softly. Louis grunted; Clyde was alarmed when he turned around.

"What time is it?" Louis asked.

"It's very late in the morning. What's wrong? You look like death warmed over," Clyde said.

Louis smiled weakly. "It must have been colder out on the deck yesterday than I realized. It took forever to fall asleep, too, so that didn't help my health," he said.

"Oh, Louis. You stay here. I'll get you some food, coffee. I don't want you to get sicker by moving around," Clyde said.

"I'm sorry I'm making this trip harder," Louis said weakly.

"It's fine. I just want to make sure you get better sooner. No rest for the wicked or men whose meals are set around a specific time," Clyde joked. Louis smiled; it warmed Clyde's heart to see it.

"Sounds good," he said.

"I'll be right back," Clyde said, heading to get food for his ailing friend.

He had felt great before, but now he was worried. What if everything was cleaned out before he could grab some food? He hurried up, hoping for at least one plateful. If he had to wait until lunch, so be it. He'd know hunger again; since they were heading to Mexico by the seat of their pants, he would know hunger again. All he cared about was making sure Louis was going to live. He could not go through this new life without him. Louis was the smart one, the one who would survive no matter how many lies he had to tell. He could not be taken out by a garden-variety cold.

He breathed out in relief when he was able to get food for both of them. One of his bunkmates—Horace, he believed—gave him a questioning look. Thankfully they had an understanding that neither of them could understand the other, so Clyde pointed back to their cabin, placing a hand on his stomach in distress. Horace could understand the sign language of sickness, nodding his head. Clyde made it back to their cabin, seeing Louis sitting up in bed, much improved compared to when he had left him.

"Good news—they didn't run out," Clyde said, handing Louis a bowl. "I know it isn't proper medicine or even soup, but it's better than nothing."

"I'll take it," Louis said. "Now that hits the spot."

"I aim to please," Clyde said. They ate in silence, letting breakfast talk for them. After taking his last swig of coffee, he turned to Louis. "Feeling any better?"

"Yeah. Sustenance helped me. Thank you," Louis said.

Clyde smiled. "I'm glad. I can't live without my right-hand man," he joked.

"Hey! I thought you were my right-hand man," Louis said.

"Agree to disagree." Clyde laughed. "Let's have a day to ourselves. Let's not bother with Genevieve or exploring the ship or outer deck. Just two buddies plotting out our next stop in Mexico."

"That sounds like a plan," Louis said with a smile. Clyde smiled back, and a part of him was relieved. The old Louis was back, which meant nothing was seriously wrong with him.

Louis hadn't been lying when he had said he hadn't slept well the previous evening. He had tossed all night, reliving the moment when he had seen Genevieve kissing another man. He didn't judge her for it because he didn't know the whole story of the great escape from Clyde. All he knew was that Clyde had decided it best to not pursue her anymore at a certain point. His problem with the whole affair—which, he mused, was a poor choice of words—was that he didn't want to tell Clyde about it but also knew that not telling him would be a massive violation of trust. What would Clyde say if he found out about this? But at the same time, wouldn't it be a relief knowing that Genevieve wouldn't care where they went?

These questions were going through his brain the whole night. He had slept fitfully, feeling like death warmed over when Clyde had woken him up. But as they had sat eating their breakfast that morning, Louis had finally felt a sense of clarity. Clyde was happy here with him. It didn't matter what the good guy / bad guy dynamic of their marriage had been; Genevieve was delighted with her life, while Clyde would be happy with his. If he told Clyde about what Genevieve was doing, it would only set him back mentally.

When Clyde had woken him up, he had been able to see that it had rattled Clyde to see him looking so ill. He had decided to work through this fog in his head. He would not think about anything that he had seen out on deck. As far as he was concerned, he hadn't seen Genevieve for months; when Clyde delivered his letter, Genevieve would be old news. It didn't matter what she did. It was Mexico for them, so why worry himself to death?

"Did you ever think your life would turn out this way?" Clyde asked him after their hearty breakfast. Louis sighed as he pondered the question.

"No, I didn't. I didn't even know if I would ever make it off the streets alive," he said.

"I never thought I'd make it out of America, but I did. Then, with everything that happened in Southampton, I just wonder, are we making the right decision? Going off into another country?" Clyde asked. "I know, a bit late to ask that question, but what if I'm making another rash decision by running away somewhere exotic?"

"You listen to me, friend; you listen well. You need an escape. For the first time in your life, you can live the life that you want. We can live the life we want, with no responsibilities," Louis said.

Clyde nodded, smiling. "You're right. It's not the first time in my life that I'm thankful for meeting you," he said.

Louis smiled back, still not feeling totally right about hiding the truth from his friend but knowing they needed to get to Mexico. Clyde needed a new chance at life.

Clyde felt better after their heart-to-heart about the risks of their future. With less alcohol came a better quality of thought. This was always what he did, wasn't it? He ran away when the going got tough, constantly piling his problems on someone else. But Louis had a point. They needed to get away from this life. If anyone could talk him into a good time, it was Louis.

Clyde talked him into rest after lunch. He could see that food had done Louis a world of good, but he did not want him to get worse without proper

sleep. Clyde decided to get up in his bunk, quietly imagining what the future held for them. He also wanted to be close to Louis in case he took a turn for the worse.

He only found himself looking forward to the good times they would go through, not the worry they would no doubt occasionally encounter. Would money and food be scarce? The answer was yes, but he didn't have to worry about a wife or children depending on him should he fail. Clyde felt a pang of sympathy for those who did have families; he knew many of them in third class on this ship. But each moment they got closer to New York, he felt more relief that he had escaped that life. He knew that Louis would never find himself in that situation, so he was the luckiest out of the whole lot of them.

He noticed that Horace had come into their bunk and could see Louis dozing. He mimed to Clyde that it was dinnertime. Clyde smiled gently, nodding at Horace before climbing down to wake Louis. It was funny, when he had first come on the ship, he hadn't even thought about friendship or even kinship beyond Louis. But now that he didn't care about getting Genevieve back, he appreciated Horace for acknowledging that Louis needed help.

"Wake up, buddy," he said gently to Louis.

Louis opened an eye with a smile. "We in New York already?" he asked.

Clyde laughed heartily at his joke. "No. We're still in the middle of the ocean, but it is dinnertime," he said.

"I'll take it!" Louis said, standing up. Clyde could see his color had much improved; while not a doctor, he thought that Louis would make it.

While they ate, Louis mused about the trip thus far. "We must be halfway by now."

"I'm not the captain of the ship, so I'll take your word for it," Clyde said.

"At any rate, I can't wait to get there so we can start our journey. Who knows what will happen next in our lives?" Louis said.

"You're right," Clyde said.

It had been easy to see all the negatives that had happened in his life, but now he looked at it from a new perspective. If he hadn't moved to Southampton, he would have never met Louis. He could have still been stuck in a marriage

he hadn't wanted to be a part of. Everything good that had happened in his life could be attributed to Louis. He was a good friend.

Louis had been lively during the meal, but after the food, when they sat at the table talking quietly, Clyde noticed his eyelids closing before he opened them rapidly. It was a losing game to try to stay up past his bedtime. It got to the point where Clyde had to get him to bed, for he feared Louis would fall asleep at the table. Louis protested only once before allowing Clyde to lead him to his bunk.

"You get some sleep, Louis. I'm going up to deliver Genevieve that letter, but I'll be back. I promise," he said.

"You be...careful," Louis said before breathing out. Clyde knew he was sleeping soundly.

He quietly changed into the steward's outfit, hopefully for the last time. He grabbed the letter, checking on Louis before departing. After everything that had happened today, he knew he didn't have to deliver the letter, but he would start this new life of his as a gentleman. What kind of gentleman didn't let his wife know that there were no hard feelings for trying to stab him to death? He had to stop at that thought before quietly chuckling. Nobody else could understand the life he had lived. He composed himself before returning to the task at hand. He reached the corner, peeking around to make sure no one was at the end of the hall when he saw something that made his blood boil: Genevieve, his wife, kissing a man with abandon.

In the recon he had done on his wife, he knew who this man was; it was more of a punch to the gut than the kissing itself. He was no first class gentleman; he was the help. She would prefer kissing the help over him? As she unlocked the door and they swept into their bedroom, he realized that they were going to do more than just kiss. He growled, heading to her room. He had no idea what he would do when he got inside. Then he stopped midstride, thinking of how Louis had acted these past two days.

Yesterday when he had returned from the deck, he had seemed ill; today he had blamed the deck again for his state. Clyde crumpled up the envelope in his hands, realizing what had in fact transpired: Louis had seen the two of them on deck yesterday, either kissing or holding hands—it didn't matter which.

He knew that Genevieve had moved on quite suddenly, but instead of telling him, Louis had kept it all a secret. Clyde shook his head, backing away from the door. He didn't care anymore about Genevieve betraying him; she had done so in the past, in more ways than one. Let her think she has escaped my wrath, he thought. He would deal with her soon. He wanted to deal with Louis first.

But not right now, not during the middle of the night. Morning would come all too soon for Louis. As he trudged downstairs, though, he knew that he could make up for lost time; as he undressed, he found a bottle of alcohol, started chugging as if his life depended on it. He didn't have a future, a wife, or a friend.

It was time to burn it all down.

Chapter Eleven

Genevieve opened her eyes in the morning, sighing contently as she saw Victor by her side. She bit her lip as she watched his dozing face. He looked so peaceful at the moment; as she remembered what happened last night, she felt blissful. Never in her five years of marriage had she ever felt love like she had last night. While she wished they could stay in that moment forever, she knew they had to get up to face the day. She kissed him softly on the cheek before trailing down to his chest. He lazily opened his eyes, smiling at her.

"Good morning, my love," he whispered. "It was a good night."

"That it was." Genevieve giggled. He turned to kiss her on the mouth, and she melted in his embrace once again. "Maybe we don't need to get up quite yet."

"We should attend church service, lest Lady Duff-Gordon knock down our door," Victor said.

"You might be right." She stroked his face, not ready to share him with the world.

"Time to be dressed; I ordered a tea tray to your room," Victor said.

"Sounds charming." She grinned.

She dressed in a dark-blue dress as the tea tray was delivered. She poured two cups of tea, offering a cut orange to Victor, who popped a slice into his mouth.

"How delectable," he said seductively.

"A welcome treat, for sure," she said, opening her mouth as he offered her a slice.

They walked to Nana's cabin to collect her for church service before joining the other first class passengers. Genevieve sitting next to Madeleine. She saw Captain Smith approach the front. He led the service; Genevieve felt calm. It had been so long since she had felt this way.

"How did you enjoy the service?" Victor asked after it was over.

"It was wonderful," Genevieve said with a smile. "I've never felt more at peace."

"I'm glad," Victor said.

Lunch was later that day since the service had been in the dining saloon, so they walked around on the outer deck. It was not the first time this trip Genevieve was thankful that she had fur coats to keep her warm against the freezing cold that had befallen them. Once they had had enough, they strolled back inside, finding Margaret.

"Aren't you two a sight for sore eyes." She grinned.

"It's wonderful to see you, Margaret. I fear that we're neglecting other people this trip," Genevieve said.

"Nonsense! We'll have plenty of time once we get home to see one another once more. I must admit that I, too, have been focusing on exercise this voyage, if only to keep my mind off the state of my grandson," Margaret said, stepping in line with them. "There's no greater reason to concentrate on yourselves than love."

"Still, Margaret. It's good to see you," Genevieve said.

"Beautiful service, wasn't it? Smith sure has a way with those," Margaret said. "It's always a good omen when the service is that good."

"This voyage has been a good omen for me," Genevieve said, smiling at Victor.

"I'm truly happy for both of you. I know more than most that both of you deserve happiness. I'm happy that you could find it now," Margaret said.

"Thank you, Mrs. Brown," Victor said, respectful as always.

"I'll see you both later. You know me—always ready to exercise," Margaret said, taking off for another lap around the deck before lunchtime.

"She's a good woman. I'm glad you have her influence," Victor said.

Genevieve sighed with contentment. "I'm glad as well. She's helped me grow stronger, to move past the nightmare that is my husband. It's women like her that have helped me realize that men like you are good, right, and true," Genevieve said.

Victor smiled, squeezing her hand. He was about to say something when they ran into Lady Duff-Gordon and her husband, Sir Cosmo Duff-Gordon. Everyone seemed to hold their breath, unsure of what Lady Duff-Gordon would say or do. Finally, she turned from the pair, her husband following after her, uncertain of what had transpired.

"What do you make of that?" Victor asked.

"I'm not sure. I've always thought that she was jealous of us, of what we have," Genevieve said.

"I was unaware that a woman like her could feel jealousy," Victor replied.

"I'm not surprised that she's jealous. We love one another; we don't care for money or otherworldly possessions. Imagine living a life in which all you did was care about things like that," Genevieve said.

"Lady Duff-Gordon isn't the only one who thinks like that," Victor said.

"True, but she's the most excessive on those fronts. The Astors, Margaret, Ben care for people outside of their circles. They would never treat us like Lady Duff-Gordon treats us. It's up to us to find people who care for us, no matter what our financial situation is," Genevieve said.

Victor smiled at that. "I agree wholeheartedly," he said. They heard the bugle, alerting them that lunch was starting. "Shall we head to lunch?"

"That sounds perfect." Genevieve smiled.

They made their way to the dining saloon, finding Colonel Astor, Madeleine, and Nana. Genevieve hugged Nana and Madeleine in greeting; Victor and Colonel Astor nodded at one another respectfully.

"How was that service?" Colonel Astor asked. "I feel refreshed."

"I loved it," Genevieve said.

"I'm glad, Miss Wilson," Colonel Astor said. "I can't believe we're halfway to New York. The days will fly by now."

"It's true," Genevieve said.

All too soon, they'd be back in the States; this daily routine would be over. She looked up at Victor, wondering how they would be able to continue with their relationship. He gave her hand a gentle squeeze; she smiled softly at him, knowing that one way or another, they would endure what came next. It helped that Ben was supportive of them, but their schedule on the *Titanic* allowed them to see each other regularly. What happened when they had a busy schedule, and Victor was always with Ben?

"Not to fret, Miss Wilson! We'll still have plenty of time to enjoy," Colonel Astor said. "Not to mention that we will have to have you all over sometime."

"Of course," Genevieve said.

He was a good man to think of her feelings. He did seem like a man who was used to higher-class people, but he did seem to care for her. Whether it was because of her close friendship with Madeline or because he could show off around her, she wasn't sure. It wasn't lost on her that he did refer to having them all over, Victor included. Maybe in his small way, he was accepting Victor—or at the very least accepting what his wife had accepted.

"It's been a marvelous time so far, but I can't wait to get home," Madeleine said.

"Don't worry, darling. We'll be home soon, and you'll feel better," Colonel Astor said.

"I will miss this whole experience. Meeting new people, experiencing new things is something I haven't had a chance to do before," Genevieve said.

"I, for one, will miss this scrumptious food." Colonel Astor sighed as they dug into their lunch. "I do feel I will need to work out after we get home, though. I can't let my image go down."

"I refuse to believe that will happen, Colonel Astor," Genevieve said.

"You flatter me too much, Miss Wilson. I'm afraid I'll get too big a head due to meeting you," he said with a twinkle in his eye.

As she dug into some baked jacket potatoes, though, she knew he was right. She had never dined this elegantly before. Though all the courses were

decadent, dessert was the most delectable. She closed her eyes after she finished her custard pudding; she felt like taking a nap on the spot.

"Would anyone care for a walk around? I feel I haven't properly enjoyed this ship," Colonel Astor said after they had finished.

"I'd love to, darling," Madeleine said.

"I'll leave that to you younger people. I'll think I'll see how Margaret is faring," Nana said.

"Genevieve? Victor?" Madeleine asked.

After a nod from Victor, Genevieve grinned at her friend. "We'd love to. Thank you for asking," Genevieve said.

"A perfect little walking party." Colonel Astor smiled.

"Where shall we go?" Madeleine asked.

"I feel like I've seen so much of this ship already," Genevieve said as they made their way out of the dining saloon.

"Is there any part you have yet to visit?" Colonel Astor asked.

"The boiler rooms. I know it's probably just a dirty mess that no woman should be around, but after seeing the bridge yesterday, I want to see how the ship works." Genevieve said. "But it's unfortunately off-limits."

"There's nothing wrong with being adventurous, Miss Wilson," Colonel Astor said. "Tell you what, after the *Titanic* docks, I'll see if we can get a tour of the boiler rooms."

"Thank you, Colonel Astor," Genevieve said as they walked into the sitting room.

"I have to admit, they had impeccable taste when designing this ship," he said. "Almost more impressive than my hotels. Almost."

"Nothing is better than your hotels," Madeleine said with pride.

"Credit due where credit is earned," he said.

They meandered onto the deck. Genevieve felt it was colder than ever out there. It was even colder than it had been when she and Victor had walked outside only hours ago.

"Maybe we shouldn't go outside again all trip!" She shivered as they came back inside.

"I agree," Madeleine said.

"It's a good thing it's almost teatime for you ladies," Colonel Astor said. "You warm up. Victor and I will see you later."

"I'll see you later, darling," Madeleine said. Genevieve gave a gentle smile to Victor before following her friend to a table by the fire. "I hope we can warm up. I can't believe how cold it is!"

"I think it's getting colder every day," Genevieve said.

"At least you have Victor to warm you up," Madeleine teased. Genevieve thought about last night before she laughed. "When did that officially happen?"

"Yesterday. After the stalker incident, I realized that my past does not dictate my future; I love him more than I've ever loved anybody before," Genevieve said.

Madeleine sighed. "That is so beautiful," she whispered.

"It's true." Genevieve smiled blissfully. "What's the temperature like in New York? I never visited my grandmother there, so I don't know what to expect."

"I–I...uh," Madeleine stuttered before crying.

Genevieve looked at her, stunned, wondering what was the matter. "What's wrong?" she asked softly.

"I had the most horrible dream last night! It felt so real," Madeleine said.

"Maybe you'll feel better if you tell me," Genevieve said.

"We were on the ship. Jack and I were in bed," Madeleine said. "All of a sudden, I felt this tumble, like the ship was on gravel. We were told to get up. I was placed in a lifeboat, while Jack was left on board. And then the ship just sank!"

"I know how hard nightmares can be," Genevieve said after Madeleine had succumbed to tears. "But it was just that—a nightmare."

"But I can't shake the feeling of it!" Madeleine said, wiping tears away from her eyes with a napkin.

"Repeat after me: the *Titanic* is safe; this ship is unsinkable," Genevieve said.

"What good would that do?" Madeleine asked.

"Right now the nightmare has power over you; you need to get power over it," Genevieve said.

"Whom did you learn that from?" Madeleine asked.

"A wise woman." Genevieve smiled, remembering Margaret's advice.

"Well, in any case, I do feel better now," Madeleine said. "Thank you for listening."

"That's what friends are for," Genevieve said. "Perhaps no more talk of the cold."

"You're right. We're all OK." Madeleine sighed.

They finished their tea and were walking out of the tearoom when Thomas rushed past them. Genevieve ran after him, wondering what the problem was.

"Thomas, what's the matter?" she asked.

"They aren't going to take anything seriously," he responded.

"Who?" Genevieve asked.

Thomas sighed, slowing down so they could walk in tandem. "There was supposed to be a lifeboat drill today. Ismay canceled it," he said. "He thinks because it's an unsinkable ship, we don't need it!"

"You disagree with the decision, but Mr. Ismay's word is the law on the matter?" Genevieve guessed.

Thomas sighed. "Yes, unfortunately," he said. "He should know as much as anyone that anything could happen when it's least expected. A split-second decision could save hundreds; on the other hand, people could lose their lives."

"There aren't as many lifeboats as you wanted." Genevieve shivered, but it wasn't due to the cold. Madeleine's nightmare no longer felt like a dream. It could happen.

"Yes! You understand," Thomas said, not noticing her unease. "I just fear that something bad will happen because I couldn't change Ismay's mind."

"Don't think like that," Genevieve said. "Everything will be OK. I'm sure of it."

"I wish I had your optimism, Genevieve," Thomas said. He looked around to make sure they had not been overheard, taking a step closer to her. "You can't tell anyone about this. Can you keep this secret?"

"Yes," she said.

"There's a fire on board, in the boiler rooms," he said. "You've heard of the coal shortage?"

"Yes, it was the talk of the town. People were properly scared," she said.

"Because of that, the *Titanic* wasn't able to receive nearly enough coal; then the coal caught on fire." Thomas shook his head. "That's why we couldn't slow down to do the lifeboat drills. It's why we can't slow down even though we're in the middle of an iceberg warning!"

"Icebergs?" Genevieve asked.

"We got the warning this morning," Thomas said. "I only just heard about it."

"Who else knows about the fire?" she asked.

"Besides us, Ismay, Captain Smith, all the officers on the bridge," he said. "Ismay didn't want to cause a panic."

"Are you trying to say we'll all die by fire?" she asked.

"No, the stokers have it maintained," Thomas explained. "But if they use all the coal to stop the fire, we'll be stuck in the middle of the ocean. We'll lose electricity—no way to make substantial meals, no heat."

"We won't burn to death. Instead, we'll freeze," Genevieve said.

"Precisely." Thomas grimly nodded. "We aren't trying to make a transatlantic record; we're trying to stay alive."

"There's no way another ship could loan the *Titanic* coal?" Genevieve asked.

"Unfortunately, Mr. Ismay doesn't want this information to get out beyond the *Titanic*," Thomas said. "He thinks it's a personal embarrassment; he doesn't want people to think that he'll let them down."

"Is this because White Star Line is in bankruptcy?" Genevieve asked.

"Yes," Thomas said.

"Why are you telling me all of this?" she asked.

"Honestly, you're the one person I know who can keep this a secret," he said.

"No pressure," she joked. "Anything else I should know about?"

"Not that I know of," Thomas said.

"Is that why the officers were uneasy when I asked to go to the boiler rooms?" Genevieve asked.

"Aye." Thomas sighed. "It's good to get it out in the open."

"I'm glad you feel better," Genevieve said.

"Talking with you calms me down. Fancy a small walk?" Thomas asked.

"Of course," Genevieve said.

"Shame you won't be on the return trip. I won't have your calming attitude to soothe me," he said.

"You'll just have to find someone else to calm you down from Mr. Ismay's irritating decisions," Genevieve said.

"I don't think there'll be anyone else," Thomas said. "I can't explain it, but you are special, Genevieve. Everyone I've met agrees. You care about people; you don't have an agenda."

"Maybe that's how everyone should act," Genevieve said.

Thomas smiled. "Perhaps," he said.

They walked around, while Genevieve thought about what he had said: *agenda*. Did people in this life only care about what they could get from other people? Maybe it was a good thing she hadn't lived first class her whole life. This trip had been an eye-opener for her.

"There you are," Victor said as he approached them.

"My apologies. I borrowed her a minute to talk about pressing matters. She's all yours now," Thomas said. "Have a good evening."

"Thank you, Mr. Andrews," Genevieve said before accepting an arm from Victor.

"Did your tea help you warm up?" Victor asked.

She thought about Madeleine's dream but kept quiet about the affair. She didn't want to risk divulging Thomas's secret. "It did, thank you," she said.

"I'm glad. I would hate to see you so cold," Victor said.

She smiled. "I always have you to warm me up," she said.

He turned his head to her, surprised, before laughing at her openness. "I suppose we do have that," Victor said.

They continued walking on while Genevieve thought about what Thomas had said. "Is it true that people in first class are only friends because of an agenda?"

"For some, it's true, yes, especially so for Lady Duff-Gordon. But you are different than anyone I've ever met. And that includes Mr. Guggenheim. You care about people; you even care about me," Victor said. "It's a rare quality you have, my love."

"It was how I was raised," Genevieve said.

"Perhaps more people should be raised like you, then," Victor said.

They continued walking before they adjourned to their separate rooms to change for dinner. Genevieve decided on a dark-blue beaded dress. She smiled at Nana once she joined her in her room.

"How is Margaret?" Genevieve asked her.

"Better today, thankfully. How has your day been?" Nana asked.

"It's been good. It is quite cold out there, though. I don't envy the officers who have to be out there," Genevieve said.

"I should think not! At least they're there for our safety," Nana said.

"That's true." Genevieve looked in the mirror, smiling. "Thank you for everything on this trip, Nana. If it wasn't for you, I'd still be in Southampton, not here with you; I'd never have met Victor. It's all because of you I'm going toward a better life."

"I know there's a part of you that would fight to find a better life whether I was there or not. I'm just glad to know that you will be OK," Nana said. "You deserve all the happiness that is coming your way."

"Thank you, Nana," Genevieve murmured. She was happy to know that no matter what happened, she could always count on her grandmother, that her grandmother was proud of her unconditionally.

She applied some rouge while waiting for Victor to knock on her door. She ruminated on what Nana had said, that she deserved all the happiness coming her way. Before her relationship with Victor, she would never have believed that. But now she knew she was deserving of this happiness; they both were. If anyone didn't believe that, they did not belong in their lives. She turned to the door with a smile when Victor's cheery knock sounded on the door.

She opened the door; he smiled when he saw her. "You are the most beautiful woman I've ever seen. Every time you open this door, you are more confident," Victor said. "I know you don't need to hear this from me, but I'm so proud you were able to overcome all of your obstacles. You're an inspiration to women everywhere."

"Thank you," Genevieve said. "I've been thinking about what you said before, about me helping women find the man they need in their life; you're right, I could help them. All because I finally found the right man."

"Oh, Genevieve," Victor said, brushing her lips with a soft kiss. She shivered at the contact. He broke away, giving her a magnificent smile.

"Ready for dinner?" he asked. She nodded, deciding her voice would be too shaky for a decent answer. They walked to Nana's door to pick her up, then proceeded to the dining saloon.

Something felt different this night, like something was changing. She decided that it was because she had a love she had never experienced before. It was happiness she was feeling. They reached Madeleine; Genevieve hugged her friend. She had only been on this ship for five days, but it all seemed so routine at this point. She was going to have a new life that felt right and true.

"Good evening, my friends! Nothing will top our dinner with Captain Smith yesterday, but I invited Benjamin and Miss Aubart to join us tonight. It only seemed natural since we have been stealing you away from him, Victor," Colonel Astor said with a twinkle in his eyes.

"It'll be good to see him and Miss Aubart not in passing," Victor said. Genevieve smiled at Miss Aubart, curtsying to Ben, who kissed the back of her hand. Before they all sat down, though, he took her aside.

"We haven't had time to talk, but I've never seen Victor happier. That's all thanks to you, Miss Wilson. You see him better than anybody else—even better than I. I wish both of you happiness in this life. I don't know what prompted you to need Victor's full-time protection, but I see he has opened up—both of you have. It was good fortune for all of us to be on this ship, then," he said.

Genevieve smiled, remembering how Victor had told her the same thing. "Since you're a good friend of my grandmother's, there's no doubt that we would have met eventually, but I'm glad that it was on this trip that we met. Victor has been a good friend, among other things, and you and Miss Aubart have been so supportive of us. I don't know if this trip would have been a success for me if I didn't have people like you in my life," Genevieve said.

"I heard that you two announced yourselves to the world—or, more appropriately, the ship," Ben said.

"I hope you don't mind," Genevieve said, realizing that perhaps they should have waited.

"Nonsense! I'm so happy that you two have found one another, that you have true love in your lives. It's well deserved all around. I only wish that you could have found one another sooner," he said.

"I wish that as well," she said.

"Now you can both make up for lost time," Ben said.

"That sounds wonderful," Genevieve said.

He smiled, pulling a chair out for her to sit in. He sat next to Victor, giving him a wink. Victor smiled at the gesture before the hors d'oeuvres were served. During the third course of poached salmon with mousseline sauce, Miss Aubart brought up Lady Duff-Gordon.

"I heard yesterday that unpleasant woman saying some horrible things about the two of you," she informed Victor and Genevieve.

"Some people just don't know when to butt out," Nana said.

"I've found when people say horrible things about me, I'm usually doing something right," Miss Aubart said, echoing the women's conversation at tea a few days ago.

Genevieve smiled at the sentiment. "You're very kind to say that. I've learned that just because something is considered first class doesn't always make it right. Whether she can believe it or not, Lady Duff-Gordon helped teach me that," she said.

"It's as if they think their approval will make us change our minds on the matter of love," Madeleine said. Colonel Astor lovingly grasped her hand; no more was said on the matter of Lady Duff-Gordon or her approval.

The courses continued until dessert, at which point Genevieve was enjoying a delicious éclair. She looked around the room, and she noticed Colonel Gracie. She gave a small wave in greeting, which he amicably returned.

"How are you, Miss Wilson? I trust everything is going smoothly on this trip?" he asked her.

"Very smooth, Colonel Gracie. How are you on this fine night?" she asked.

"Very well. I've been a bit lax on my regular workout regimens, so I've been enjoying some activities today. I have some more lined up for tomorrow, so I must get to bed, but I would love to share a dinner soon with you and your grandmother. Tomorrow night, perhaps?" he asked.

"I would love that, Archibald," Nana said.

"I would enjoy that as well, Colonel Gracie," Genevieve said.

"Wonderful! Until then, I bid you all a good evening," he said before taking off.

"Good evening, Colonel Gracie," she said.

If she had more desserts like this éclair, she might have to start working out as well. After the dinner was over, Ben promised to have dinner with them again. Genevieve smiled at Miss Aubart before the pair disappeared to their rooms.

"Rest would be good for me," Nana said.

Genevieve frowned. "I hope nothing is the matter," she said.

Nana shook her head. "This voyage has been grand, but it's more intensive than my normal routine. I just need a little rest, then I'll feel better," she said. Genevieve and Victor dropped her off at her cabin. Victor turned to her with a smile.

"You want to hear something?" he asked her.

"Hear what?" she asked. He held his hand out to her, and she accepted it. She followed him to an empty room that had been cleared after the busy day. He led her to the piano, where he started playing a soft, romantic tune. "You can play?"

"I used to play all the time back home in Liverpool," he said.

"You don't talk much about your life before Mr. Guggenheim," Genevieve cautiously said.

Victor stopped playing, considering her words before smiling. "Maybe one day I'll talk about my life, but I like the fact that I can keep my personal life and private life separate," he said before playing once again. She listened in rapture at his tune. It was beautiful; she felt even more at peace. After he finished, she smiled serenely at him.

"That was beautiful," she said.

"It's what I feel for you in my heart," he said, leaning his head closer to hers, capturing her lips in an intense kiss. She moaned at the feeling, caressing his face. They separated before he grasped her hand, leading her to her cabin. Just outside her door, he stopped and put his hands on her hips. She smiled and

put her arms on his shoulders. "You are the most important person in my life. I love you more than words can describe. No one else will ever compare to you."

"Victor," she whispered, touched by his words. "You mean the same to me. You gave me patience when you didn't even know what I had gone through in life. You were there for me; I'll be there for you as well. I don't care what anyone says. I don't need them. You are the only one I need—now and forever."

Victor pulled her closer to him, enveloping her lips in a delicious kiss. Her mind couldn't think of anything except for this moment. Her life before and her future did not matter; what mattered was the feeling of love she had in her heart. She didn't even realize that they weren't in their cabin yet until Victor took the key out of her hand and unlocked the door. He ushered her in, placing her back against the door, and he started kissing her collarbone. Her eyes rolled back into her head in ecstasy at the sensation. He pulled away, looking her in the eyes, silently asking for her consent. She smiled, nodding before turning around so he could help her undo her dress. She grabbed his hand in hers, walking backward to the bed before falling on top of it. He started taking off his clothes before joining her. If last night was about passion, tonight was about love, the love the two of them shared.

They looked in one another's eyes as they lay side by side, not wanting to interrupt this incredible sensation. Victor wrapped a piece of hair over her ear; she blushed at the close proximity. He kissed her forehead, bringing her to his chest, wrapping her tight in an embrace. She brought an arm around, hugging him close, letting his heartbeat lull her to sleep. She was almost asleep when she heard the most horrendous noise she had ever heard. She didn't know how to describe it until she remembered what Madeleine had said had happened in her dream: "like the ship was on gravel." The two of them sat up after the sound stopped. She also realized the engines had stopped moving.

"What was that, I wonder," Victor said.

"Would you believe me if I said it wasn't anything good?" Genevieve asked.

Victor looked at her, concerned. "I've come not to doubt anything you say," he commented. "I'll check it out, see if Mr. Guggenheim heard it. I hope it's nothing bad, but just to be safe, get dressed. I'll get answers, then come back here when I have any information."

"OK. Be safe," she said.

Victor got dressed, giving her a quick kiss before disappearing. Genevieve quickly got dressed in her gown, waiting for Victor to return. She walked back and forth in her cabin. She frowned. Was the ship *tilting*? That didn't bode well for them. She ran over to her door when it was knocked on.

"Victor, thank..." she said before stopping. "Wait...get off me!"

She had no idea who this was, but she knew that this was not Victor. She tried to pry her wrist from his grasp, but he was strong. He pulled her downstairs until they were near the third-class kitchen. "Let me go!" she yelled. She grabbed a pan, whacking his head. He grunted at the impact. When his hood fell off, Genevieve backed up, shocked.

"No. I killed you," she whispered.

Chapter Twelve

After the sleepless night the day before, Louis passed out after Clyde deposited him in his bunk. Louis didn't remember much of the previous evening, but he realized that he had passed out when he woke up in bed. He felt refreshed, but when he looked up at Clyde's bunk, he realized he wasn't there. What had he done last night? He remembered almost too late that Clyde wanted to give Genevieve the letter. Had he gone to Genevieve's room? Perhaps he was getting food, letting Louis sleep a little longer. There was no need to panic or assume Clyde had been caught; he just had to reason with himself. He got out of bed, started going over the places Clyde could be.

He checked the dining area, expecting to see Clyde over breakfast. No dice.

Next he checked the deck. He presumed that Clyde would steer clear after Louis's sickness, but he had to make sure. The deck was empty.

Finally he looked around the whole area, asking people if they had seen Clyde, either last night or this morning. Those who knew Clyde told him no. Now he started to panic. If Clyde was nowhere to be found, then it was possible that he had been captured by officers up in first class. Hopefully his letter could convince them that he had meant no harm. Louis started wringing his hands as he returned to his cabin before stopping at the sight before him: Clyde, safe.

"You're OK! When I couldn't find you, I presumed the worst," Louis said before realizing that something was wrong with his friend. "What happened? Did Genevieve catch you?"

"No, Genevieve didn't catch me. I caught her, though," Clyde said before taking a drink of whiskey.

"Clyde, it's early in the morning. You shouldn't be drinking alcohol. What do you mean you caught her?" Louis asked.

"You know what I mean," Clyde said, slurring his words and glaring at Louis with the vengeance of hell. Louis closed his eyes in defeat. He should've told Clyde the truth about what he had seen, but he had been a coward.

"Look, I'm sorry..." he began before Clyde pushed him away.

"It's not enough that my wife is sleeping with the help; no, that's the least of my concerns. *You* saw them. You didn't tell me!" Clyde yelled.

"I'm sorry! You were doing so well, not drinking or thinking about her, that I thought it would hurt you if I told you," Louis said.

Clyde shook his head in disgust. "You think you're so high and mighty, top of the food chain, but you're nothing more than a coward!" he yelled.

"You're right. I am a coward. I had so many opportunities to tell you; instead, I let you think that nothing was going on. A friend doesn't do that. I wasn't a good friend to you," Louis said.

"You're right. You're not my friend," Clyde said.

"Wait, let's talk it over. I kept something from you; that's wrong, but I'm still your friend," Louis said.

"No, you're not. Maybe you never were," Clyde said.

"What about Mexico after we dock?" Louis asked, in shock that it had gone this far.

"I don't care what you do. I'm getting my wife back. We don't need distractions like you," Clyde said as he finished the bottle, shuffling off for a refill.

"What if she doesn't want to come back to you?" Louis asked, trying to get Clyde back to reality.

"She might not. I'll just have to kill her. That was my plan all along. I was just too foolish to think that she would never move on," he said.

Louis's blood turned ice cold. "This whole time you were going to kill her? That was not what we agreed on, man. If anything, you lied to me first!" He growled. "Perhaps we never were friends after all."

"Now you're getting the point," Clyde said, still slurring his words, as he walked out of the room.

Louis grunted before punching his bed in frustration. Getting your wife back was one thing, but planning to kill her was quite another. He couldn't believe he had gone out on a limb for Clyde! He had lied from the start.

Louis started breathing calmly. He wasn't going to talk to Clyde anymore, but he had to keep an eye on him. Genevieve's life was in danger. He regretted that he had ever met Clyde. Louis opened his eyes; he started searching for the steward's office to get another uniform, cackling when he found it.

A braver man would have raced up to first class to tell her the whole sordid tale, but he was not courageous. Not when it came to Clyde, anyway. He had always been fierce when he drank; now that he was drinking with abandon, it wouldn't take much for him to go off the deep end. Louis put the outfit in his bunk and decided to keep an eye on Clyde for the whole rest of the day. He couldn't reverse his decision to come on this ship, but he could make sure an innocent woman wasn't killed. He had enough on his conscience; he didn't need that to be the next big thing.

Clyde had found a good stash of alcohol and was on his third bottle. He ignored everyone he came into contact with; who cared about petty people when your world was imploding? He hadn't stopped to eat anything that day. The last proper meal he had eaten had been the previous night's dinner. The only thing circulating in him now was alcohol; when it commanded him to do something, he followed it.

It wasn't leading him right now, though. It just recycled the same scene through his eyes: Genevieve kissing that scoundrel—the help, for God's sake!— with a ferocity she had never shown him in their five years of marriage. Had he been so terrible? All right, he would admit he had been awful after the death of

their child; that was a given. But in the first year of marriage, he hadn't been that bad. Were there parts of her that disgusted him, that he had wanted to make better? Yes, but did that make him a horrible person? The answer seemed to be yes; so be it. Death to Queen Genevieve, then.

It was after his fifth bottle that he decided enough was enough. He could no longer relive the moment he realized she had moved on from him. He finished the bottle in one quick gulp, then found a hood to cover his face. He didn't want anybody to see his face when he went up to Genevieve's room. If her little lover was there with her, Clyde would kill him. He no longer cared about the repercussions he would face if he was discovered. He had enough; he would end it tonight, no matter who lived or died.

Meanwhile, Louis had kept tabs on Clyde the whole day. His friend had done nothing but drink alcohol. Louis had thought that maybe he had forgotten all about his ultimatum to kill Genevieve until he had finished yet another bottle and picked up a hood, putting it on, heading up once again. Louis wasn't a fool; he knew precisely where Clyde was heading. He hurried back into his cabin, changing into the steward's outfit. He didn't know how, but he had a feeling that he needed to wear it just then.

He raced up to Genevieve's room, going in a different direction. He could be killed himself if he cornered Clyde. He couldn't keep Genevieve safe if he was mortally wounded. He raced around corners, not caring if he ran into anyone. The only person he hoped to run into was the man who had noticed him the first time he had come up here: Thomas Andrews, if he remembered the name correctly. But still he ran, undetected by the dozing passengers who were tucked away safe in their staterooms. If only they knew that there was a damsel in distress just feet away from them all. He reached Genevieve's door, cursing.

"Damn!" he said out loud, not caring who heard him.

The door was wide open; he feared what he would find when he entered. No blood, thank God, but he wasn't sure what had happened. If her lover had been here, he would have been killed, so Louis could be thankful that he hadn't

been. But where would Clyde have taken Genevieve? He pondered the question as he stepped out of the room, heading back in the same direction. He had reached a corner when he heard someone run to her door. He hid, wondering if he should tell them what he thought had happened.

"Genevieve? Where are you?" the man asked.

Louis peered around the corner, knowing without a doubt this was Genevieve's lover. Clyde had called him the help, but this was the most impressive man Louis had ever seen. Another man joined him, and Louis knew this to be Thomas Andrews.

"Do you know where Genevieve is? I just left for a second because we heard a horrible noise. She knew it was bad news; after everything that has happened, I wasn't going to discount her again," the man said. Louis felt a twinge of regret. He had helped Clyde this week; he was the reason Genevieve had been alone.

"It is bad news, Victor. This ship is going to sink," Thomas murmured.

Louis stepped back in shock. "But this is supposed to be an unsinkable ship," he heard Victor say to Thomas. Louis could tell the man was just as devastated as he was.

"I'm sorry, Victor. This was all out of my control. But the time has come to evacuate the ship and get into lifeboats," Thomas said.

"All the more reason to find Genevieve. Then we can all get on a lifeboat," Victor said.

It was a sound plan from Louis's perspective.

"There aren't enough lifeboats for everyone, not even by half. Even if the crew doesn't get on a lifeboat, there's still not enough room. The captain will call women and children first, you know that," Thomas said with sadness.

"Even if men could get on, they would never allow me," Victor said, looking down. "I can accept dying, but I want to make sure that Genevieve has a chance at life."

"Aye, I agree. The problem is that I don't know where she would be right now. We don't have time to search the whole ship!" Thomas said.

Louis sighed. If he wanted to save this woman, he would have to expose himself. "Excuse me, sir, but I know what happened," he said, coming around the corner.

"Do I know you? Yes, that third-class steward from the second day of the voyage," Thomas said.

"You know where my Genevieve is?" Victor asked.

"Not where, but there was a passenger down in third class. He had been fine the past few days until this morning. He's drunk, angry, violent. He says that he's her husband. He wants her back; if she doesn't go back to him, he'll kill her," Louis said.

Victor covered his face with his hands, moaning in agony.

"Do you know where he would take her?" Thomas asked.

"No, sir. I was racing up here to stop him, but I seemed to be too late," Louis said, thinking of what Clyde would do. He would want to find somewhere private, but if he was going to kill her, where would he get any weapons? "The third class kitchens, perhaps? Somewhere private?"

"It's the only place that makes sense. Let's hurry down to save her!" Thomas said.

"But if they're not down there..." Victor said, unable to finish the sentence.

"It's our only lead so far," Thomas said.

Victor nodded. "All right; let's go," he said.

They all raced down to the third class kitchens; Louis prayed that they weren't too late. He was sure the other men shared the sentiment. Louis fell in behind them, hiding once they reached the kitchens. He was heartened to hear Genevieve's voice. She wasn't dead; he knew that these two men would save her. He hid back, just in case Clyde was able to overpower them. But he took a deep breath, knowing he had stopped the murder of an innocent woman.

Now all he had to do was to stop Clyde—forever if need be.

Chapter Thirteen

"No. I killed you," she whispered in shock. Everything had happened so fast: Victor leaving before she was grabbed in her stateroom while alone. Perhaps she should have gone to Thomas or Colonel Gracie for assistance while she was alone, but it was too late to change the past. She had been concerned about Madeleine's dream coming true; meanwhile, Clyde had been leading Genevieve toward her fate.

"You only wished you had." Clyde sneered.

"This is just another nightmare," she said to herself.

"Ah, you had dreams about me, sweetheart?" he said. "Well, good news! I'm here for you now."

"No. I am done with you," she said.

He placed a hand over his chest sarcastically. "Oh, I'm so hurt!" he said in mock indignation.

"How did you survive? How did you get on this ship? It's sold out," she said.

"I always survive. When I woke up after you stabbed me, I knew where you were going. So I had a friend get us on this ship," Clyde said.

"Why expose yourself now?" Genevieve asked.

"I've been around, baby. You haven't seen me?" he asked.

"You did break into my room," she said.

"I did a lot of things over this week. Too bad you aren't as observant as you think you are." Clyde smirked.

How she wanted to smack that grin off his face! "The blankets, the knocking. It was you; all of it was you," she said.

"Yeah, I did all that. Stole some poor steward's keys. The problem is I forgot which door was yours. Do you know how difficult it is to think when you haven't had anything hard to drink for two weeks?" He cackled. "So I unlocked that poor broad's door instead. Lost the key somehow, so I left it unlocked."

"You scared Miss Aubart half to death," Genevieve said.

"Oh, Miss Aubart, is it? She was beautiful," Clyde said.

She scoffed. "That's exactly what every wife wants to hear," she said.

"I figured you didn't care about that after you stabbed me," Clyde said. "Plus, I've seen you on this ship. It didn't take you long to move on from me."

"It wouldn't take me long since you tried to kill me, you alcoholic slob," Genevieve said. "Why do you care, then? Why are you on this ship?"

"At first I wanted to drag you back home, but there came a time when I was willing to let you go. I found peace in my life, knowing that you would have your life, then I would have mine. My friend and I, in Mexico. Then you both betrayed me," he said, shaking his head in disgust. "You doing the help."

"Why do you hate me?" she asked.

"You stabbed me," he said with a growl.

"That's not what I mean. You started drinking, then I lost you. You became so addicted, and we lost everything," she said. "Why wouldn't you talk to me?"

"Talk to you about what?" Clyde asked.

"After I lost the baby, it was obvious you were angry at me, but you just decided to ruin our lives," Genevieve said.

Clyde shook his head. "You don't understand. I wasn't angry with you. I was angry at myself," he said.

Genevieve was stunned. "You...what?" she asked.

"It wasn't lost on me that maybe you wouldn't have lost the baby if we had stayed in the States," he said.

"So you decided the best course of action was to get drunk constantly?" she asked. Before, she may have believed him, but she had grown so much on this trip. She was no longer going to be manipulated by him.

"Either you've started to see through my lies, or even that was too much," he said. "I never wanted the married life. I wanted a life in which no one depended on me. But we've come too far for me to let you willingly leave me."

"Now what?" Genevieve asked.

"You already know all my plans; if you don't come back willingly to me, I guess it's time to kill you," Clyde said.

"You don't have to do that," Genevieve said, trying to think of a solution.

"Tell me one good reason," he said, bemused.

"I, uh...I could learn to love you again," she said, looking for something to incapacitate him. She found something, swallowing her bile when she knew what she had to do. "We could learn to love each other again; we could have another baby."

"Really? You'd come back? That's not love. That's just a reason to keep me from killing you," Clyde said.

Genevieve took a step closer, hoping he didn't see through her ruse. "No, Clyde. I'll be there with you, through the thick and thin," she said. "I haven't been a good wife. I haven't met your needs."

"What exactly are my needs?" he asked.

She pulled his collar toward her, kissing him. He lost himself in the kiss, and she used that to her advantage, reaching for the steak knife behind him. After she made sure he hadn't noticed her reach, she pushed him away from her, causing him to stumble. She used that to her advantage, running from him.

"You wench!" she heard him yell as he got up. She ran faster, not wanting his hands or lips on her ever again. She knew she had played her last card with him. She could never again try to pretend that she would come back to him. One way or another, this was ending tonight. Somehow, she believed it would end with one of their deaths—maybe both of them would die. As she stumbled across the floor, she realized the boat was tipping more dangerously. Victor surely would have started looking for her already; she wondered what he thought had happened to her. All of a sudden, she stopped in her tracks, her eyes widening at what she saw.

"You thought you could..." Clyde said with a sneer before realizing why she had stopped. "What the hell is this?"

"It's water!" she said. "This ship is sinking."

"That's impossible!" Clyde cackled. "It's unsinkable."

"I assure you it's not," Thomas said as he and Victor appeared behind them. "I can assure you, though, a dead man can't appear on a ship."

"We were wrong about him being a crew member; he was hiding in third class all along," Genevieve said. Thomas motioned for her to join them; she gladly went over to Victor's loving arms. He gently grabbed the knife from her; she relaxed.

"He's been harassing me all trip."

"I knew something was wrong when you weren't in your room," Victor said.

"He grabbed me after you left," she said.

"You disgust me," Thomas told Clyde.

"You don't even know me." Clyde sneered.

"I know plenty enough," Thomas said. "Your wife is a good woman. She takes care of others above her well-being. She deserved more. You're nothing but a selfish shell of a man."

"There's just one problem," Clyde said. "I don't care about any of that."

Genevieve shrieked as he punched Thomas in the face. She backed out of the way as Victor tried to help Thomas. A figure rushed past her; while she didn't recognize him, she saw that he was trying to help Victor and Thomas. But if there was one thing she knew about her vile husband, it was that he was a wily one; if he wasn't stopped now, he would come at them tenfold. She looked for something to help them. She grabbed a pan, whacking Clyde in the head as hard as she could at the same time the unknown man punched him squarely in the face. He fell to the side. Thomas came over to him. Victor hugged her close after the close call.

"Did I—did I kill him?" she asked.

Thomas checked Clyde's pulse, shaking his head. "He's only knocked out," he said. Genevieve looked to see who the other man was, to thank him; she was shocked when she saw it was Charles, the baker—so much for him not hurting a fly. Although it was good fortune that he had been here, assisting them all. He looked worse for wear, but it had nothing to do with the fight against Clyde.

"I would escort him to a room so the Master-in-arms could see to him later, but all the rooms are underwater, sir. What would you have me do, sir?" Charles asked Thomas.

"We'll take care of him. You go on," Thomas said gently.

"Thank you, sir. I think I'll throw some chairs in the ocean for people to use," Charles said, bowing before Genevieve. She looked at him as he went topside, wondering what was wrong with him, before turning to Thomas.

"What's going on? There's so much water," she said.

"That's why it was important to find you fast," Thomas said somberly. He then explained how six compartments were flooded, which meant certain disaster. "We could survive if only four were flooded, but six? It's a miracle we haven't sunk by now."

"But the lifeboats," Genevieve said. "What are we going to do?"

"Captain Smith has called out to all the ships in the area; one of them has to help us. Meanwhile, all the women and children are called to the lifeboats," Thomas said. "Precisely why it's important to get you to a lifeboat. There's not many left."

"Women and children...only?" Genevieve asked.

"Aye," Thomas said softly.

"Even if there were some leeway, you know I couldn't be on a lifeboat without some controversy. As Benjamin Guggenheim would want me to say, it is my honor to make sure women and children are put on a lifeboat before I am," Victor said.

She looked at him, shaking her head in horror, as tears filled her eyes. She had finally found the man she loved with her whole heart, but he would be taken away from her.

"I can't—I won't leave you," she whispered.

"Yes, you will," Victor said.

She burst into tears when he said that, knowing that her heart was breaking with each beat. He held her close, kissing the top of her head.

"This is so unfair. You're a good man; you deserve a happier ending," she said.

"As long as you get a chance at a good life, that's all I need, because the last thing I expected in my life was you," Victor whispered. He pulled away from her, putting a necklace with a silver heart pendant around her neck. She looked down at it before looking into his eyes. "You'll always have my heart, no matter what happens next."

"I always will have it, my love," she whispered.

He grabbed her hand, giving it a gentle squeeze. "Let's get you to a lifeboat, then," he said.

They ran up to A deck, where they found pandemonium. Thomas stopped them for one moment.

"I need to help with the evacuation; you need to find a lifeboat. Get yourself safe. But can you do one thing for me?" he asked Genevieve.

"Anything," she said.

He took off his ring, putting it on her necklace. "Give this to my wife, tell her I loved her and Lizzie," he said.

"I will," she said, nearly choking.

"Then go. Find that lifeboat." Thomas gave her one last hug before he hurried away from them. Tears blurred her vision as she saw the last of him before she and Victor hurried away.

"Miss Wilson! You're still here? Follow me; I'll help you find a lifeboat," Colonel Gracie said as they ran into him.

"My Nana—and Margaret?" Genevieve called out.

"I personally put them on a lifeboat. I'm just glad I'm able to make sure you are safe as well; there are not many lifeboats left—and not much time," he said.

All around them, she saw fear, grief, tears like her own. They rushed past the band, who had set up playing, probably trying to soothe people's emotions. It wasn't working. She was horrified when she saw a family of three just sitting there, not even trying to find a lifeboat for their little girl.

"Victor, Colonel Gracie, wait! There's a child!" she said. The men looked behind them, cursing.

"What are you all doing here? Find a lifeboat; at least save your wife and daughter!" Victor yelled to the father.

"We can't. We won't leave without our son," the mother cried out.

"We got separated from our baby boy and his maid. We don't know if they're still on board or not. We've decided to stay on," the father said. "We've come on this ship as a family, we'll die as a family if need be."

"I'm sorry," Colonel Gracie whispered.

"Genevieve, let's go," Victor said.

Separated from their baby, no way of knowing if he had gotten into a lifeboat or not—she couldn't even imagine the pain they must have been feeling. That was why the lifeboat drill had been so important; the panic going on now was not helping anyone. She held tightly onto Victor's hand; she did not want to get separated from him. She saw that Charles was indeed throwing chairs and other upholstered objects in the ocean, which did not bode well for any of them. They looked for a lifeboat, and Genevieve gasped as she found a man she was well acquainted with.

"Look! There's Colonel Astor." He kept jumping in and out of the lifeboat. She wasn't sure why until she saw Madeleine. She looked petrified; he kept trying to calm her down. Genevieve knew what she had to do. "Colonel Astor, it's OK. I'm here now. I'll look after Madeleine."

"There you are, Miss Wilson! I was so worried; your grandmother will be so relieved. She got on a lifeboat earlier," Colonel Astor said after he jumped back on deck. "See, Madeleine, you'll be safe with her for the moment. Another ship is coming for me, so I'll see you in New York."

"It was a pleasure to meet you, Colonel Astor," Genevieve said after he got back on deck.

"None of that, Miss Wilson. I'll see you soon," he said.

"Miss Wilson, I must return to my duties to help bring more women and children into the lifeboats. When you see Geraldine and Margaret, please give them my best," Colonel Gracie said with a nod. He disappeared into the crowd, and she saw that Ben had come up, whispering something into Victor's ear. He turned to her with a sad smile.

"I'm sorry, Miss Wilson. There seem to be things above even my control. It was a great privilege to meet you. It's time to get on a lifeboat to save yourself now," he said. "I'll see you after the lifeboat lowers, Victor."

She turned to Victor with a pained expression. "I don't want to leave you," she said.

He placed a hand over the pendant; she sighed at the feeling. "Remember, you have my heart, always," he said.

She placed her arms around his neck, kissing him as long as she could. She knew the lifeboat would leave with or without her; unfortunately, time was of the essence. She pulled away with tears in her eyes as she caressed his beautiful face one last time. "I love you."

"I love you, always and forever," Victor said.

She kissed him lightly one last time before turning to the lifeboat, Victor holding her hand steadily, giving it a gentle squeeze one last time, helping her as she made the jump from deck to the lifeboat, jumping in across from Madeleine. She turned to her friend. "It's OK. I'm here with you."

"Thank you," Madeleine whispered.

Genevieve looked around the lifeboat, shocked. It wasn't that full. More people could have fit. She looked at Victor as tears fell down her face. He and Colonel Astor were still there, looking at the women they loved with all their hearts. Genevieve looked beyond Victor, raising her hand in a tearful goodbye to Thomas one last time. He raised his hand to her before looking at his pocket watch in regret, walking hauntingly back inside the ship. She saw Captain Smith walk around deck, looking her in the eyes, giving her a nod. He disappeared without a word. Then the lifeboat was lowered into the water.

She looked at Victor the whole time, knowing that he wouldn't be able to escape this sinking ship. If a boat was able to help them soon, he might have a chance, but she had a feeling in her bones that wouldn't be happening. Fate's cruel hand had once again dealt her a blow she felt she couldn't survive. He was the love of her life; she would have to live life without him.

He looked at her with the same kind of sadness as he slowly disappeared from her view. She placed a hand over the pendant he had given her, feeling it against her skin. She felt his love for her in the pendant. She knew she would never love anyone like that ever again. They were lowered into the water, and she could no longer see him. Her heart broke.

Now that they were in total darkness, tears flowed easier; she knew if Madeleine saw them, she would know the men would have no chance at life, which would break her before they could be saved.

"Kitty," she heard Madeleine whisper. Genevieve looked back at the deck, following Madeleine's gaze. That's when she saw her friend's prized Airedale terrier pacing up and down the deck. Madeleine turned to Genevieve. "They'll be OK, won't they?"

"They're being honorable men, allowing us women to get to safety first. I'm sure your husband is right; a boat is coming for us all soon," Genevieve said. The officer in command of the lifeboat looked at her solemnly but didn't say anything. He too knew it was a lie. He turned his attention back to the front so he could start rowing; just then a figure dropped between the two heartbroken ladies. Genevieve couldn't properly identify him as it was very dark, but she could tell it was a man.

The boat mostly consisted of women. Would the officer be so callous as to throw him out? But then something remarkable happened; Madeleine threw her big hat over his head. Genevieve found a coat that had been dropped in the lifeboat, putting it over him. The two women looked at each other, making a silent pact. They would save him since they couldn't save the men they had left behind.

"Row, men! Row like your lives depends on it," the officer yelled as the boat reached the water. Genevieve gasped as she saw how high the boat was lifting out of the water.

"Look! There's another boat," another woman said. Genevieve looked but didn't see anything that would suggest another boat had already come to their rescue.

"Your eyes are just deceiving you," she said.

"At any rate, we have to get out of the way, or the ship will suction us back in," the officer said as the lady started to protest.

"Well, I never," she said, indignant. But that was all that was said on the matter.

Genevieve looked around, seeing the boats that were already in the water. The emptiness in some of them was a punch in the gut. She looked at Madeleine

as a horrifying thought entered her mind. "Do you know if Miss Aubert got on a lifeboat?" she asked.

"I don't know," Madeleine whispered. "I think she got on one before us."

That was a relief; she didn't want to lose any more people than she had to. But she did wish for Margaret and Nana to be on this lifeboat with them. It was hard being strong when all she wanted to do was break. She wondered exactly where they were rowing. There wasn't another ship around; it wasn't like they could row back to England or row forward to New York. But it was already a tense moment; no need to make it any worse. She looked at the ship, watching its sinking progress. The ship—with so many of the passengers still on board— was running out of time.

"What is this?" the officer asked roughly, taking off the unnamed man's hat. "Where did you come from, boy?"

"Leave him alone!" Genevieve said.

"We have rules in place, missy. We can't be taking on deadweight," he said in a growl.

"It's just one boy. We have more than enough room," she said, leaning close to him. "It's not lost on me that we have no idea where we're going, so he could help your men row when their arms get tired."

"Fine. But if he doesn't work for his spot, it'll be overboard for him," the officer said to her. "Keep rowing, men."

Genevieve took her seat across from Madeleine and the boy she had just saved. More lifeboats had gone out into the water; the tail of the ship was getting higher into the air. Genevieve didn't know how much longer there was until the end. Not nearly enough people were in the lifeboats, but she didn't say anything to Madeleine. She had already been through enough. Genevieve's attention went back to the ship when she heard screaming. Madeleine covered her ears, whimpering at the sound.

"My God," the officer whispered.

Genevieve could see why people were screaming; in their haste to get lifeboats in the water, one lifeboat had come dangerously close to crushing another one. They were so close together the people on the bottom lifeboat were beating on the underside of the one above them. It looked as though they were about to

be crushed. After a few tense seconds, the bottom lifeboat was able to get into the water with no harm done. Genevieve's and her boatmates sighed in relief.

"It's all right, Madeleine. Everything is OK," she said. Madeleine looked up at her, nodding.

"OK," she whispered.

"Look! The lights!" The female who had been sure there was another boat shouted. The *Titanic's* electricity had been turned off. It was now eerily dark, but due to the starry night sky, she could still see the ship in the water. Then a horrendous noise made everyone in the lifeboat cover their ears in pain. Some would say it was an explosion, but it sounded different to Genevieve. Whatever it was didn't bode well for the people who were still trapped on board.

"Steady, men. Steady," the officer said.

Everyone in Genevieve's lifeboat seemed to hold their breath, waiting for something to happen. The ship was almost vertical. It was a horrifying sight to behold. It stayed that way for a second or two until it just seemed to sink down. Genevieve watched it until it disappeared from existence, sealing the fate of the one she loved. That was when the screaming started. She closed her eyes as she heard them. The water was so cold, they were going to freeze to death, with no help coming for them. Her Victor and Madeleine's Jack were no doubt still in there, alongside Ben, Thomas, Captain Smith, and in all likelihood, Colonel Gracie. Their screams would never leave her memory or her heart. Tears filled her eyes as she knew the one she loved was dying a cruel, freezing death. She knew that no ships were close enough to save them, much less the people in the water; how much longer until the cold stopped his breath forever?

"Can't we help them? They're dying out there!" Genevieve said to the officer.

"They'll crowd our boat, sink us. We can't go back yet," he said.

Madeleine started crying; Genevieve's heart broke at his judgment. While there was already a slim chance they could save anybody, their chances of saving Colonel Astor and Victor were now moot. She grabbed Madeleine's hand, hoping to give her strength.

"It'll be OK; maybe some of the other boats can get them," Genevieve whispered. There wasn't an answer, and Genevieve couldn't blame her. All they had

to do now was wait for a ship to come help them all. But the screams were being extinguished; she doubted that anyone in the water could be saved.

Everyone in the lifeboat was quiet; even the officer was silent as he gestured his commands. They were soon surrounded by other lifeboats. Sometimes someone called out a name to see if they were in any of the boats. The answer was almost always no. Genevieve called out for Nana and Margaret when she saw a lifeboat. The answer was always no. She hoped they were in another lifeboat that was farther away. But now all the survivors could do was wait.

"If I had known the boat was actually sinking, I would have grabbed more of my things: checks, money, a picture," a woman said before crying.

"I know how you feel," another woman said. "All my husband thought to do was to put some oranges in my coat pocket. Lots of good that's going to do us. Not even enough to share equally among us."

"Did your husband give you anything?" the woman next to Genevieve asked her.

"A heart-shaped pendant. He knew he wasn't getting on a lifeboat unless every woman got on one," she said.

"How tragic! But you have a good one there. My husband just threw me in here and went back inside, complaining of the cold." The woman rolled her eyes. "How's that for love?"

"I'm truly sorry for your loss," Genevieve said.

"I'm sorry for all our losses," she said, looking at Madeleine, who was hugging herself tightly. The conversation in the lifeboat lolled as they all surveyed the water around them, wondering if they would see anyone in the water, whether dead or alive. Another lifeboat approached them; Genevieve could sense a change.

"You, in that lifeboat! Who are you?" a voice rang out. Genevieve remembered that voice from somewhere.

"Quartermaster Perkis, sir," the officer in her lifeboat said.

"Good. I want to transfer some of the survivors evenly between you and two others," the man said. That's when Genevieve placed his voice: it was Officer Lowe, from the bridge.

"You can't be serious!" one of the other officers yelled.

"I can get out there, save more people! I just need to transfer these civilians so my boat doesn't capsize," Officer Lowe said.

No one seemed to move. Genevieve couldn't stand it anymore. "Come on, everyone! They can still be saved," she shouted. "They need help; right now we're the only ones who can provide it."

"She has more courage than you lot of boys," Officer Lowe said. That motivated officers to start to move people into the other lifeboats. Genevieve and Madeleine moved over so people could join them.

"Please, help! I don't want to drop the baby," she heard a woman say.

Genevieve scooted back to the other lifeboat to help. "I'll get the baby for you," she said gently. They both carefully moved together to keep the infant safe. Finally he was nestled in Genevieve's arms, and the woman was able to get into their lifeboat. "I could hold the baby for you, give your arms a rest for a minute."

"Well, all right," the woman said.

"I'm Genevieve. What's your name?" she asked.

"Alice Cleaver, ma'am," the woman said. "The baby you're holding is Trevor. I'm his nursemaid."

"A baby boy," Genevieve whispered, remembering the family that had refused to get on a lifeboat. "Does he have an older sister?"

"Yes, he does, ma'am," Alice said. Genevieve closed her eyes in sadness.

"I'm so sorry; there's a chance they didn't make it. I saw a family on deck before I got into this lifeboat," she said. "I don't think they were willing to get on a lifeboat without knowing Trevor was safe with them."

"We got separated in the confusion. I thought I was doing the right thing trying to save him, ma'am," Alice said.

"You did do the right thing. Unfortunately, other people in power didn't help any of us," Genevieve said bitterly.

"Did you lose anybody, ma'am?" Alice asked her.

She closed her eyes in pain. "The one I love," she whispered.

"What happens next, ma'am? What's going to happen to us all?" Alice asked.

"I don't know." Genevieve looked down at the sleeping babe. There was motion at the front of the lifeboat; she wondered what the plan was.

"We're going back now," Perkis said.

Genevieve perked up at that statement.

"You can't be serious!" a woman said.

"It's been long enough. They won't overcrowd the boat," he answered.

"If the one you loved were out there, wouldn't you want someone to go back for him?" Genevieve asked.

She was met with silence; the lifeboat went back without any more complaints. The water, which had been filled with screams before, was now eerily quiet. Perkis kept shouting out, hoping to hear someone call for help. As the night continued onto the morning, they were able to rescue five men from the water. They continued deeper in the water, and Genevieve was amazed to see an overturned lifeboat that had more than a few handfuls of men balancing on it. She was even more amazed to see someone she knew standing on it. "Colonel Gracie, is that you?"

"Yes, it is! I'm afraid I can't turn my head to look at you, lest I lose my balance. Who are you, child?" he called out.

"Genevieve Wilson, sir," she said.

"Miss Wilson! I'm glad to hear you are well. It's been some time since we last saw one another," he said.

"All right, men. We can't get too many of you, or we'll be overloaded, but I think we can get at least five of you," Perkis said.

"Check the other end, then. I have a good balance here. I think there's a man who needs to be relieved of the water more than I," Colonel Gracie said.

"Good man. More lifeboats are coming, so I suspect you'll find one soon," Perkis said. "Five more of you into my boat, as long as you don't tip over this one."

"Please, sir! I can't feel my legs anymore," a man said. Genevieve could see that a young man was lying atop the lifeboat, his feet pinned in the water by some of the other men. He had to have frostbite, for sure.

"Good God, Bride! Steady, men, steady; let's try to get him in here," Perkis said softly.

With a careful bit of maneuvering of the men on the lifeboat, Bride was finally able to get in. He was shivering so hard he was shaking the boat, but no one said anything about it, knowing that he was in so much pain. Genevieve took off her coat, throwing it over Bride, hoping to give him some level of protection.

They received more men before they rowed away, in hopes that another lifeboat could help the rest of the survivors. The boat was now so full that some people stood up so the men who had been saved could sit comfortably. Genevieve sat carefully on the side, stifling her cries when they took in water. It was freezing. It had been a miracle that they had been able to rescue eight.

The hours passed; the baby was passed around to various people. It was the only thing giving people hope at the moment. Genevieve had almost fallen asleep when someone cried out, "There's a ship!"

"Come about!" Perkis yelled. She couldn't believe it; a ship had finally come to their rescue, not a moment too soon. She looked over at Madeleine, who looked hopeful for a second before turning her downcast face back to the ocean, where the *Titanic* had disappeared. There was no way of knowing if Officer Lowe had been able to save anyone, much less Colonel Astor, Victor, Ben, or Thomas.

Their lifeboat waited in line to reach the rescue ship. Genevieve wasn't sure if Nana and Margaret would already be on the ship. She looked behind her, seeing all the lifeboats, wondering how long it would take to get everybody on the new ship. They eventually got their chance to be at the front; Perkis looked at the people in the lifeboat.

"Look lively, boys," he said. "One at a time now, people. How about you go first, Bride? Get warmed up?"

"No, sir, these women should get warmed up first. It wouldn't be right for any officer to put themselves before passengers," Bride said. The other crew members among them heartily agreed with him. Unfortunately, two of the crew members they had picked up from the ocean had perished, the cold having proved too much for them.

"You're all good men; I'll make sure you get recognized for this," Perkis said with pride. "All right, how about the baby goes up first, then?"

"I'm the baby's nursemaid. Is it OK if I take the baby?" Alice asked. Trevor was placed back in her arms, and they were both hoisted up to safety.

"Who's next?" Perkis asked.

"I think it should be Madeleine," Genevieve said. Madeleine looked at her with tears in her eyes. "It's OK; go get warm."

"OK," she whispered, carefully getting in the rope pulley, soon disappearing from Genevieve's view. A few more passengers climbed up the rope ladder before she went up. It was terrifying at first, but so was what they had all just been through. She felt like she could finally breathe once her hands reached the opening. An officer helped her up the rest of the way, and she was finally on solid wood. She walked out of the way so more people could come up. An attendant with a clipboard approached her.

"Name, ma'am?" he asked.

"Genevieve Wilson. Has another Wilson come on board yet?" she asked.

He consulted his list, before shaking his head. "No, ma'am. I'm sure they'll come on board soon. If you follow me, I can take you to a room to give you some warm food," he said.

"I'd rather stay here, see with my own eyes they're OK," she said; he hesitated. "I won't get in anyone's way, I promise."

"All right. Don't get too cold, though," he said before approaching the passenger who had come up after her.

She leaned in closer to see all the lifeboats lining up so they could be saved. She could barely tell who all the passengers were, but she could see how empty they all were. One lifeboat had barely a dozen passengers. It was an absolute disgrace to behold. She watched all the people come up, looking for Nana or anyone else she knew. She gave a sad smile to Miss Aubart when she came up. Miss Aubart's eyes filled with tears, knowing that they both lost the ones they loved.

She waited patiently for more passengers to arrive before her heart swelled with gratefulness when Nana climbed up into the boat. Nana's eyes filled with tears when she was finally reunited with her granddaughter. Genevieve hugged her tight as tears of her own flowed freely.

"Oh, my love! I was so worried when Victor couldn't find you in your room," Nana said. She pulled away to look at her granddaughter, holding her hands delicately. "Is he...is he here?"

"No, Nana. He was a good man, like Ben and Thomas," Genevieve said.

"I'm so sorry, Genevieve. I know how much you love him. I hope one of the lifeboats finds him," Nana said. They looked back to the opening, finding Margaret climbing aboard.

"Genevieve! There you are. We were so worried," she said as she joined the pair. The attendant came up to her with a clipboard. "Are you the one to whom I make my complaint about how much of an idiot the officer was?"

"What?" Genevieve asked, looking from Nana to Margaret.

"No, ma'am, I—I want to get your name for an official count of survivors," the attendant said, looking nervous.

"Margaret Brown. Our idiot officer could barely row the boat, much less be in charge of it. We didn't even go back for survivors! Can you believe that?" Margaret said. The attendant looked flustered before heading away.

"I can't believe that. We picked up eight crew from the water—well, six in the end," Genevieve said. "We picked up so many the water was coming into the lifeboat."

"Now that's an officer," Margaret said appreciatively, before hesitating. "What about Jack or Victor?"

"They didn't get on a lifeboat," Genevieve said before remembering something important. "Oh, but I saw Colonel Gracie standing atop an overturned lifeboat with about thirty men. He didn't want to upset it by getting in my lifeboat, but he was alive the last time I saw him."

"Colonel Gracie is a survivor if I ever saw one," Nana said.

Now that she knew that Nana and Margaret were safe, she didn't need to stand out there, but that hadn't been her only reason to stand watch. She had to know if Clyde had survived one last time, if he had escaped his watery fate. She would no longer underestimate the slippery eel she had married. Her jaw dropped when she saw that Lady Duff-Gordon was in the boat that contained only a dozen passengers. Genevieve confronted her almost immediately.

"Are you insane?" Genevieve asked Lady Duff-Gordon once she got on board. "There was room for more people in your lifeboat!"

"Fair is fair, Lucy," Margaret said.

"There wasn't anyone near us when they called for more passengers," Lady Duff-Gordon said.

Genevieve narrowed her eyelids. While she could believe the answer since it had been pandemonium when she had gotten on her own lifeboat, that answer was too slick for her. "Am I supposed to believe that?" she asked.

Lady Duff-Gordon laughed a high laugh. "I don't know what you're trying to insinuate!" she said before her demeanor changed into a look of shock. Genevieve looked back to the point at which Lady Duff-Gordon was looking; it was a punch in the gut.

Bruce Ismay got on board; all eyes were on him. Genevieve went up to him, slapping him hard on the check. "There were a lot of good, honest people on the *Titanic* who deserved to be saved but didn't get the chance to be on a lifeboat. Thomas told me how you railroaded every decision of his on this voyage. You should be ashamed of yourself," she said.

To his credit, Bruce didn't say anything; he just silently disappeared. Genevieve turned back to Lady Duff-Gordon, who gave her an approving look before she too disappeared inside. Genevieve went back to Nana and Margaret, sighing in frustration. All Thomas had ever wanted was to make this voyage a success for Bruce, but all Bruce had wanted to do was to save his hide.

"I truly don't know how he's going to spin this once we get back to New York," Nana said.

"Money protects money. The line will help him, no doubt," Margaret said in a hushed tone.

The lifeboats were just about unloaded; that meant that Clyde hadn't survived, but it also meant Colonel Astor and Victor hadn't either. The attendant came over to the trio of women. "Did any of your party come aboard?" he asked.

Genevieve smiled sadly. "Only the women," she responded before they headed inside to give Madeleine the bad news.

She was eating a hot meal; she looked up expectantly at Genevieve. "Was Jack in a lifeboat?" she asked.

"No, he wasn't," Genevieve said gently.

Tears filled Madeleine's eyes, but she nodded dutifully. "I understand," she said. "If you don't mind, I'd like to rest."

"Of course. We'll be there for you if you need anything," Margaret said. The trio walked over to get some food out of Madeleine's way. "This is unreal."

"There's more that's unreal," Genevieve said. Between bites she told the two older women about what had happened with Clyde. "That's why I had to make sure all the lifeboats came in. I couldn't let him trick me one more time."

"I knew something was wrong when you weren't in your room." Nana shook her head grimly. "I'm glad Thomas and Victor were able to help you."

"Charles as well. He came out of nowhere; he whacked Clyde as if all of our lives depended on it—which in my case was utterly true. The last time I saw him, he was on the *Titanic*'s deck, throwing chairs into the ocean so people could find something to hang on to," Genevieve said.

"I can't believe it. I'm sorry that he came after you again," Margaret said. "I'm sorry for everything."

"I'm sorry for both of you as well. You had a lot more friends on board," Genevieve said.

"I should be sorry for you. You lost the most important person in your life. I'm glad you were able to see each other one last time," Nana said gently.

Genevieve placed her hand over the pendant, closing her eyes. She opened her eyes as an attendant rushed up to them, breathless. "A survivor saved from the overturned lifeboat has asked for two of you by name. Mrs. Brown, Miss Wilson, please follow me," he said. Genevieve and Margaret looked at one another before running after him.

"Is it Victor or Colonel Astor?" Genevieve asked.

"No, ma'am," the attendant said.

"Who?" Margaret asked as they went into a smaller, more private room. The man sat on a sofa before a fire, blankets piled on him, holding a drink, no doubt brandy, in his right hand. "Hello?"

"Mrs. Brown, Miss Wilson, thank goodness you're on board!" Colonel Gracie said, facing them. "I conversed with Miss Wilson while still balancing on the overturned lifeboat, but I wanted to make sure the two of you knew I had made it."

"I'm glad to see you're here, keeping warm," Genevieve said.

"I am as well, Miss Wilson. I also wanted to see if all of your party got on as well?" Colonel Gracie asked.

"All the women, thankfully, but we lost some good men," Margaret said.

"As I feared you would. I had hoped some of them would be like me, rescued from the water. I'm sorry for your losses, ladies, truly," Colonel Gracie said with a downcast face.

"Thank you, Colonel Gracie," Genevieve said.

"We'll let you rest some more, Gracie," Margaret said.

"Yes, thank you. Before we dock in New York, perhaps we could speak once again? I would like to get my bearings before we do," he said, taking another sip of brandy.

"Of course, Colonel Gracie. After all, we never got to have that dinner you promised," Genevieve said softly.

"I haven't forgotten about that, Miss Wilson; not at all," Colonel Gracie said, turning back to the fire, trying to forget the horror of being in the freezing Atlantic Ocean for hours.

"I'm glad he survived," Genevieve said after they left him.

"Luckier than a lot of us," Margaret said. They walked back to Nana, who was silently watching Madeleine. "How is she?"

"She's going to have to be strong going forward," Nana said. "Who was asking for you?"

"Colonel Gracie. He finally got on board," Genevieve said.

Nana perked up at that. "I'm certainly glad for that. He's a survivor, that Gracie," she said.

"Speaking of survivors, are you going to send a telegram to your maids that you survived? I need to send one to my son; he'll be worried sick," Margaret said.

"I didn't grab my purse before I left. The talk was that we'd get back on by morning; I was worried about where Genevieve was, so it wasn't high on my list. I hope they'll pay attention to the paper and that word gets out that I survived," Nana said.

"Excuse me, ma'am. I couldn't help but overhear. Please, send your telegram. It's on the house. It's the least we could do," an attendant said. It was a very thoughtful thing for them to do. They followed him to the operating room. Genevieve stopped short when she saw who the operator was.

"Isn't he the man my lifeboat pulled out of the water? Bride, I think it was? Shouldn't he be resting, trying to get warm?" she asked.

"Allow me to answer that question, miss. I'm Captain Arthur Rostron," a man in uniform said, coming up to them.

"Thank you for saving us," she said. "But why is he working?"

"Grief is a fickle mistress, miss," Captain Rostron said, lowering his voice, leaning toward her. "While your lifeboat was able to get him off the capsized lifeboat, his feet were in the water far too long. They were crushed beyond all repair, sat on by one the other survivors. Truth be told, we're not sure he'll keep them. All Harold Bride feels comfortable doing right now is his job. He also lost his partner in the disaster, so he's using this to crush his grief."

"I can understand that," Genevieve said before she followed Nana into the room.

"How can I help you?" Harold asked. He seemed frantic in his work, but she couldn't blame him. This experience was not one she would soon forget.

"I need to send a telegram to New York. Message: 'I'm alive. Will be in New York soon.'" Nana dictated.

"I got it," he said. Genevieve smiled at him before thanking him. She followed Nana as they decided to relook at Madeleine. This was all too much for her, but she had to be strong now. They all had to be.

Chapter Fourteen

\mathcal{B}ack on *Titanic* in the third-class kitchen, Louis had hidden once Thomas and Victor had entered the kitchen. He didn't want Clyde to see him. It would only cause more hysteria in him, which could mean certain death for Genevieve. He almost entered to help when Clyde started beating up the men, but another steward—a cook, perhaps—entered the fray; he and Genevieve knocked Clyde out. Louis was impressed by it all. He stood off to the side, allowing Genevieve and Victor to say an emotional goodbye.

"You've done a good thing telling us where Miss Wilson was. If you go up to the lifeboats, there's a chance one of them will have use for a steward. It's the least—more appropriately, the only thing—I can do to repay you," Thomas said.

Louis was touched, but he knew he had to make sure Clyde was taken care of. "I appreciate that, but how about you give me three minutes? At least make sure this gentleman doesn't wake up to get on a lifeboat," he said.

Thomas hesitated; Louis knew they all didn't have long on this ship. "Three minutes, nothing more. If the water level rises, save yourself. No one else will," Thomas said before attending to Genevieve and Victor.

Louis looked after them as they raced back up in the hopes that Genevieve could find a lifeboat. He sure hoped so; she was a strong woman to finally end a marriage from hell. This was not the way for her to go. But as he turned to Clyde

with a mirthless laugh, he knew this was the end he deserved. Time would only tell if he would share that same fate.

He leaned down in front of Clyde, poking his head with a finger. He hoped Clyde would wake up to be aware of what was happening, but he wouldn't stick around too long. As a gift from God, though, Clyde opened his eyes, groaning at the sight of his former friend.

"What do you want?" he asked.

"I just wanted you to know that Genevieve is on a lifeboat; she will be safe. I might even get off on a lifeboat because of this steward's outfit, so thank you for that," Louis said with a poetic smile.

"I'll get off; I always get off." Clyde sneered.

"Not this time. If you try to follow me, or if I see you alive ever again, I'll kill you. That's a promise," Louis said before standing up, then walking topside.

He found chaos around him. With a chill, he realized that if he hadn't had this steward's outfit, he would have been good as dead. He found people running around, unsure of where to go. He ran into Victor after he turned from the deck; he had tears in his eyes. Victor nodded at him—all the thanks Louis needed. He looked for any lifeboat that was still around to see if he could help.

"You a steward?" he heard a man say to him. He looked to be first class, looked sad.

"Yes, sir. I'm trying to get to a lifeboat," Louis said.

"Can you give my wife a message?" the man asked.

"Er, I don't know your name. My apologies, sir," Louis said.

"It's Benjamin Guggenheim. If anything should happen to me, tell my wife that I've done my best to do my duty; she will be in New York," he said.

"I'll try my best, sir," Louis said.

"You get on that lifeboat; there's not much time left," Benjamin said.

"You were the one who helped save Genevieve?" Victor asked as he came upon them.

"Yes, sir," Louis said.

"Let me make sure you get into a lifeboat. It's the least I can do for all of your help," Victor said. Louis couldn't even imagine the bravery the man was

displaying, making sure his beloved was put on a boat, then making sure Louis got on one.

"You do that, Victor, then come back. And you, remember my message," Ben said.

"I will, sir," Louis said.

"Now, how about some brandy," Ben said as he went back inside.

Louis followed Victor out to find a lifeboat. They were almost all full. Louis feared that Benjamin's message would remain with him for all time. Perhaps he had waited too long with Clyde. He could have been on the same lifeboat as Genevieve, cold but safe. Luck was on his side as there was one more lifeboat.

"Do you have any use for a steward?" Louis called out.

"Yes! Jump in quick. There's not much time," an officer called out.

"I'll look out for Genevieve when we get saved," Louis called to Victor. It wasn't the most dignified way to show one's appreciation, but it was all he could do with the time he had. He also made sure to remember Benjamin's message.

"God bless you, sir!" Victor called out before returning inside to Benjamin.

Louis was handed an oar; he started paddling as soon as they hit the water. His teeth were chattering, but it wasn't because of the cold. The boat was in bad shape; it was even worse than he had thought it would be. He could see that Thomas had been correct; there were still so many people on board, yet all of the lifeboats were out in the water. There were some good people still on there. He was lucky to be one of the survivors. Those left on board would die cold, slow, horrific deaths. He gritted his teeth at the thought.

He only knew of one man who deserved that fate.

The fight had left Clyde after Louis had left. He stood there in the third-class kitchens, looking at the wall in defeat. He finally moved after the water wrapped around his ankles. He cursed, running up the stairs to the main deck. It wasn't a pretty picture. As he looked around, he saw sadness. This wasn't what he had had in mind when he had planned to get on this ship. He strolled around, considering the world outside of his lens for the first time in life.

"We won't be separated from each other, my love," an older gentleman said to his loving wife of many years. They held each other, and they looked the most composed out of the group of people stuck on board.

"We are dressed in our best and are prepared to go down as gentleman," a middle-aged gentleman said to a steward. "But we would like a brandy."

Clyde looked to see the man his wife had fallen in love with; Victor his name was. Victor's eyes flashed with anger as he saw Clyde before he lowered them, the fight taken out of him. Clyde just looked at them as they sat down in two mahogany chairs; this man was ever the gentleman even in this time of crisis. He couldn't understand why Victor didn't just pound him to death. He had to know that if he ever got off this ship...

"No," he whispered. The answer came to him in a flash.

He pushed past the crowd, not caring if he hurt people in his mad escape to the outside. He couldn't believe that the lifeboats were already full. But as he reached the deck, looking down both sides, he saw it was sadly true. No wonder Victor didn't care to incapacitate him; they were both stuck on the boat, with Genevieve safely tucked away in a lifeboat. Clyde breathed out in irritation, knowing that somehow Louis had gotten on one as well.

"I was too late for everything," he said.

"You don't have to be too late for this. Believe in Jesus Christ," a voice said behind him.

"That's a tall order to fill," Clyde said.

"If I had the time, I'd let you know that it's never too late with Jesus," the man said.

"There you go, preacher. You don't have time, so don't waste it," Clyde said, pointing back inside. "There are some better men in there. Why don't you talk to them?"

"I'll pray for you, my son," the man said before hurrying off to tend to someone else's need.

"Don't waste your breath," Clyde said.

A family of three raced out onto the deck; he could see a small child in the mother's arms.

"Where are the lifeboats?" the father asked.

"They're all gone. They left without us," Clyde said.

"We waited too long to find our son; now we'll die," the mother said.

"At least we'll be together," the father said.

Clyde moved on from them, thinking, How stupid I've been. It would have made a world of difference if he had stuck with his original plan of letting Genevieve go. Yes, he would still have been stuck on a sinking ship, but at least he could have died with Louis. Now he was all alone. It was what he deserved for everything he had done. He looked up as a slew of people started running up the stairs from third class. Since Clyde, and Louis, for that matter, had been busy, they had been unaware of the struggle down below to escape the watery hell.

"Horace?" Clyde called. They couldn't understand one another, but it still would be nice to have a friend at the very end.

"He escaped earlier. If you didn't see him up here, maybe he escaped on a lifeboat," a man said, running out onto the deck.

Good old Horace. He still had some fight left in him. Make it two from third class whom Clyde knew that had been saved. But as he sat down next to a pillar inside, hearing the band play on, he knew that same fate would never come for him—any of them, for that matter. He had played all his cards; he had used them on himself. He looked up at a tall, distinguished man with dark hair standing near him.

"I bet when you started this trip, you never thought that you would be standing next to a third class rube," Clyde said.

"No, I can't say that I did. But that's the thing about first class: I always thought I was safe," the man said. "I bet that makes you hate me, doesn't it?"

"First class isn't too bad. I like the music," Clyde said as the band continued playing. All too soon, they would be swallowed up by the ocean.

"Yes, my wife, Madeleine, always said..." Clyde didn't get to hear what Madeleine had said because the boat pitched forward—even more than it had been doing—and knocked them all off balance. The pressure of the water exploded a window, carrying the man out into the ocean. Clyde tried to grab for him, but the suction was too strong.

The screams of the people made him cover his ears until he joined in with them as the water was below freezing. He started shaking, then he decided not to fight it anymore. This was the penance he deserved for putting everybody in his life through hell. He didn't care what happened next. Heaven, hell, or into the black void—he would end it. Right there he would start owning up to his mistakes. As the water fully enveloped him, he opened his mouth, letting it fill his lungs.

And thus ended the life of Clyde Williams, who had just done the first, the only selfless thing in his life.

Louis was shaking as he watched the ship descend into the ocean. He closed his eyes, hearing the screams of those who were in the frigid water. The only consolation they had was that soon, very soon, hypothermia would set in to kill them. But as the screams heightened, he knew that it wouldn't be soon enough for them.

"What happens now, Louis?" a woman said.

"I'm sorry, do I know you?" he asked.

"Yes, it's Sarah, Sarah Roth," she said.

He breathed a sigh of relief, having another third class passenger to survive. "I'm glad you're safe, Sarah. I'm not sure. I hope another ship comes for us soon," Louis said.

"I'm grateful my fiancé wasn't here with me. Who knows what might have happened if he had been? I'm just sorry for all the poor souls who were still left on board," she said before slipping into silence.

Louis agreed with her. The screams had subsided; he doubted that anyone had survived. If they had, they were the luckiest human beings to roam the world. But now those in the lifeboats had nowhere to go. Who knew when help was going to come? They came across more lifeboats, and people shouted out names, no doubt hoping to find their loved ones saved. Louis tried out Genevieve's name, unsure of where she would be right then.

"How do you know my granddaughter?" an older woman said.

He remembered that Genevieve had been sailing with her grandmother. "I made a promise to someone to look out for her. A Victor, I believe his name was?" he said.

"She's not in this lifeboat. Thank you for looking out for her," the old woman said.

They all lapsed into silence. There wasn't much to be said about what happened or what could happen next. What if everyone in the lifeboats eventually died, they too succumbing to the frigid air? Louis tried to make peace with whatever time he had left in this world. This whole experience was a good lesson: they had no idea when they would all take their last breaths. He just wished he could have made more of his life before dying.

That was when they all saw a ship coming for them. Their salvation was finally here. All of the lifeboats got in a line to be lifted up, to finally find some peace from the frigid atmosphere. They were one of the last boats to unload their passengers; Louis made sure Sarah went up safely. Even though he wasn't a true steward, he ensured that all of the passengers unloaded before him. He traveled up; he was surprised when he saw everyone stare at him. The jig was up; he had been discovered.

Except, no, they weren't looking at him; they were looking at the gentleman who had gone up just before him. It had been pitch dark when he had jumped in the lifeboat, so he hadn't known any of the passengers, but he realized that he was the stiff that Genevieve had talked to the day he had knocked on her door. He saw Genevieve on the deck; he was heartened to see her. She walked up to the man, slapping him on the face so hard that even Louis jumped.

"There were a lot of good, honest people on the *Titanic* who deserved to be saved but didn't get the chance to be on a lifeboat. Thomas told me how you railroaded every decision of his on this voyage. You should be ashamed of yourself," she said. He turned from her, walking away. Nobody guessed where he was going, but Louis was happy her anger hadn't turned on him.

Over the next four days, the survivors of the *Titanic* made their way to New York via the *Carpathia*, the only ship which made it to them. There were no longer class distinctions among them; they had all lost someone close to them: friends, family, even animals had been on the ill-fated ship. Louis did what he did best, serving as a facilitator for everyone, especially those who couldn't speak English. He reunited with Horace, his old bunkmate. He only told Horace the bare minimum of what had happened with Clyde. Horace couldn't tell anybody what had happened, but he didn't want to revisit it.

As they finally approached New York, Louis sneaked a peek at the city. He had no idea what his plan was once he got off a free man. It didn't feel suitable to travel to Mexico without Clyde; it was too painful to think about, no matter how things had ended. But what kind of life could he find in America? He kept thinking about it as he exited the *Carpathia*, saying goodbye to Sarah one last time. He had been lucky he was in her lifeboat. If he hadn't gone off with her, who knows what the ship officials would have thought of his being a stowaway?

He supposed all he could do was walk around New York for now. He had no future, here or anywhere else. He walked to the seedier part of the town. Some would have been scared of this part of town, but he felt safe in this place. It was what he had grown up with. He sat down in a little corner, falling asleep without a care in the world. He might not have a future, but he had a place to sleep; tomorrow, he would find a way to feed himself.

This was home for him.

Chapter Fifteen

Life on the *Titanic* had been full of energy, but now that they were on the *Carpathia*, time seemed to slow with their grief. Bruce Ismay had requested a private room; he hadn't been back out since. While slapping him had been cathartic for Genevieve, she had no doubt someone would kill him if they saw him, so hiding was not only his best option; it was his only option.

Genevieve only slept for a few hours every night. The screaming hadn't left her ears. She was there for Madeleine when she had nightmares; she helped with Trevor. But mostly she went out to the deck, watching the water when she had nothing to do. She couldn't believe all these people that had been lost. Their friendship had made her life so much better. She placed a hand over the heart pendant, remembering Victor's anguished face when he put it around her neck. She closed her eyes, knowing that even though he hadn't survived, she would always have his love with her.

She moved away from the railing, closing her eyes in pain. She couldn't wait to get off this ship. There were too many memories on board. She hoped she would feel better once she reached Nana's house; maybe being on land would take away some of the grief. She settled into another place to stew through her thoughts. But she looked down when something bumped off her boot. She looked down to see a ball. She remembered the child from the *Titanic*; she looked for the owner of the ball, hoping to find another survivor of the disaster.

"Hello?" she asked. An older child came up to her; she handed the ball to him, saddened, disappointed that it wasn't the child from before. She had never known the child's name or what class he was from. She walked away, then felt the ball bounce against her boot again. She turned to see the boy smirking at his game. She smiled back, kicking the ball back to him softly.

It was an excellent little game that took her mind off of the grief she had experienced. She had no idea if he had been aboard the *Titanic* or if he had been one of the *Carpathia*'s original passengers, but he seemed to know that she needed a break. "Thank you," she said after his mother called him back in. He smiled before going inside. She walked back to her area, feeling lighter than ever. She saw her party eating and smiled at them.

"Were you outside again?" Nana asked.

"I was. It was a good time," Genevieve said. Nana nodded; she said no more on the matter.

"After we dock in New York, how are you ladies getting home?" Madeleine asked. She hadn't said much since they had been rescued, but now that she was finally eating, she was thinking of a future without her husband.

"I hope that my maids and driver got my telegram. If not, then I hope they are reading the paper, that they will pick Genevieve and me up," Nana said after she pondered the question.

"Won't we be a sight to see?" Genevieve asked.

"At least someone will be glad to see you," Madeleine said. "I telegrammed Jack's son, but I don't think he'll come when we dock."

"Why not?" Genevieve asked, surprised.

"They've never really taken a liking to me," Madeleine answered.

"You didn't know the Astors before the ship, which means you never heard of the drama that unfolded last year after their engagement," Margaret explained. "It wasn't exactly pretty."

"I'm so sorry, Madeleine," Genevieve said.

"We'll help you get home, dear. It's the least we could do," Nana said.

"Thank you both. Your friendship means so much to me during this time," Madeleine said.

Genevieve smiled at that before covering her mouth, rushing to find a chamber pot, emptying her stomach of the food she had just eaten. She felt lightheaded after she finished; she sat on the floor with her eyes closed, trying to regain her equilibrium.

"A napkin for your mouth, miss?" someone behind her asked. She grabbed the napkin to wipe her mouth before smiling her thanks to the person. Her jaw dropped when she realized it was someone she knew.

"Charles? You survived?" she asked, carefully standing up. She hadn't seen the baker since the night of the disaster, so she had naturally assumed he had died in the tragedy as well.

"Yes, miss. I was fortunate, indeed. I'm very sorry about Mr. Andrews, miss. He was a good man. Mr. Giglio as well, for that matter," Charles said.

She looked down, smiling at his kind words. "They were. I'm sorry too. I'm sure you had a lot of friends on board who didn't make it," she said gently. "Thank you for helping that night. You helped save my life."

Charles nodded before heading off. She walked carefully back to her party, all of whom looked concerned.

"Are you all right, dear?" Nana asked.

Genevieve sighed. "I have no idea. I just felt so sick," she said.

"Maybe you should get some rest," Madeleine said gently.

It was true that she still wasn't sleeping properly, but she quite honestly didn't think she would ever sleep well again. Thankfully, Madeleine's nightmares were decreasing in frequency. In that sense, she was getting better. Genevieve just hoped Madeline could get home in one piece. She had been delicate when Genevieve had first met her; she feared that this event would break Madeleine. But she wasn't the one getting sick, so Genevieve acquiesced to her wishes. She felt better after she rested; she hoped it meant she was getting better. But she was more worried about Margaret.

She had been strong so far, but Genevieve knew that strength would only last for so long. When they had a moment alone to themselves, Genevieve came up to Margaret. "How are you? I'm concerned," she said.

"Don't worry about me. I'm fine," Margaret said.

Genevieve knew better than to pry during this emotional time. "Will you be going to your sons' house after the *Carpathia* docks?" she asked to lighten the mood.

"I'll be taking the first train I can. He'll be happy to see me for two reasons now," Margaret explained.

"I'm glad you'll be able to see him, plus your grandson," Genevieve said.

"Me too. I'll never take anything for granted ever again," Margaret said. Genevieve agreed. Life had been taken from so many people in seconds; she very well could have died herself if Victor and Thomas hadn't saved her. "Don't worry, though. Once I make sure my grandson is OK, I'll visit you and Madeleine. You can't get rid of me that easy."

"I'm glad about that," Genevieve said. She sighed. "What do you think people will say about this? It must be one of the most bizarre things to happen in our generation."

"I don't have the foggiest idea. I don't even know if I want to know!" Margaret exclaimed. "But that reminds me: Be careful when talking to reporters after we get off the boat. They'll want to talk to you."

"I'd rather not talk to anyone," Genevieve said.

"Keep that attitude. They can be persistent, but stay clear of them if you can. Give them only the bare minimum when talking about anything, especially about the sinking and how the whole lifeboat situation was handled," Margaret said.

"I don't even know what I would say," Genevieve mused.

"That's good. Reporters will try to get everything they can about you and the *Titanic*," Margaret said. "Only people who want fame will go to the newspapers."

"I wish I could say that surprises me, but I am no longer naïve," Genevieve said.

"Trust me, I know," Margaret said. They turned when they saw the captain come up to them.

"Captain Rostron, how are you doing?" Genevieve asked.

"Very well, Miss Wilson. I just wanted to let you two know that we are pulling into New York late this evening," he said. "Just so you're both aware, reporters will be out in droves."

"Margaret was kind enough to tell me not to interact with them. It's distasteful how they prey on people's emotions in times of grief," Genevieve said.

"I agree, Miss Wilson, but don't worry. We'll make sure to shelter you all," he said. "Passengers will get off one party at a time when someone comes to fetch them."

"Madeleine will be coming with my grandmother and me since she probably won't have anyone for her when we get there," Genevieve said.

"Yes, of course. Whatever you all feel comfortable with. Could you inform your grandmother and Mrs. Astor of our itinerary tonight when you see them?" Captain Rostron asked.

"We will," Genevieve said before she and Margaret moved on with their walk. "Tonight we get off this cursed voyage. Funny, I was dreaming of this moment, but now that it's here, I'm a little scared."

"Don't be scared. We all need to get back to some normalcy in our lives," Margaret said.

"That's the thing, though. I have no idea what normalcy in my life will be once I reach my Nana's house," Genevieve said. "We haven't exactly talked about what's going to happen once we get there—whether I'll stay with her or go back to my parents' house."

"What do you want to do?" Margaret asked.

Genevieve sighed. "Is it too cavalier to say I wish we could go back in time to complete the voyage without sinking? But in all seriousness, I would like to stay with Nana. She understands everything I've been through. Plus, I've always admired and respected her," she said. "But I don't know if Nana would want me to stay with her. She's lived alone for so long, I'm not sure she would want company now."

"She went all the way to Southampton to see you, then did everything in her power to keep you safe. She would do anything for you," Margaret said.

"She is an amazing woman. I'm so relieved we both got off the *Titanic* safely. It was too much being separated from the two of you in the lifeboats, not to mention leaving Victor behind," Genevieve said.

"I'm honestly surprised Madeleine has survived this long. She's always been so delicate; losing Jack will be a huge blow for her," Margaret said.

"She's strong in heart; maybe this whole event will make her a stronger person," Genevieve said. They made it back to Nana and Madeleine to report the news. "Captain Rostron wanted us to inform you both that we'll be docking in New York tonight."

"I'm ready to get off this boat, but I'm not ready for everything that will be happening once we get off." Madeleine grimaced.

"The newspapers?" Genevieve asked.

"That's one aspect. Once I get home, there's preparation for Jack's funeral, then reading his will, which I suspect will be more difficult given how much his son dislikes me. I'm sure there'll be a big fight—again," Madeleine said. "All while I'm preparing to give birth by myself, being the grieving widow in the eyes of the world, and still looking like a responsible member of society by first class standards."

"Nothing easy, then," Genevieve said.

"It's not." Madeleine sighed. "It didn't seem hard when I first married Jack, but now it's more difficult than I could have imagined."

"Marriage is never easy," Genevieve said.

She had overheard the officers talk about more boats coming to the area where the *Titanic* had last been seen to pick up bodies. What would happen if they found Clyde's body? It would not be easy to tell the story of why a dead man was in the water if he hadn't been on the ship. That was a problem she would get to if it ever developed.

"Well, at least then I had the strength of Jack. We could get anything done," Madeleine said.

"You have the strength of us," Margaret said.

"We will be there for you, Madeleine, whenever you need us. It doesn't matter where or when," Genevieve said.

"Thank you both," Madeleine said. "Does this mean you'll stay in New York, Genevieve?"

"Oh…" Genevieve said, looking at Nana. She hadn't wanted to spring this all on her grandmother at the moment. She had wanted to wait a few days before discussing her future, but it was out in the open now.

"Of course you can stay with me, my dear. I'm not sure your parents' house would be the best decision for you anymore," Nana said as they went somewhere more private. Genevieve frowned.

"What do you mean?" she asked.

"Do you remember what your mother said when you first got betrothed to Clyde?" Nana asked. Genevieve truly did remember. "After everything that's happened with Clyde, and now with Victor, I think you need someone who truly understands how much you have grown, how much you have lost."

"I've known for a while that I perhaps rushed into the betrothal because of what she said. Thank you for allowing me to stay with you, Nana," Genevieve said, hugging her grandmother. They walked back to Margaret and Madeleine with a smile. "I'll be staying with my grandmother after all."

"I'm so glad. After we get home, I still want us to be friends," Madeleine said.

Genevieve realized that she hadn't told any of them what Thomas had told her—that there hadn't been enough lifeboats, that there had been a fire down below, that a lifeboat drill had been canceled that last day. She would tell them eventually, but maybe not that minute. Too many ears around; they didn't need to know right then that Bruce Ismay had sabotaged almost every moment of the trip. Plus, when she told the tale, she didn't want to be anywhere near Bruce Ismay. Just thinking about everything he had done made her blood boil.

Genevieve said her goodbyes to all of her friends. She checked on Alice and Trevor one last time before they docked in New York. "What are your plans once you reach New York?"

"Trevor has an uncle who is meeting us once we reach the docks. I don't know if he'll take me on as Trevor's nursemaid," Alice said. "I was just hired before this trip, so I might have to find other employment. Not that I mind. Whatever his uncle feels most comfortable with. Plus..."

"What?" Genevieve asked after a long silence.

"It might bring back too many memories for me," Alice said. "I know it's not Trevor's fault, but every time I change or feed him, I remember I can't give him to his parents because of this horrible ship."

"I'm sorry. It's sad to think he'll never remember them or his sister, not really, but he could remember the horrible nightmare we all went through," Genevieve said.

"That might be why his uncle wouldn't take me on. He probably doesn't want to keep on anything that would remind Trevor of the *Titanic*," Alice said.

"I wish you the best of luck no matter what happens next," Genevieve said.

"Thank you, miss. I hope everything works out for you as well," Alice said.

Genevieve gave them both one last smile before heading to Colonel Gracie. He had seen better days; she hoped that once he reached home, he would feel better—a wish she held for everyone on board.

"Colonel Gracie, how time slips away from us," she whispered as she sat across from him.

"My dear Miss Wilson, how true that is," he said. "I'm sorry that we never got to talk after our rescue. But I think you know more than most how grief eats at us on this ship."

"I do, Colonel Gracie. I hope after you get settled back home that you can visit Nana and me. Dinner is better late than never," Genevieve said.

He smiled fondly. "I would enjoy that. Good luck settling into your new life with Geraldine. Give her my best," he said before turning away thoughtfully.

She left him to his retrospection, moving to rejoin her party before being approached by Miss Aubart. Genevieve hadn't seen much of her and only knew that she was still alive.

"'Ello, Miss Wilson. I just wanted to send my condolences to you about dear Victor. He was a good man; I know that he loved you," Miss Aubart said.

"Thank you, Miss Aubart. Might I also extend my condolences to you about Mr. Guggenheim? He was a good man as well," Genevieve said.

"Merci, Miss Wilson," Miss Aubart said before pausing. "You know, I hear rumors about Benjamin's and Victor's last minutes on the ship. They say that Ben said, 'We are dressed in our best and prepared to go down like gentlemen,' before asking for some brandy."

"That does sound like Ben," Genevieve said before laughing a little. "I only laugh because if I don't, I feel I will cry, that I will never stop. I wish they could

have been saved, but I'm thankful that Ben was with Victor in his last moments. I would hate to think that Victor was alone when he died."

"I know that even if Ben had been able to get on a lifeboat, he wouldn't have left Victor behind for anything in the world. Victor meant a lot to him. Au revoir, Miss Wilson," Miss Aubart said.

Genevieve walked back to her party thoughtfully, thinking of the exchange. The two women, while coming from different lives, now shared a common bond in this tragedy.

"Everything all right?" Nana asked.

"I was saying goodbye to Alice, baby Trevor, and Colonel Gracie; Miss Aubart wanted to extend her condolences," Genevieve said.

Madeleine sighed. "That poor child. I hope everything works out for him," she said.

"I think it will—at least, I hope it will," Genevieve said before turning to Nana. "Colonel Gracie wanted to give you his best. I invited him to come to dinner after he's settled back in at home."

"Good. I worry about him after being on that collapsed lifeboat for so long," Nana said, but their worries now were focused on docking in New York.

There was an air of nervousness about the passengers—this held true for both sets. The *Carpathia* passengers would be getting off first; the plan was to let them escape the mayhem that would befall the survivors. Genevieve kept close to her party. She did not want to be accidentally separated once they were able to get off the ship.

Finally, the *Carpathia* reached the docks, and its passengers were able to unload. Genevieve saw the boy from before who had played ball with her. She gave him a wave; he smiled goofily at her before leaving with his family. She hadn't seen the child from the *Titanic*. He hadn't made it; she now knew of two children who hadn't made it. It broke her heart to think of the pain they had gone through. After the *Carpathia* passengers departed, Captain Rostron came up to the rest of them to explain what was to happen. "We'll call out names, one by one, as receiving parties arrive," he said. "Miss Dorothy Gibson, you and anyone in your party are ready to go."

A pretty young woman came up to the front, looking petrified. She held on to the hand of an older lady—no doubt her mother—and they walked outside to the media frenzy. Madeleine later told her Miss Gibson was a silent movie star, very prominent in first class society. Genevieve was shocked; she hadn't seen a movie in years. She wondered if Miss Gibson would get back to acting. She looked like she'd instead go home and never go back out.

More people were called out; Genevieve gave one last sad smile to Miss Aubart as she was leaving. She had a feeling that she would never see Miss Aubart ever again. As was the case with her and Madeleine, some people wanted to help each other through the pain but would find it too painful to remember the men they loved. They were gentlemen to the very end; that was all she could ask for. It still didn't make the grief any better, though. They had deserved more.

The ladies all looked up when Margaret's name was called. "Good luck," Genevieve said.

"I'll see you all soon. Stay strong, ladies," Margaret said before leaving. It was now only the three of them, the lone trio. It was a sad thought.

"Mrs. Wilson?" Captain Rostron called out.

Genevieve followed Nana and Madeleine out of the room, down the gang-plank to whoever had come for them. Genevieve looked back at all of the survivors, seeing their grief one last time, before looking forward to her future. She turned her head discreetly so the media wouldn't get a clear look at her face for all the pictures they were taking. She saw two men come up to them; Madeleine stopped short when she saw who it was.

"Vincent?" she asked, sounding surprised. It was quite dark, so Genevieve couldn't see him properly, but it seemed to be Colonel Astor's son, judging by Madeleine's reaction.

"I know we've had our differences, but I hope we can overlook them right now, given what has happened," Vincent said.

"I would like that very much," Madeleine said, sounding touched. She turned to Genevieve and Nana. "This is Vincent Astor, Jack's son. Vincent, this is Geraldine and Genevieve Wilson. They were good friends on the *Titanic*."

"I'm dreadfully sorry for your loss, Mrs. Wilson, Miss Wilson," he said.

"I should be the one giving you the condolences. Your father was an amazing man. He was one of the men who made sure I was in a lifeboat, so I owe my life to him," Genevieve said.

"I thank you for your kind words, Miss Wilson. I trust you both have a way home?" Vincent asked.

"Yes, we do. I'm glad Madeleine has a way home too. I give you all the best for the future," Nana said.

"If you need anything, please let me know. I hope I see you soon," Genevieve said to her friend. Madeleine squeezed her hand.

"I shall see you soon. I know I didn't say it after we were rescued, but I am sorry about Victor. He was a good man; I know you loved him dearly," Madeleine said.

Genevieve smiled sadly. "Thank you," she said before seeing her friend off.

"I suppose you and I are ready to finally head home," Nana said softly. "Here's my butler, Jimmy; he is also my driver. Time to go home, my dear."

"I can't wait," Genevieve said before screaming as hordes of press came up to her, taking thousands of pictures.

"Hey! Get out of here," a strong, authoritative voice yelled out. All the cameras retreated, but Genevieve was left shaken by the experience. "I'm sorry about that, miss. These cameramen are vultures."

"Thank you for helping us," Nana said, putting a protective arm around Genevieve.

The man pulled out a card, giving it to her. "No problem. If you need any more help, just call me," he said before moving away from them.

She had no idea who he was, but she was grateful he had been able to get her away from all of those cameras. She hoped he found whom he was looking for.

Thankfully they were able to get into Nana's automobile and drive to her house without accident. She followed Nana into her home, where two maids ran to them frantically. "Mrs. Wilson! We were so worried about you. We are so glad you are all right," the older one said.

"It was an experience one does not wish to go through again." Nana shivered before turning toward Genevieve with a smile. "While this is not how I wanted to present her to you all, this is my granddaughter, Genevieve; she will be staying with me from now on."

"Welcome, miss," the younger maid said excitedly.

"These are my maids, Olivia and Allison. And this is my cook, Leroy. Only the best for my household," Nana said. The way they looked at her with reverence was proof that they were treated well, that they adored her. "As you can all imagine, all of our luggage drowned in the sinking, so tomorrow we will need to get my granddaughter some new clothing. But for now it would be nice to get washed before going to sleep."

"Yes, of course, ma'am. We'll get a bath set for you. Since you don't have any nightgowns, Miss Wilson, I'll be happy to give you one for tonight," Allison, the younger maid, said.

"Thank you. It's Genevieve, though. I'm not used to this kind of treatment," she said. Allison blushed; Genevieve realized that maybe maids shouldn't be on a first-name basis with the people in their care.

"Well, follow me. I will take you to your new bedroom," Allison said.

Genevieve hadn't seen much of the outside as it was, but it was very charming inside. White walls, wicker furniture, a staircase that wasn't as grand as the *Titanic*'s but was good competition; there was a homey feel to it. She was going to love it here. She knew it. Her bedroom was just as good as the rest of the house: a spacious bed, a velvet chair, a nice window that no doubt would give her a good view of the land. Allison left for a minute before returning with a nightgown for her, helping her undress for the night. She reached for the pendant from Genevieve's neck; Genevieve stopped her.

"Don't, please. I want to be careful with this," she whispered.

Allison gave her a subtle smile. "All right. Have a good night's rest, Genevieve," she whispered before leaving.

Genevieve smiled at the interaction before carefully placing the heart pendant and Thomas's ring on the bedside table, looking at them with tears in her eyes before she fell asleep for the night. She dreamed of Victor's arms around

her, feeling comforted when he kissed her forehead. She finally felt peace after the terror of the last few days.

⌒

She jumped when she awoke; where were all the passengers, her friends? She closed her eyes, sighing when she realized she was no longer on a ship but rather safe in Nana's home. She looked at the door when it was knocked on, then saw Allison come in with a basin of water so she could wash her face.

"Good morning, Allison," Genevieve said, looking in the mirror, realizing how tired she looked. This trip must have taken more out of her than she had thought.

"Good morning, Genevieve. How did you sleep last night?" Allison asked, making the bed as she talked.

"I slept all night, which is an improvement. I almost forgot I was here when I awoke, though," Genevieve said.

"I can't even imagine what you went through. I'm very sorry, but the only dress appropriate for you right now is your dress from yesterday. I only have my maid's outfit, plus a few for church, of course, but none that would befit a lady of first class." Allison looked embarrassed at that.

"It's quite fine, Allison. It was a good dress, if not a bit overused at this point. I hope we can go into town later today," Genevieve said.

"Of course, Genevieve. Jimmy is getting the car ready as we speak. I'm to get you dressed for breakfast so you can go out," Allison said, helping her with everything before Genevieve walked downstairs to the dining room, eating some choice foods. She had gotten sick a few times after her first incident, but she hoped now, being on dry land, her stomach would cooperate with her. She looked up when Nana entered the room, smiling.

"Good morning, Nana. How did you sleep?" she asked.

"Much better than on the *Carpathia*. Hopefully we'll be able to heal now that we aren't surrounded by everything that happened," Nana said thoughtfully before smiling. "How about you, dear?"

"I slept the whole night," Genevieve said truthfully.

"Wonderful! After you're finished with breakfast, I'll take you to town to get you proper clothing," Nana said.

She finished up with breakfast, then followed her Nana out to the car. Now that it was light outside, she could see it was a beautiful, spacious property. She smiled, knowing that they were going to be all right. They drove into town, but before they could get far, Nana stopped Genevieve. "Take care of what you say about the disaster. The old man was a co-owner of this store."

"That poor man!" Genevieve murmured.

While she had never been formally introduced to him, she knew of Isidor Straus, the co-owner of Macy's stores, and his wife because of her many conversations with Colonel Gracie. She also knew that the pair wouldn't be separated when the lifeboats were going down, so they both stayed on board. She often wondered if she should have stayed with Victor, but she knew that he would have wanted her to leave the ship.

"Head held high; let's do this," Nana said.

Genevieve followed her grandmother's lead, agreeing with many of her grandmother's choices since she knew best. They were walking out of the store toward the car when she saw a newspaper title that made her blood boil.

"All of the *Titanic*'s passengers killed in the disaster?" she read out loud in anger.

"Not to worry, miss. That was disproved last night," a man said behind her.

"Why would they publish that article, then?" she asked, appraising her new companion. He was tall, mid-thirties, with a long trench coat. He looked well-to-do, with a handsome face and polished brown hair.

"The newspapers loves to jerk people's emotions. Just the other day, there was an article saying that everybody survived. Which is the crueler article?" the man asked.

"The latter," Genevieve said bitterly. "And how do you know all of this, Mr...."

"Harry Buchannan, miss." He introduced himself. "It's my job to know everything about everyone."

"Because you are a reporter," Genevieve said.

Harry put a hand over his heart in mock sarcasm. "I must be losing my touch. Most women don't glean that so easily," he said.

"Perhaps I'm smarter than the average woman you accost on the street," she said.

"I assure you, you're much smarter than the average person," he said, flashing her a charming smile. "Do you have any thoughts on the *Titanic* that you'd like to share?"

"No, I'm not talking to reporters," she said.

"Why not?" he asked.

She laughed. "Would you like a list?" she said.

He gave her a pitiful look; she rolled her eyes. "Fine. My thoughts are that the sinking was a tragedy, that the newspapers needs to butt out."

"I admit, I stepped into that one. But I'm not like other reporters," Harry said.

"I'm sure you all say that." She rolled her eyes.

"I'll give you an example; if it doesn't convince you, I'll leave you alone," Harry said. She looked back toward the car and saw that Jimmy was still putting purchases in the back. She nodded in agreement, waiting for Harry's argument. "My newspaper was begging me to get the scoop on the Astors. Either their obituary or how they survived the disaster. The truth didn't matter to them. I declined. I want the truth of things, facts."

"I bet that makes you a celebrity among your peers," she said.

"Decidedly not. But who are witnesses going to trust more: men who tried to make money off of their demise or me?" Harry asked.

"I won't dignify that with an answer," she said.

"But did it make you trust me?" he asked.

She considered the question as she walked to the car to take them home. "Genevieve Wilson," she said. Harry looked at her surprised before smiling. "And if you misquote me on anything, I will throw you into the Atlantic Ocean."

"As I said before, truth only," Harry said, holding his hands up in surrender. He helped her into the car before closing the door and waving them away.

It wasn't until she was home and she found the card her unknown savior had given to her last night that she realized she had met Harry Buchannan before.

She walked downstairs for tea, wondering what his plan was. Did he not remember her from last night? Just a lucky coincidence that he had been there? She didn't know if she trusted him, but that didn't matter anymore. She sat with Nana while they had tea.

"For the time being, would you like privacy, ma'am?" Olivia asked.

"Yes, I would. No visitors for the time being; I would like it kept under wraps that we were involved with the *Titanic*," Nana said.

"Of course, ma'am," Olivia said.

While they sipped their tea in silence, she wondered how Madeleine was getting on. At least when Genevieve was preoccupied with something, it kept her mind off of everything. It was only when she stopped moving that everything came crashing down on her. She had a new routine at Nana's, and she had found happiness in her way.

About two weeks after the disaster, Genevieve was walking down the stairs to the tearoom when Allison came running up to her, breathless.

"Allison, what's the matter?" she asked.

"I know Mrs. Wilson said not to admit anyone, but I think you'll want to see who's inside," Allison said.

Genevieve frowned as she went to investigate. She gasped when she saw the side profile of the man who was in the tearoom.

"Jack?" she asked. Was it possible? Had he found some way to survive? He turned to her; she closed her eyes in disappointment. "I'm sorry, Vincent. I just thought..."

"That I was my father? I wish you were right, Miss Wilson," he said. "I hope you don't mind me coming here; I wanted to talk to you about what happened on the *Titanic*."

"I can't blame you for wanting answers, but I don't know what I can offer. Another teacup, Olivia," Genevieve said as she saw the older maid come in. Olivia nodded, putting it across from Genevieve's seat. "And you remember my grandmother?"

"I'm afraid I only met her that night, but it's an honor to meet you, ma'am," Vincent said when Nana came into the room.

"My condolences, Vincent. What brings you here?" Nana asked him.

"Madeleine is distraught, of course. She couldn't tell me much, but she did mention that you were friends with Thomas Andrews, Miss Wilson," Vincent said. "Did he say anything to you?"

"Could we get some privacy, Olivia?" Genevieve asked after Olivia had poured the tea. Olivia bowed before leaving the room. "Margaret Brown didn't want me to talk to the newspapers about anything, but you deserve to know why your father died."

"I won't tell a soul," he said.

"Madeleine couldn't tell you anything because I kept this a secret from her. I promised Mr. Andrews I wouldn't say anything. Plus, Madeleine had already been delicate while on the *Titanic*; I didn't want to destroy her any more than she already had been," Genevieve said, remembering everything Thomas had told her. "We all thought the *Titanic* was unsinkable because Bruce Ismay wanted us to think it was unsinkable."

"What do you mean?" Vincent asked. Genevieve told both him and Nana everything: the fire down below, the lifeboat numbers cut down, the canceled lifeboat drill that led to everyone's demise, finally how Ismay had railroaded all of Thomas's plans. Anger flashed in Vincent's eyes. "That murderous snake! He had the gall to cut the number of lifeboats in half, then he gets on one when the going gets tough."

"Sadly it's true. There was a group of good men like your father who stayed on board," Genevieve said. "It was his duty to own his mistake, but instead, he made this harder for all of the survivors and families of the victims."

"I'm so sorry you felt you had to keep that a secret, dear. No wonder he hid away on the *Carpathia*," Nana said.

"I have half a mind to knock on his door and punch him in the face," Vincent said.

"I may have already slapped him when he got on board the *Carpathia*," Genevieve said. Vincent looked surprised before laughing. "What?" she asked.

"Miss Wilson, I can see why my father became friends with you!" he said.

"Perhaps. I always thought he liked me because he could impress me," Genevieve said. Vincent smiled gently. "That does sound more like the old man," he said. "Thank you both for your time and the information. It'll never be easy, even knowing what happened, but it helps to know a little."

"That's very true," Nana said.

"If you need anything else, please let me know," Genevieve said.

"The reason why I'm asking all this is that there's going to be an inquisition about the *Titanic*; they want me to talk," Vincent said.

"Talk about a disaster you weren't even present for? Preposterous." Genevieve scoffed.

"Well, they don't want any women to speak; even if it were allowed, Madeleine wouldn't be able to," Vincent said.

"Ah, yes, of course. Women don't understand anything," Genevieve said bitterly.

"I think that was the overall tone. Plus, they want to protect the White Star Line. Money only protects money." He sighed. "If only they would invite women like you and Margaret Brown to talk, then they would get things done."

"Margaret is a fierce woman. I think that's the one thing I learned from her," Genevieve said.

"She's a good woman. I'll be at the inquisition next week. My father's funeral is in three weeks. I'll send you the information. You both should come," Vincent said.

"I'm sure it's a private affair; we don't want to impose on you or your family," Genevieve said.

"My father was the highest of society. I can promise you, it won't be private. As one of my father's friends on the *Titanic*, you wouldn't be imposing. If anything, come for Madeleine. She needs a friend like you there," he said.

"Then we accept your invitation," Nana said.

They didn't see Vincent Astor again until the following week. They were at the table for tea when Olivia admitted him. He looked livid.

"Vincent, what's the matter?" Genevieve asked.

"I apologize for barging in on you both," Vincent said, his temper cooling immediately. "I've just come back from the inquisition. While they'll make sure it is safer in the future for ships, they aren't assigning any real responsibility here."

"Bruce Ismay is getting off scot-free?" Genevieve guessed.

"Worse. They're trying to get a pasty to take the blame. Probably Captain Smith or Thomas Andrews," Vincent said grimly.

"They can't do that!" Genevieve said.

"Unfortunately, they can. Remember what I told you before: money protects money," Vincent said. "Unless you have a dependable journalist you trust, it's how the newspapers will broadcast it to the world."

"I do know a trusted journalist," Genevieve said, running up to her room to get Harry's card. She reappeared, giving it to Vincent.

"Harry Buchannan? I like his recent stories about the *Titanic*. Very comprehensive, thoughtful. This could work. How did you get his number?" Vincent asked.

"A swarm of photographers tried to get my picture after I left the *Carpathia*. He chased them off before he gave me his card. The next day I saw him; I don't think he recognized me from that experience," she said. "Now I guess my secret will be out."

"Fancy that! But you don't have to reveal your secret, Miss Wilson. If you prefer, I'll make contact with him, make sure he learns everything, that he is going to write it in an unbiased way," Vincent said.

"This is more important than us or keeping a secret identity. I want to be a part of this, Vincent," she said. "Thomas saved my life; the least I can do is save his reputation from vile men."

"Shall we call him up now, see if he can help us?" he asked.

"Sounds like there's no time like the present," Genevieve said, taking the card, dialing up the number.

"Harry Buchannan. Who is this?" He answered the phone.

"Mr. Buchannan, this is Genevieve Wilson, from right outside Macy's the day after the *Carpathia* docked," she said.

"Ah, the girl who got away," he said in a mock-romantic tone.

"This isn't a social call, Mr. Buchannan," she said as she rolled her eyes.

"You have a juicy news story for me?" he asked.

"I do, but I make the rules. If I don't like what you've written, you can't publish it," she said.

"Done. Where should I meet you?" he asked. She gave him Nana's address; he promised to be there soon.

"He'll be here shortly," Genevieve said, turning to Vincent and Nana.

"I'll tell Leroy to prepare more food for dinner, then," Nana said.

"Thank you for all this," Genevieve said. "I don't want to put you on the spot."

"This is important to you. You are never putting me on the spot if it's important," Nana said.

"Thank you," Genevieve said, then they all waited for Harry to show up. She fixed her hair, made sure her dress was presentable. This was her first actual interview with a reporter. She hoped she could trust Harry, that he wouldn't double-cross her for his gain. Somewhere deep in her gut, though, she knew she could trust him. Whether it was naivete or earned knowledge, she wasn't sure. But they would soon find out.

Olivia admitted him when he arrived; he swept into the room with a bow. "Miss Wilson, an honor to see you again."

He didn't see Vincent or Nana, so she cleared her throat to get his attention. "Might I introduce Vincent Astor and my grandmother?" she asked.

He looked up with an embarrassed grin. "Here I thought it was an exclusive you had promised," he said.

"I didn't promise you anything," she said.

"If you're here to punch me for anything I've published about your father, Colonel Astor, might I request my stomach? My face is too beautiful to be blemished by a broken nose," he said.

"With an ego to match," Genevieve said. Harry winked at her but said nothing.

"No one is going to be punched," Vincent said. "We do have a story for you."

"My kind of business. What kind of story?" Harry asked.

"Perhaps we should sit down for dinner. It's quite a story," Nana said.

"If it's as good as you all make it out to be, I think I'll hardly eat," Harry said, but he followed them to the dining room anyway. "So what is this story?"

"I was on the *Titanic*," Genevieve began.

Harry closed his eyes. "You were the girl that was mobbed by cameras that night. I'm sorry," he said.

"I wasn't going to talk to any reporters, ever, but some things have come up; we can't fix it without you," she said.

"I promise you, I will listen to you all with the utmost attention," Harry said.

Genevieve told her tale once again; Vincent told him everything about the inquisition. True to his word, Harry didn't eat much dinner; he was too entranced by her tale. After she was finished with her account, he was silent, digesting what she had told him.

"No one is going to take this seriously?" he finally asked.

"No. That's why we needed you," Genevieve said.

Harry nodded thoughtfully, finally eating some food. It was no doubt cold, but he didn't say anything. Perhaps he was only eating to seem polite.

"I can help you all. I assume you don't want to be named in the article?" he asked.

"If possible. But it is imperative to reveal it to the world," Genevieve said.

"I just want to make sure my father, along with everyone else involved, gets proper justice," Vincent said.

Harry looked at Nana, who smiled. "I'm just here to moderate this meeting," she said.

"I'll get this all typed up. You can expect me to publish it within the week," Harry said. Genevieve smiled. "Thank you," she said.

"Yes, thank you, Mr. Buchannan. And thank you for hosting tonight, Mrs. Wilson. Have a good evening, everyone," Vincent said before leaving.

"I'm sorry I couldn't enjoy the dinner more," Harry said. "Maybe if the article works out for all of us, we can do it again."

"If you don't double-cross my granddaughter, we'll talk about it," Nana said.

"I wouldn't dream of it." Harry smiled at Genevieve.

"Let me walk you out, Mr. Buchannan," Genevieve said, leading him out of the house. "I have to admit, at first, I didn't think you were one of the good guys. I was afraid you were playing with me. I can see now that I was wrong. I apologize."

"You can make it up to me by having dinner with me," he said.

She frowned. "I thought you were coming over for dinner again?" she asked.

"Oh, I am, but I mean just the two of us," Harry said. "You know, intimate, all that."

"Does that line work with all the girls?" She rolled her eyes.

"I don't want it to work with other girls," he said as they made their way out onto the porch.

"You barely know me." She scoffed.

"True, but most women throw any information at me that I ask for. You barely blinked when I asked for your opinion. You call me one of the good ones, but you are one of the good ones," Harry said. Genevieve looked away; he sighed. "I seem to have ruined this somehow. I'm sorry if I made you uncomfortable."

"It's not your fault, but I lost someone significant in the sinking. We loved each other so much, even though we didn't know each other that long," Genevieve said, placing a hand over her pendant.

"I'm so sorry. Pretend I didn't say anything. Most women do," Harry joked before leaving.

Genevieve sat in one of the wicker porch chairs, looking up at the night sky, remembering Victor, remembering his love, his touch, his kisses, those last few moments. It was a love that had been cut short, but it was a love that she would never forget.

Genevieve looked in the mirror, petrified, as Allison helped her put the black gown on for Colonel Astor's funeral. She had never been to a high-profile funeral before; while Vincent had been a gentleman while here in this house, she was sure the situation would be different in front of the world. But she knew

that she had to be there for Madeleine. She needed to know that at least one friend was there while the world was scrutinizing her every move.

"You must be frightened. I can't imagine going to the funeral of one of the *Titanic* victims. Please be careful while there, Genevieve. The people might flock to you for answers; they might not like those answers—no matter how truthful they are," Allison said after securing the gown, then brushed Genevieve's brunette hair into a slick bun.

"Don't worry; I'll be careful. If they want any answers, I'll point them to Harry Buchannan's article," Genevieve said.

Allison raised an eyebrow. "I wonder how he was able to get all that first-hand knowledge of the disaster. Whoever gave them that information knew what they were doing," she said with conspiracy in her voice.

Genevieve laughed, knowing that even Colonel Astor would have appreciated that. "I'm glad the crews could find his body. Not everyone was so lucky," she said.

Thomas, Ben, and even her Victor had not been found. She had held out hope and planned to be the one who claimed Victor's body, but it never happened. Thankfully, though, Clyde's body had never been recovered either. She had remembered those last few moments in Victor's arms, when Thomas had told her the terrible truth that would befall all of them. The water cascading into the room, no doubt picking up Clyde's unconscious body, taking him down deeper to the bottom of the boat before he died, the water filling his lungs. It had been outrageous, thinking that he would be saved by a lifeboat. Although he had been a monster to her, she still hoped that he had stayed unconscious the whole time. It would have been too cruel a fate otherwise.

"I'm sorry, miss, that they never found your beau. He sounded like a good man," Alison said softly.

Genevieve smiled sadly at her in the mirror. "He was. I wish you could have met him properly. I wish—oh, I wish for a lot of things," she said, picking up her purse, feeling she was finally ready to face the ceremony.

"I wish you the best, Genevieve," Allison said before Genevieve walked downstairs to Nana so Jimmy could drive them to the Church of the Messiah.

"Ready?" Nana asked her. Genevieve sighed shakily.

"Ready," she said. Nana nodded before they headed out to the car.

Genevieve kept her hand clasped in her lap as she clutched her purse. Multitudes of people would be there; she felt the recognizable fear of feeling alone. She knew that Nana would be there with her, but she realized how much Victor's companionship had helped her feel confident with people. It was true that having the right partner in life helped raise you up, not tear you down.

But her thoughts dissipated once they reached the church. She breathed out only once before grabbing Jimmy's hand as he helped escort the two of them out of the car. They walked up to the church; they were among the many sending their condolences to Vincent, Madeleine, and an older woman and a young girl who were no doubt Jack's ex-wife and daughter. Madeleine saw Genevieve, giving her a subtle smile before continuing her polite conversation with another woman. Genevieve saw that Vincent had excused himself from the slew of people and decided to approach him. He kept his head down; it was no doubt a hard day for him and his family.

"Might I extend my condolences again?" she asked.

"Yes, of course. How did you know him?" he asked, still keeping his head down.

"The *Titanic*," she said, causing him to lift his head; he smiled at his standoffishness.

"I apologize, Miss Wilson. It's been a trying day, to say the least," he said.

"I completely understand. It must be so hard to bury someone you thought would come back in one piece. I was there with him; it still seems surreal," she said. "But you do remind me of someone that I once knew. He was always so tense on *Titanic*. I always had to remind him to unwind, or he'd go crazy. Since it is a funeral, though, I think you have a reason to be tense."

"All that, plus more. I'm sure I don't have to tell you the ordeal we all went through when he married Madeleine?" he asked. Genevieve shook her head, thankful that Margaret had helped her understand what happened. "We never reconnected after that. Was I a bit too harsh? Maybe, maybe not. But if I had known what the future held, maybe I would have tried to reconcile sooner."

"That does sound hard," Genevieve said, wiping a tear from her eye.

Vincent smiled, though, holding up a finger. "There's someone I'd like you to meet," he said, talking to the older woman who had been beside him. "Mother, this is Genevieve Wilson."

"How do you do, ma'am?" Genevieve asked. "I'm sorry for your loss."

"She was on the *Titanic* with Father. She was the one who helped Harry Buchannan with the article," Vincent said, making sure no one heard them.

His mother perked up immediately after hearing that. "Well, well, well. That would also make you the one who slapped Bruce Ismay," she said.

Genevieve blushed at that. "I wasn't aware I was becoming somewhat of a celebrity." Genevieve joked.

"That's the thing about Jack. He was always making people more than what they thought they were," the older woman said, smiling fondly at the memory, no matter what she had thought of the marriage between Jack and Madeleine. "I'm Ava Lowle Willing. Walk with me a bit. I'll see you up front when the time comes, Vincent."

"Of course, Mother. Thank you so much for coming, Genevieve," he said before turning back to the guests. Ava linked arms with Genevieve, and they walked to a quiet area where they could talk.

"Tell me, how did you and Jack meet?" Ava asked.

"He's good friends with my grandmother, Geraldine Wilson," Genevieve explained as she pointed out her Nana, who was talking gently with Madeleine. "But he did approach me to see if I could be a friend to Madeleine. I know your family had trouble with their marriage, but it was the best thing he ever did. For Madeleine and me."

"Perhaps none of us supported Jack in this endeavor of marriage, but today is a day on which we can put aside all of our differences. Tomorrow is a different day," Ava said with an upturned eyebrow.

Genevieve chuckled lightly. "I know what you mean. Not everyone can turn aside from their differences after a tragedy," she said.

She had only had one conversation with her parents, letting them know she was back stateside with Nana, Clyde dead. She had decided to keep how he had died a secret.

"You're coming home, aren't you? I have so many prospects for you; you'll be married before the end of the year!" her mother had exclaimed. Genevieve had scoffed, remembering that scheming voice.

"No, Mother," she had said. Silence had followed; she had imagined the fit that was sure to follow.

"No?" her mother had asked, indignant.

"No," Genevieve had repeated. "While on the ship to America, I met someone who loved me, who helped me become confident. He loved me, while Clyde only wanted to possess me. This other man wanted me to help other women understand they can marry for love. He and Nana helped me realize that your influence led me to marry an alcoholic slob. Never again. My home is with Nana; my heart belongs to him as long as I live."

"If you choose this way of life, Genevieve, I will never speak to you or your grandmother again," her mother had said in an icy tone.

"For the first time in a long while, we are agreed on this situation. Goodbye, Mother," she had said cheerily before hanging up.

She and Nana had had a hearty meal that night as she had regaled her grandmother with the conversation. Nana had felt cheered by how well she had handled herself.

"I'm so proud of you, Genevieve. You have proven that you have grown stronger in these past five years. I wish it hadn't involved all these hard lessons, but I'm glad you are here with me now. You will always have a warm home here, where your decisions are your own," she had said.

"Thank you so much, Nana," Genevieve had said.

She turned her mind to the present conversation, knowing that the past was in the past. No use going back, or it would tear her heart apart.

"Thanks to you, the reporters have a juicy story. Perhaps this one time they can butt out of this funeral," Ava said.

Genevieve looked behind her, smiling at the sight of a newly arrived guest. "I hope you don't mind one reporter," she said.

Ava looked behind her as well, laughing. "If it isn't Harry Buchannan? We were just talking about you," she said. "I'm glad to know the newspapers only sends their best."

"I think my superiors knew you weren't going to accept any other member today, so they gave me the go-ahead. Miss Wilson." Harry tipped his hat to her.

"I'm glad to know there's another friendly face here. If it had not been for Vincent, I might not have come. I hardly know anyone here; crowds don't quite excite me as much after the *Carpathia*." Genevieve shivered.

"No doubt it didn't help when all the cameramen bombarded you after you docked," Harry said apologetically.

"As I said before, sometimes reporters needs to butt out!" Ava said before turning to Genevieve. "Thank you for everything you've done. I think it's helped Vincent to be proactive, to feel like he's done something for his father's memory."

"I'm glad I could be there in any way you needed," Genevieve said.

"I must rejoin my family, but thank you both for being here," Ava said.

Genevieve smiled at Harry, accepting the proffered arm. "I suppose you'll have to sit in a special section during the ceremony?" she asked him.

"Any other scoundrel maybe, but I think I got in good with the family," Harry joked.

Genevieve chuckled lightly. "I haven't laughed this much at a funeral before," she said. "But Jack would have appreciated that."

They rejoined Nana, who was delighted that Harry was there after all. They all settled into the pew, Genevieve seeing numerous survivors from the *Titanic*, many of whom she had never been formally introduced to. She looked to her right when someone sat down next to Nana; she was heartened to see Colonel Gracie. He gave them both courteous nods before Madeleine, Vincent, Ava, and the young girl sat down in the front row. Hushed silence followed before the minister approached the front, starting the ceremony.

There wasn't a dry eye in the church. Colonel Gracie was a tough man, but she saw him dab at his eyes from time to time. Genevieve understood completely. She had only formally known him for less than a week, but she felt the pain they were all feeling. For someone to die at such a young age, so cruelly, was something they had never imagined. They had all felt safe on that "unsinkable wonder." The true wonder, she realized, was the fact they had thought nothing would ever happen to them. Stupid fools, the lot of us, she reflected bitterly

as the ceremony was ending. Soon John Jacob Astor IV would be put into the ground, with all his hopes.

After they all stood up, Harry offered her a hankie, which she accepted. "Dreadful, completely dreadful," she whispered.

"I can't even begin to imagine," Harry said as they made their way out of the chapel.

"One of the last things Ben Guggenheim said to me was 'Some things are beyond even my control.' Perhaps he truly knew the extent of what was going to happen to us all," Genevieve said.

"Sounds like he had a good brain on the matter at hand," Harry said.

"That he did, young man. That he did," Colonel Gracie said as he and Nana trailed after them.

Genevieve turned to him with a smile. "I'm so glad to see you, even under the circumstances," she said.

"I'm glad to see you as well. I know we had a promise for dinner, but I wanted to let everything settle down, wait until after the funeral." He looked back to the chapel with a sigh. "He was a good man, Jack. Amazing how fate can just take us out like that."

"I'm truly sorry. He was a good man," she said. "You have a standing invitation for dinner, whenever you are ready."

"I do have a project on my mind, but I think the two of you can help," Colonel Gracie said with a twinkle in his eyes.

Genevieve turned to Nana in shock. "We can help?" she asked him.

He put a finger in front of his lips. "It's a secret, my dear Miss Wilson! Although, I would like to know who your source is on all things *Titanic*, Mr. Buchannan. They would be helpful," he said.

Genevieve turned to Harry, who only had a smile on his face. "I'm sorry, Colonel Gracie. I made a promise to my sources; they wanted to help but not reveal their names," he said.

"You can't blame me for trying! I will see you two girls in the future. I survived the sinking, but I still get winded after trying times," Colonel Gracie said, kissing the back of Nana's hand, smiling at Genevieve.

Harry whistled after he left. "I think it's a miracle that you trusted me with your big news story. Any other reporter would have just told him," he said.

"I wonder how we can help him, though," Nana said curiously before smiling. "I wonder if you might be able to share a meal with us after that trying funeral?"

"You can't turn me away from Leroy's fabulous cooking! I might need a photo or two, but then I'm all yours," Harry said.

Genevieve was pleased he had stayed friends with them. She had been afraid at one point or another he would turn bitter at her refusal of him romantically, but he came over often enough that she could tell that he wasn't there to change her mind—a welcome relief after the conversation with her mother. She looked up expectantly when Vincent approached them.

"I'm sorry, but might I borrow Miss Wilson for a moment? It won't take long, I promise you," he said.

"I'll stick with Harry. You go on, Genevieve," Nana said.

Genevieve nodded before she followed Vincent back into the church, going into a coatroom. "You two won't have much time, but I figure this could be the last good thing I do for her. Goodbye now, Miss Wilson," he whispered before leaving.

Genevieve stepped further into the coatroom before she saw Madeleine; the two girls hugged each other tightly.

"It's been ages," Madeleine whispered.

"I didn't want to disturb you while you were mourning!" Genevieve said.

Madeleine pulled away to look at her with a sad smile. "That was sound. It's been a hard few weeks. But now I hope we can see each other more often. You're the only one who knows what it's like," she said. "Once they found Jack's body, I stopped looking at the newspapers. Did they find Victor's body?"

"No, they didn't," Genevieve whispered.

Madeleine sighed sadly. "I'm so sorry, sorry for it all," she said.

Genevieve hadn't yet told her about the abuses of her last marriage, so there was more to be sorry for. But she let today be all about Jack so as not to worry her friend about a past that would never haunt her again. "I should let you get about your day. It was very trying for us all," she said.

"I will see you soon, I promise!" Madeleine said. "I still have loads to teach you about this life—even if it was all a waste."

"I won't have Victor—I won't deny that—but I will need your help. I'll still be here with Nana; any chance I can see my friend, I will take that," Genevieve said.

Madeleine softened at that. "I'll call upon you soon. I don't you want to presume that my friendship was only because of the ship or Jack," she said.

Genevieve smiled. "Good luck," she said before the two separated.

Genevieve looked for Nana and Harry. She found them murmuring under a tree, brightening when they saw her approach.

"All right, Genevieve?" Harry asked.

Genevieve nodded. "I was just giving my regards to Madeleine," she said, walking in step with them to Nana's automobile so they could travel home.

"That poor dear. I hope she can find strength before the baby comes," Nana said softly.

"I think she will. She's gotten much stronger since getting off the *Titanic*," Genevieve said as they piled into the automobile.

Her thoughts drifted as Jimmy drove them home. They had all grown stronger since their return. She couldn't account for Margaret since she was still attending to her grandson, but she was sure nothing would knock her wayward friend. Still, it was good to know that this tragedy hadn't destroyed them mentally. Genevieve's nightmares about that night had gone away. She still had dreams about Victor, about their time together, but her only complaint about those dreams was waking up. They were never long enough.

Her mind returned to the present when they reached home; she thanked Jimmy for opening the door. They walked inside the house. It was as if the grief of the ceremony was over. They had paid their respects to Jack; Genevieve felt relief. She knew that the bodies of the other men in their lives wouldn't be found, so she had said her respects to them in her heart.

"I wish I had known Jack. He seemed like a good man," Harry said respectfully.

Genevieve smiled. "He was. Even in the short time I knew him, he always seemed the perfect gentleman," she said.

"Let's sit down for a good meal. I can tell you a tale or two about John Jacob Astor. I assure you, my dear, he was a good man," Nana said.

They dug into their dinner, with Nana regaling the two with tales about Jack. Genevieve and Harry listened with rapt attention, smiling at one another at some of the funnier points in the story.

"Geraldine, you spin quite the tale!" Harry said.

"It's all true! Anyone who knew Jack would tell you that," she said.

"What about you, Genevieve? Do you believe any of this tale?" He grinned.

"I—excuse me!" she said before finding a chamber pot to empty her stomach. She put a hand on her stomach, closing her eyes. Why was she still getting sick? She was off the *Carpathia*; she was healing from the whole experience. She should have been fine. She opened her eyes before smiling at the thought that entered her mind. She couldn't tell anyone until she was entirely sure, but for the first time in a long time, she was happy.

She reentered the dining room, where Harry and Nana looked concerned. "Are you all right?" Harry asked.

"Yes, it was a trying day," she said.

His eyes softened; she could see that he had bought the lie. "Perhaps I should leave, let the two of you rest. I'll be back soon," he said.

"Have a good night," Nana said to him before turning to Genevieve. "How about you get upstairs, get some sleep? I don't want you to get sick."

"I will, Nana. I'm sorry about Jack. I know you were friends long before the *Titanic*," she said, hugging her Nana close.

"I was, but you were my granddaughter before the *Titanic* and will be long after," Nana said.

Genevieve smiled, walking upstairs, deep in thought about what the future held for her. If she was correct about why she was sick, it would change her life forever, in the best way possible. A reminder of Victor would be with her forever. She was sitting on the bed, smiling at the thought, looking over at the door when Allison knocked before walking in.

"I heard you were sick! I knew that going to the funeral would be taxing on you," she said.

Genevieve smiled at her. "I'm not that kind of sick, Allison," she said.

Allison looked puzzled before smiling in delight. "Does anybody else know?" she asked.

Genevieve shook her head. "Not yet. I want to be sure before I tell anyone," she said.

"Your secret is safe with me. Shall I leave you alone for a minute before I help you out of the dress?" Allison asked.

"Yes, please," Genevieve said.

Allison smiled, backing out of the room. Genevieve lay on her back, smiling at the good fortune that had befallen her after a horrible tragedy. She placed a hand on her pendant before placing a hand on her stomach, knowing that if Madeleine could weather this storm alone, so could she. She was a strong woman; she would continue letting her strength win against the fears that the past had held for her. She could no longer do anything about the past, but she could ensure her future was safe and protected.

Chapter Sixteen

It had been four months since Genevieve, Madeleine, and Margaret had all been together last. Genevieve and Madeleine had seen each other plenty. Still, she had made sure not to tell Madeleine anything that could destroy her emotionally until Margaret came back, until after Madeleine had given birth. And she had given birth recently, to a little boy named John Jacob Astor V, or Jakey for short. He was a beautiful baby; she knew that he would get his looks from both his parents.

"I'm sorry I couldn't be there for Jack's funeral," Margaret said as they sat at Madeleine's tea table. "It sounded like it was a lovely ceremony."

"It was a lovely ceremony, thanks in large part to Harry Buchannan's exposé. It made people even more outraged," Madeleine said.

"I wonder who gave him all those details," Margaret said, looking suspiciously at Genevieve. She raised an innocent eyebrow at the older woman.

"Colonel Gracie wanted to know the same thing. But Harry Buchannan was a perfect gentleman and didn't reveal the source. It sounds like he's a good reporter," she said.

Margaret smiled at her reasoning. "It does sound like that," she said.

"I wonder if you would say the same about the reporter who dubbed you the 'Unsinkable Molly Brown.'" Genevieve smirked.

"I don't mind since it is true. But many other people besides me helped. Shouldn't they be getting recognition?" Margaret asked.

"Was anybody else helping in a way that mattered? Most people were either scared or selfish..." Genevieve began.

"While other people were smacking Bruce Ismay," Madeleine interrupted with a smirk. Jakey gave a little laugh that caused the women to chuckle at his excellent timing.

"If there is anybody that deserves credit that night, it is you, Margaret," Genevieve said.

"If it helped the inquiry committee decide to make voyages safer, I will take it. But I think more individuals deserve credit: Colonel Gracie, Ben, Victor," Margaret said.

"I won't argue with you on that point. They all helped to get so many women and children on the lifeboats. Even if they thought they would die in the process," Genevieve said.

"I wonder if they knew about the trouble the *Titanic* was in long before we set sail," Madeleine said thoughtfully.

"I don't believe so. Colonel Gracie asked Harry Buchannan for his source after Jack's funeral. That doesn't sound like something a man who had all the answers to begin with would do," Genevieve said.

"That's true," Madeleine said, taking a sip of tea.

Genevieve looked at her friend, deciding she should tell her everything that had happened to her while on board. "There's something I have wanted to tell you for a long time, but I didn't know how to say it," she said.

"Whatever could it be?" Madeleine asked. Genevieve looked at Margaret, who nodded in support. Genevieve unloaded everything about her marriage and what had happened with Clyde on the *Titanic*. Madeleine looked petrified throughout the tale. "Oh, my dear Genevieve. I'm so sorry. I'm so sorry you felt like you had to hide this from me."

"That may have been on me," Margaret said. "I didn't think it wise to divulge her secret while on a ship. It might have been too much for you; while I'm sure you would have accepted her tale, what if you hadn't? It would have been too-cramped quarters then."

"I don't want either of you to think I'm too delicate to not hear about what is going on in your lives. I want to hear about it all: the good, the bad. You are my friends, through the thick, the thin," Madeleine said strongly.

Genevieve bit her lip, fighting a grin. "I'm glad to hear that. Do you remember when I got sick on the *Carpathia*?" she asked. Madeleine nodded. "I wasn't seasick."

"Then why—oh!" Madeleine exclaimed before crushing her in a hug. "I knew it! I knew something was happening."

"I didn't know until the day of Jack's funeral. I'm not scared, not exactly, but I'm glad that I had Victor, if only for a short time," Genevieve said.

Madeleine pulled away with a sad smile. "Another reason I wish we all had made it to New York," she said.

"Me too. But I'm glad I'm having his baby. I loved him so much; now I have one more thing to remember him by." She took off her necklace, placing Thomas's ring on the table to show them both.

"What is that?" Madeleine asked, intrigued by it.

"It's Thomas's ring. He made me promise him I would get it back to his wife." Genevieve said. "I was hoping they would find his body, but they never did. I feel like I must get this to his wife."

"So you're going back?" Margaret asked.

Genevieve sighed. "I suspect so. I hardly think it's to send it via mail. I wouldn't want it to get lost or stolen, either," she said.

"When will you go?" Madeleine asked.

"I suspect soon. The baby was a surprise; we're getting everything set up, but I'd like to give it to her before I give birth. I know that having Victor's pendant helps in my grief, so I hope I'm giving Mrs. Andrews help by giving her his ring," Genevieve said.

Madeleine clasped her hand in support. "I'm here if you need anything," she said.

Genevieve smiled. "You were one of my first friends after everything that happened to me. Maybe our children can be friends," she said.

Madeleine smiled fondly at Jakey. "I sincerely hope so," she said.

They finished their tea before Genevieve traveled home, promising Margaret to see her before she went home to Denver. When she got home, she saw that Nana and Harry were deep in conversation.

"Good afternoon, Mr. Buchannan. Nothing the matter, I hope," she said.

"Nothing at all, Miss Wilson. Your grandmother is a great conversationalist," he said.

"That's what I'm good at." Nana smiled. "How was tea, darling?"

"It was good to see my friends again. It's different now, though. We're connected by a horrible event we'd all like to forget," Genevieve said.

"I'm sure all the newspapers isn't helping," Harry said apologetically.

"Well, the regular reporters were leaving us alone, but then Miss Gibson had to make that movie." Genevieve shivered, referring to the silent film about the *Titanic* called *Saved from the Titanic*. "I suppose I get the appeal of a film about the disaster, but to have a survivor be the main character? I hardly know how she could do it."

"I've found actresses to be a weird lot," Harry said.

"You'll find people will try to capitalize on the disaster, on what happened. Hopefully, Miss Gibson will be truthful in her medium," Nana said.

"My paper has called on me to review the movie, but don't worry, I won't invite either of you to the premiere," Harry said.

"I would have declined if you had asked me," Genevieve said.

"It's not something I would like for either of us to be around," Nana said. Genevieve and Nana shared a look before Nana shook her head in approval.

"Harry, would you like to go for a walk?" Genevieve asked.

"I'd love to, Miss Wilson," he said, proffering his arm to her. She accepted; they walked outside around the large property before she found a bench so they could talk.

"You've been very kind, Harry, but I think it's time I tell you what happened on the *Titanic*, why we can't be together," she said, not sure where she should start.

She decided to start with her marriage to Clyde, their baby, his drinking—his eventual abuse. How she had made it onto the *Titanic*, not knowing he had followed her. How he had tricked her throughout the voyage. She told him

about her friendships on board, about how Victor Giglio saved her more times than she could count. Finally, how he had her heart for all time. She finished her tale there, not wanting to let him know anything else until she knew what he thought at that point.

"Genevieve, I'm so sorry you went through all that," he whispered.

"You don't want to run away from here?" she asked, surprised.

"No. I understand that you'll always love Victor. Now I truly understand why. I admit, I was attracted to you when we first met, but I see now that you don't need love. You need friendship," Harry said.

She smiled at his support. "Good. Because there's something else I haven't told you," Genevieve said.

He frowned. "What else?" he asked.

"I'm having Victor's baby," she said.

"I give you my congratulations. How do you feel about all of this?" he asked.

"It was a surprise, but I'm so happy. If I didn't have to go back across the ocean," she said.

"You're going back?" he asked.

She sighed, showing him the ring. "I made a promise to an old friend before he died," she said.

Understanding showed on his face. "What do you need?" he asked.

"I need an address for Thomas Andrews and a ticket for a ship," she said.

"I understand. I'll get the address for you, then the tickets for us," he said.

"You're coming with me?" she asked, surprised.

"Of course. I'm not letting you get on a ship alone, especially not pregnant. I'll be your escort," he said.

"You don't have to do that," she said softly.

"I feel that I must. I'm sure you know how important it is to feel safe, given your experience on the *Titanic*. I'm sure you'll feel better if you have a familiar face on board. It is my honor," he said.

Her face softened at what he said. Victor would have liked him. "Thank you for your kindness, Harry," she said. "Who knows? Maybe it will be a good thing to get away, let the excitement from the movie simmer down."

"Yes. I fear what the newspapers will do to get their juicy stories from the survivors," Harry said, growing serious.

They went back inside, telling Nana of their plans. Nana understood why Genevieve had to go, of course, but it didn't make Nana any less nervous.

"I feel like I just got you back," Nana said, grasping Genevieve's hands before turning to Harry. "Make sure they get back to me in one piece."

"I will, ma'am. Don't worry; we won't leave just yet. I'd give it at least two weeks, depending on how soon I can get Mrs. Andrew's address," Harry said, putting his coat and hat on.

"Thank you for everything, Harry," Genevieve said.

"I'll let you know the minute I know anything," Harry said before taking his leave.

Harry returned two weeks later, after Miss Gibson's film was released.

"How was the film?" Genevieve asked.

He sat down next to her on the couch with a sigh. "It was a difficult movie to watch, especially after everything you've told me," he said. "Even talking with Miss Gibson after watching it, I felt this deep sadness about her. I don't know if she'll be an actress for much longer. She seemed more petrified than I've ever seen her."

"It was a lovely article," she said.

He finally cracked a smile, holding up a letter. "I finally got an address and tickets for a voyage," Harry said.

"Wonderful! When do we leave?" she asked.

"Tomorrow," Harry said, looking at her regretfully.

A spasm of panic ripped through her. She placed a hand on her stomach for comfort. She had thought she would have more time to prepare herself, prepare her friends for what she would do. Harry noticed her nervousness; he tried to reassure her. "I'll get tickets for another time. It's too soon. I should have realized."

"No. I need to do this. That poor family needs some sort of closure; plus, I should do it well before I give birth. I suppose I have packing to do now," Genevieve said. She knew that if she didn't get on that ship tomorrow, she never would.

She told Nana about the trip; Nana whipped up the maids to get Genevieve's things together, asked Leroy to cook for dinner that night, made sure Jimmy had the car ready for tomorrow.

"I'm sorry this is all last-minute," Genevieve said.

"Don't worry. I'm just glad I can be there for you," Nana said. "Now, I hope you can stay for dinner, Harry. Leroy makes a grand meal."

"I'd love to stay, Mrs. Wilson," Harry said. Genevieve excused herself from the room to call her friends. She rang Madeleine first.

"Astor residence. How may I help you?" a maid answered.

"Miss Wilson for Mrs. Astor," Genevieve said.

"I'm sorry, Miss Wilson. Mrs. Astor is out of state; I'm not sure when she'll be back. May I take a message?" the maid asked.

"No. Have a good evening," Genevieve said, disappointed. She grabbed a piece of paper, writing out a letter detailing what was happening. She went up to Olivia, then handed her the letter. "If Mrs. Astor should come by when I'm gone, could you give this to her?"

"Of course, Miss Wilson," Olivia said.

Genevieve went back to the phone, calling Margaret this time. Thankfully she was at home. She would have felt like she was betraying her friends if at least one of them hadn't known of her plans.

"Genevieve! How are you?" Margaret asked after picking up the phone.

"I'm heading out tomorrow on the *Lusitania*," Genevieve said.

"So soon?" Margaret asked.

"If I don't do this now, I know I never will," Genevieve said.

"I understand. Be safe," Margaret said gently.

"Harry is going to escort me; don't worry," Genevieve said.

"That's not what I mean," Margaret said.

She could hear in Margaret's voice how much the disaster had taken out of her. "I'll be OK; we both will be. I'll try to see you and Madeleine after we get back," Genevieve said. "I'll let you know I've made it back safely in any case."

"Have a good evening," Margaret said.

Genevieve gave her the same sentiment, then headed back into the dining room, where a magnificent dinner was waiting. The three of them sat down at the table, discussing what would happen on the voyage.

"I hope the other passengers have discretion." Genevieve sighed.

"I'll make sure no one brings up the sinking; if they do, I'll make sure they leave you alone," Harry said.

"Just promise me you'll bring my granddaughter back safe," Nana said.

Genevieve smiled sadly, grabbing her grandmother's hand in support.

"I will, Mrs. Wilson," Harry said.

After dinner they said good night to one another, and Harry promised that he would be back early so they could get to the docks. Genevieve turned into bed, still feeling uneasy about the whole affair. She let sleep take away the anxiety about tomorrow. Her dreams were peaceful. She was less sure about the dreams that would occur while on the *Lusitania*, but she could not worry about the future just yet. She still had one last night in this house.

When she awoke in the morning, she didn't waste any time. She devoured breakfast, then put on a blue dress, going back into her first class world. She went downstairs to greet Harry and saw their suitcases being loaded into the car.

"Good morning, Harry," she said.

"Good morning, Genevieve. Did you sleep well?" he asked.

She pondered the question as all too soon, she would be back on a ship. "I did. I'm not exactly sure how the next few nights will go," she said.

"As long as you are safe, it should go well for the two of you. I hope you find peace by giving Thomas's ring back to his wife." Nana embraced her as they said their goodbyes. She didn't want Nana to get caught up by reporters. Before Harry and Genevieve could leave, though, Madeleine came barreling into the house, breathless.

"When I got home, my maid told me you had called last night. I just knew it had to be because you were leaving," she said, pulling Genevieve into a hug.

"I'm glad you came." Genevieve breathed out. They pulled away; Genevieve saw tears in Madeleine's eyes.

"I can only imagine how scared you must be," Madeleine said. "Just be careful. Don't forget everything Margaret and I have taught you about first class."

"Don't worry; I remember. Harry will be my escort, so you don't need to worry about me being alone," Genevieve said.

Madeleine beamed at Harry. "That is one worry lifted off my mind. You both stay safe; let me know when you get back. I'll want to know everything, be there for you when your baby comes," she said, embracing Genevieve.

"I will," Genevieve said before Madeleine left. She hugged Nana one last time.

<p style="text-align:center">◡⟩</p>

She had made sure to wear a big floppy hat so as not to attract attention to herself. Thankfully, no one paid her much attention, except for the captain, once they arrived at the docks.

"Fancy seeing you on my boat again, Miss Wilson," he said.

"Captain Rostron, I had no idea you were going to captain the *Lusitania*," Genevieve said, surprised.

"I presume you're here under the radar?" he asked.

She nodded. "I don't want to make any scenes," she said.

"Good. And you are?" Captain Rostron asked Harry.

"Her escort," he said, not letting on that he was a reporter.

Captain Rostron nodded. "Good. Keep her safe. I'll get you there in one piece," he said gruffly before heading to his duties.

Genevieve was shown to her room, adjacent to Harry's. She looked around, feeling the absence of warmth from the decorator. She supposed she would never feel secure about another ship. Not after the friendship she had had with Thomas.

She joined Harry outside her room as the voyage began. "Is your room anything like the one you had on the *Titanic*?" he asked.

She shook her head. "Nothing like it," she said. The whole voyage was nothing like it.

She didn't find friendship as she had before. No one else here was important in her life, except Harry; there was no one to make her feel special like Victor had, and most importantly, no other women felt quite as extraordinary as Madeleine or Margaret. But she was here on important business, not leisure. She was worried about what she should say to Mrs. Andrews.

"Just tell her the truth. She'll appreciate it," Harry said when she asked him what to say.

"Won't she be suspicious about why her husband gave me his ring?" Genevieve asked.

Harry shrugged. "I find people don't usually ask questions when dealing with trauma. If she does ask, just tell her he agreed to escort you while on board; he made sure you got on a lifeboat, and he was worried he wouldn't make it, so he gave you the ring for safekeeping," he advised.

"Thank you, Harry. I'm glad you're here. I couldn't have done this without you," Genevieve said.

"You're traveling back across the ocean to get a grieving widow her dead husband's ring. You can do anything," Harry said gently.

She thanked him for his sentiment before getting everything repacked in her suitcase. They were almost to Belfast. She was heartened to see that it had felt longer to get to their destination this time. She remembered how Jack had said their voyage on the *Titanic* had swiftly passed by. Perhaps it should have been a clue of their demise.

They got off the boat, then traveled to an inn. They decided they would approach Mrs. Andrews tomorrow. Better to give them some rest to refresh their minds.

Belfast was an impressive city; she could see why Thomas had lived here. They went to dinner, going to bed early. Genevieve hadn't slept well on the trip, unsurprisingly. After they had returned to New York, she had thought she would never get on a boat again. She had been so tense the whole way; she had only snatched a few good hours every night. The dreams—nightmares—hadn't helped, either. She had known that being back on a ship would be rough, but

she hadn't realized it would be unbearable. She could tell that Harry was concerned about her state but didn't pry, thankfully.

After a whole night's rest, then some breakfast, the pair went to the Andrews home. They had already agreed that Genevieve should go up to the house alone. She walked up to the door and looked back to Harry for support. He nodded, and she turned back to the door and knocked. Mrs. Andrews opened the door, frowning.

"No reporters," she said.

"I'm not a reporter. I was a passenger on the *Titanic*," Genevieve said.

Mrs. Andrews opened the door a little more, looking at her in shock.

"What are you doing here, child?" she asked.

Genevieve took her necklace off, placing Thomas's ring in Mrs. Andrews's hands. Mrs. Andrew looked at the ring before kissing it, holding it to her chest.

"Come in," she said to Genevieve. Genevieve followed her inside and was seated at a table, where she was served tea. Mrs. Andrews sighed; Genevieve could see that Thomas's death had been hard on her. "How did you get my husband's ring?"

"I was on the *Titanic*, all by myself; he was kind to me, took notice of me when I was in trouble. Thomas was one of the brave men who made sure I survived that voyage in more than one way. He and a few other select men all made sure as many women and children were placed in a lifeboat as possible," Genevieve said. "He put the ring on my necklace before he made sure other women and children could get on. I knew I had to get it to you. I owe my life to your husband."

"Thank you," Mrs. Andrews whispered. "I will treasure this forever."

"I think that's what Thomas wanted. Somehow he knew he wasn't coming back," Genevieve said. "He loved you and your daughter. He spoke of you both with so much love."

"I won't lie; I wish he hadn't been on the *Titanic*. But I'm glad he helped you. Of course he would have wanted his last act to be helping people in need," Mrs. Andrews said.

"I'm sorry he's gone. He was a good man," Genevieve said before heading back out to Harry. He looked at her with concern.

"How are you feeling?" he asked.

"Complete," she said. "I did what Thomas wanted me to do. Now I can move on."

"Let me guess. After we get back to New York, you're never getting back on a boat again?" he asked.

"That would be correct," Genevieve said.

"Soon we head back. Your grandmother will be happy, and Madeleine will be relieved," he said as they headed back to their inn.

Genevieve smiled as she realized that she had people in her life who cared for her. It had been so long since she had had that, and she didn't want to lose it. She placed a hand on her stomach, knowing that her child would also feel that. No matter the child's gender, she would teach them how to be respectful of others, how to find the correct people in their life to take care of them; she would let them know about the good man who was their father. He would always be there with her, no matter what happened.

When they reboarded the *Lusitania*, she felt lighter than she had all trip. She had fulfilled all of her promises to the people she had cared about; now was the time for healing of her mind, body, soul. She came onto the deck, sighing, seeing the sights one last time.

"A charming city," Harry commented.

"Ireland was one of the last places we docked. The *Titanic* dropped off letters, received them. It didn't seem necessary to see who was going to be on the voyage. Many of Nana's friends were already aboard, so I don't think any of us came to see the land one last time. I wonder, if we had known what was going to happen, would we have acted the same way?" Genevieve said.

Harry grabbed her hand in support.

"I wonder about a lot of things when it comes to that voyage, Miss Wilson," a voice behind them said. She turned to see Captain Rostron looking out at the town.

"No need to wonder, though, I suppose. We can't change the past," she said.

Captain Rostron smiled, looking down at the deck. "You're completely right. We can always look to the future to make sure we don't repeat the past, though. What if we had been closer that night? What if, what if. A good lesson, though," he said.

She frowned. "What is?" she asked.

"I do believe the lesson is not to be too complacent, Miss Wilson, to not to let the chairman of the shipping line take control of the reins. Don't quote me on that, though," he said, looking at Harry, whose mouth dropped open.

"I was not aware that you recognized me," he said.

Genevieve chuckled at this surprise.

"A man drops the biggest story of his life about the *Titanic*, and you don't think I'd recognize him? I do wonder who your source was," Captain Rostron said, looking at Genevieve. She looked back at him with the same innocence she had put on at Jack's funeral. "I do wonder that myself," she said.

Captain Rostron chuckled. "Whoever they were, were incredibly lucky to know all that information about the ship. I dare say, they were one of the few people Thomas Andrews trusted with information that few people were privy to. They were a lucky person," he said. She looked back at the city with a subtle smile. She was a lucky person indeed. "I'll get you back home, Miss Wilson. That's a promise I can keep for you."

"Thank you, Captain Rostron. It means a lot," she said softly.

He nodded to her and Harry before going back to his duties.

"I think I was the lucky one," Harry said. "But I don't mean about the article. Who cares about recognition when you finally find friends who don't try to backstab you?"

"It was just good timing for you. If you hadn't given me your card, I wouldn't have called you when Vincent Astor had needed it," Genevieve said.

"Still, it was fortunate for us indeed. Ready to go back inside?" he asked.

She looked back at the coastline one last time, placing a hand on her pendant. "Ready." She smiled.

Chapter Seventeen

Genevieve couldn't say the journey was getting easier for her, but it was almost over; that was all she cared about. Soon she would be home with Nana and would welcome her child. All they would know was love. They would not be treated like she had been by Clyde or her mother. She wondered thoughtfully how her brother had taken the news—assuming that her mother had told him about their conversation. He had appreciated the job Clyde had given him but had never been keen on their marriage. Perhaps she did have another family member who cared for her.

She walked onto the deck to find Harry. He, too, had been reflective this trip. She found him out on the deck, watching the ship progress. She walked over to him, smiling. "Penny for your thoughts?" she asked.

"I think I can see New York," he said.

She scoffed. "We still have over a day. It's not New York. You might be seeing a mirage," she said

"But it's so cold!" he said.

Genevieve giggled. "There's your answer: you need a hot chocolate," she said before laughing again, remembering the hot chocolate that Charles had accidentally placed in front of her door.

"You're laughing at me!" Harry said indignantly.

"No, I'm not. I swear!" She laughed again. "Now come get some hot choco-late before you freeze!"

"I had hoped to ask you something in private," he said.

"What is it?" she asked.

"You're an amazing woman; I have no doubt that you will be an amazing mother. I wonder if I would be so bold as to ask if I can be a part of your child's life in any capacity. Not as a replacement for a father—I wouldn't dare presume to ask such a thing—but I would like to know if I can still be in your life after this is over," he said.

She looked at him, shocked. "Yes, of course! The best thing—well, the only good thing—to come out of this whole trip was meeting you. I can't think of a better role model for any child of mine," she said.

Harry looked relieved at her sentiment. "I'm grateful to be your friend," he said.

She smiled. "I'm grateful for that as well. Now get back in the ship before you freeze!" she said. Harry chuckled, following her in.

As she had promised him, a day and a half later, they were docking in New York. They walked down the gangplank, saying goodbye to Captain Rostron before meeting Jimmy at the car. While he and Harry packed their suitcases, Genevieve stood off to the side, breathing in and out after leaving the boat. She wouldn't have said it was seasickness exactly, but it felt good to have New York ground under her feet once more. She looked around, seeing someone from her past who made her cross her arms, guarding against what they would say.

"I see you moved on fast—with a member of the newspaper, at that. Perhaps I made more of an impression on you than I thought," Lady Duff-Gordon said as she approached her.

Genevieve scoffed. "I haven't moved on. Harry is just a good friend who was helping with a personal matter. The only impression you made on me is that I don't want to be anything like you," she said.

Lady Duff-Gordon raised an eyebrow. "What aspect of my life do you not want? I'm a business lady in a world where ladies are supposed to be prim and proper housewives. I knew what I wanted; I made sure to marry a man who could elevate me to that position," she said. "If you're still going to be on about me being rescued on the *Carpathia*, ask yourself this: Would they have allowed your precious Victor to be on a lifeboat with you?"

"No," Genevieve said.

She remembered what Victor had said: "You know I couldn't be on a lifeboat without some controversy." She continued, "If John Jacob Astor couldn't get on a lifeboat, then Victor didn't have a chance, either. No matter how full the lifeboats were."

"I'm glad to know you are learning, even if you are still obstinate," Lady Duff-Gordon said, looking her up and down. "If this Harry Buchannan is just a friend, then I suppose this means that Victor is the father."

"Yes," Genevieve said. She wasn't going to hide the truth from anyone because she wasn't ashamed.

"I should have known when I first met you that you would do things differently than the rest of us." Lady Duff-Gordon scoffed.

Genevieve tilted her head at the older woman. "And what's so bad about that?" she asked.

Lady Duff-Gordon looked away; Genevieve knew that she had hit a nerve. "How do you expect to ever be accepted in this world?" Lady Duff-Gordon asked.

Genevieve sighed. "I don't need to be accepted. I have all that I need: Nana, Madeleine, Margaret, and Harry. I have made my mind up that I am only going to have people in my life who accept me for me. I will never destroy my morals because of an abusive man ever again," she said.

Lady Duff-Gordon looked down; Genevieve could see that she had gotten through with her message now.

"I don't suppose you'd believe that I wish you good luck?" Lady Duff-Gordon asked.

"I don't know if I would. But thank you for even thinking of saying that," Genevieve said.

She turned back to the car, seeing Harry smiling at her. "What?"

"I'm just glad to know that you got your spirit back. I was afraid that the trip had taken it out of you," he said, helping her into the car.

"I think it would take a lot to take my spirit away," Genevieve said after Harry had gotten in beside her. "All I needed was to be back in New York, for someone to show me that I needed to fight for a world that I wanted to live in."

"How did it feel, telling Lady Duff-Gordon off?" he asked.

She laughed. "She's not so bad, in her own way. I think we finally have an understanding, after everything that has happened," she said before falling silent as they drove home.

Genevieve sighed contentedly, knowing that soon she would be home with Nana. She would have to remember to call Margaret, to tell her that she had survived, but she felt complete, finally happy. She looked over at Harry with a smile once they reached the house. She accepted Harry's hand when he opened the door for her, hurried inside. She greeted Olivia and Allison before finding Nana and hugging her tightly.

"I'm so glad you're back!" Nana whispered. She pulled away to look at Genevieve. "You look like you're at peace. It might have been a tough week for me, but I can see it did you a world of good."

"It did. Mrs. Andrews was so grateful to have Thomas's ring back," Genevieve said. Nana turned to Harry with a smile. "Thank you for keeping your promise of keeping them safe," she said.

"It was my pleasure to do so, ma'am," he said.

"Madeleine was kind enough to allow us a private reunion, but I invited her to dinner tonight," Nana said. Harry coughed, which made the two ladies laugh. "You're always invited to dinner, Mr. Buchannan."

"Yes, Harry, after the kindness you've shown me this trip, you will always be invited to dinner," Genevieve said.

Harry bowed his head. "Thank you both for accepting me into your family. It shouldn't surprise anyone, but as a reporter, people don't trust me. My family is dead, so it's been a couple of lonely years. Sure, I play it up, but no one has taken notice of me as the two of you have," Harry said.

Genevieve smiled, holding his hand. She knew exactly what he meant. It felt good to have a home once more.

"Come, we'll have tea. It will do our souls good to come together to look toward the future," Nana said.

"I would love to. Genevieve, are you coming?" Harry asked.

"One second. There's one member of our party who can't make it to dinner tonight," Genevieve said. She walked over to the phone, dialing up Margaret.

"Hello?" she heard her friend ask once she picked up the receiver.

Genevieve beamed. "I'm home, Margaret," she said. She heard Margaret sigh in relief; it warmed her heart to know that she had people who cared for her.

"I'm so glad to hear that! I hope it went well for you," Margaret said. She knew better than most what Genevieve had gone through, why she had felt she had to do it.

"It did go well. Mrs. Andrews appreciated the gesture; now I'm home. I've never felt more secure in my future," Genevieve explained.

"I'm happy for you, truly. I promise to come up once the baby is born; plus, I'll write to you. You keep in touch, Genevieve," Margaret said.

"I will," Genevieve promised before heading to the sitting room with Nana and Harry.

The two were in deep conversation; she sat back in her chair, listening to them, realizing that not once had she thought about Clyde. He was gone; he no longer provoked terror in her heart. She smiled as she heard the clock chime for the new hour. Madeleine would be here soon; she felt complete in this little circle of hers. Who needed a whole world when she had everyone she needed here?

"How are you feeling?" Madeleine asked her after dinner; they had found a spot where they could be alone. The two of them, mothers of the most famous children in the world, Genevieve mused.

"Complete, in a way. I did what Thomas wanted; I'm having Victor's baby. But I still wish that the men we love were here with us," Genevieve said. She turned to Madeleine with a slight smile. "How is it with you and Jakey?"

"He reminds me so much of Jack; it does help me with the lonely feeling I've been having. Hopefully, your child will help you in that aspect," Madeleine said.

"Loneliness was never the problem. Thankfully, I have you, Margaret, Nana, and Harry. But whenever I was with Victor, he gave me a strength I never had before. Now, I feel lost without him," Genevieve explained.

Madeleine grasped her hand in support. "But now you have his child; his strength will be in this child as well. You will know how to get through this world once you look at this perfect child's face," she said.

"Thank you, Madeleine, for everything. You were the first person to accept our relationship. I honestly think if you had had your way, you would have led me straight to Victor's room that night, to reveal my feelings to him," Genevieve said.

Madeleine cracked a grin. "That does sound like me," she said. The pair started laughing, only regaining their composure when Harry walked into the room. He looked at them suspiciously.

"What are you two laughing at?" he asked.

"Just how headstrong my friend is," Genevieve said.

Madeleine smiled, hugging her tight. "I will leave you for the night. You no doubt need sleep and relaxation, but I'll be around; I'll help you with the baby. Good night," she said.

"Good night, Madeleine. If you need anything, please call upon me," she said. She saw her friend out before turning to Harry. "It's been quite a week. I presume you will be back to work tomorrow?"

"You would be right. Reporters never sleep." He grinned.

She groaned at his joke. "Thank you for coming with me. I know you didn't have to, but it helped me feel safe. I want to say something; I hope you don't take it the wrong way," Genevieve said.

Harry cocked his head. "What would that be?" he asked.

"I can't undo the past, but if I had been a smarter, stronger woman, I think I would have married a man like you. Not once have you seemed resentful toward me about my feelings—or more appropriately, lack of feelings. You still want to be my friend, a figure in my child's life. Clyde would never have accepted me under such circumstances," Genevieve said.

Harry smiled softly. "That's a beautiful sentiment, Genevieve. I would never take it the wrong way. It seems to me that part of you still fears Clyde, regardless of whether he's alive or dead," he said.

She considered his words, smiling. "I suppose you're right. I have lost the fear of him physically hurting me, but perhaps I still fear retribution for my actions. But I know I don't deserve a man like that. One of the things that Victor said I could do was show women the kind of man they should love—the right man. Maybe one day you will find the right woman for you," she said.

He took her hand, kissing the back of it. "I think the one girl for me is unavailable; for that, I'm sorry," he said.

"Oh, Harry..." she whispered.

He shook his head with a smile. "It's not any fault of our own. You were in love with an incredible man. I don't know if I could match his goodness or his love for you. I don't need love, as long as I can still be in your life. That's all I need," he said.

She smiled, holding his hand. "You always will be. Good night, Harry," she said.

"Good night," he said with a smile.

He left; she leaned against the door. She did mean what she had said: he was one of the good ones. She didn't know if she could ever love him the way he wanted. She knew of other women who had married other men after their husbands had died; the talk around town was about when Madeleine would find her next husband, but she didn't know if she could do that. While they had not been married, she still felt a love for Victor that burned so bright. On the other hand, she had lost not one but two men in mere days and hours—no matter how much she detested Clyde. To heal her heart, it was essential to not do anything rash.

She said a quick good night to Nana before heading up to her room, where Allison helped undo her dress so she could go to bed. "I'm glad you're back, Genevieve," she said.

Genevieve smiled. "I'm glad to be back. How was it here when I was gone?" she asked. Allison sighed. "Your grandmother was anxious. But Mrs. Astor came over sometimes. It seemed to help," she said.

"Oh, Nana," Genevieve whispered.

"But now you're back; everything will be better," Allison said. It was just like Allison to look at the world with a glass-half-full attitude. But as Genevieve lay in bed, she knew that Allison was correct. Everything would be better. She fell into a deep sleep that helped to cement her bright future.

Six months later

It was now late January 1913. There was a fire in the fireplace to warm the house up. Genevieve was sitting in a rocking chair before it, breathing in and out, groaning at certain intervals, pain enveloping her. The snowstorm had come so suddenly that she was all alone in the house; Nana and the servants had gone to town hours earlier. They had needed food and clothing; Genevieve had thought it had been perfect timing for them to go out, but now it was clear it hadn't been. She screamed out as a horrendous pain went through her.

"Genevieve!" she heard Harry yell.

"Harry! Help!" she screamed.

"Where's the damn key?" She heard him curse.

If she hadn't been giving birth at that moment, she might have laughed. "Under the rock by the door!" she yelled before groaning.

Harry found the key and unlocked the door, then ran in to help her. "When did this start?" he asked.

"Not long ago, about five minutes?" she guessed. "So we have time to get to the hospital?"

"It's totally iced out there. It was a miracle I was able to get here," Harry said gently.

"I'm glad you did," Genevieve said before screaming once more.

"Reporter turned doctor—unbelievable," Harry said, picking her up in his arms. "Where's a good place for a bed?"

"Down the hall, to the right. Poor Allison will need new bedsheets," Genevieve said.

"OK, what would I need to birth this baby?" Harry asked out loud.

"Towels, warm water to clean the baby," Genevieve said, recalling the practice she had from the last time she had given birth.

"Are you OK if I leave you alone?" Harry asked.

"I'll be fine. Go. Just hurry, please," she said before screaming once more.

Time seemed to stretch as she waited for Harry to return. She started breathing in and out again, knowing that the baby was coming rapidly. "Harry!"

"I'm here! I got some help too," he said, rushing in with Madeleine coming in right behind him.

"Madeleine, you didn't have to come all the way here! It sounds as though it's treacherous out there," she said before groaning again.

"I knew when the snow came down that today would be the day; it seems I was right. Where is your grandmother?" Madeleine asked.

"She and the others went out. I thought it was a good time for them to make preparations. It's just my luck," Genevieve said.

"The good news is that I'm here," Madeleine said, grasping her hand in support.

"I don't want to lose this baby." Genevieve gasped.

"You aren't going to lose this baby. He will be strong; he will give you the strength you need. I promise you that," Madeleine said.

Genevieve looked up at her, smiling. "Are you ready to push?" Harry asked.

"Yes," Genevieve said.

She pushed with determination; she was not going to lose this baby. She had lost too much already. She gave a few more pushes, finally hearing her baby cry out. She looked up at Madeleine. She was crying in happiness.

"It's a boy!" Harry exclaimed, cleaning the baby before handing him to her.

"What are you going to name him?" Madeleine asked, clearing away tears from her eyes.

"Victor Thomas Wilson, after the two men who saved my life," Genevieve said.

"That is a wonderful tribute," Madeleine said.

"Perhaps we should give you two a minute to get better acquainted," Harry said gently.

"Thank you for everything, Harry. You saved both our lives," she said.

He smiled before he and Madeleine left them.

Genevieve looked down at her son, beyond happy that she was cradling him in her arms. He was her future, her happiness, the promise of a better tomorrow. She started singing softly to Victor, getting lost in the beauty that she saw in him. She breathed out, thankful that the birth was over, that her son was alive. Then she closed her eyes, calming down from the high intensity, and felt happiness flow through her. She opened her eyes, looking around the room. She had never believed in spirits before, at least before the senseless tragedy she had gone through, but deep down, she thought that Victor had visited them just now.

"I love you," she whispered. Her son made a wild grab at her necklace; she laughed at the timing. "Someday soon I will teach you about your father, about the thousands of people who were looking to find passage to America."

"Genevieve!" she heard Nana yell. Nana paused, seeing the perfect scene before her.

"Meet your great-grandson, Nana," Genevieve said softly.

"I never should have left," Nana said, coming around to take a peek at the baby.

"It's all right. I had two friends who knew what to do," Genevieve said.

Madeleine and Harry smiled in at them; she felt complete with the friends and family she had near.

It was a few days before the snow melted enough that Madeleine and Harry could get to their respective homes. She knew that Madeleine was missing Jakey something fierce, but Madeleine never complained about the wait. After the *Titanic*, she no doubt preferred safety over everything else. The two women were able to call Margaret, to tell her the news of Victor Thomas. She was delighted, promising to come after the big thaw.

Madeleine gave her a hug, with a little wave to the baby, before she was quickly out, no doubt to make up for lost time without Jakey. On the other hand, Harry stayed a bit longer, ensuring they were all settled and didn't need any more help. Before he left she pulled him aside.

"I want to thank you for everything you've done for us. Victor—that is, my Victor—would have been proud to have known you. You were the kind of man he aspired to be," Genevieve said.

"It is an honor to hear you say that. I'll call in on you in the near future. For now enjoy that beautiful boy of yours," Harry said.

"I will." Genevieve smiled, seeing him out, before turning to Victor, holding him gently as she started her tale. "My life didn't start before April 10, 1912..."

Epilogue

From the diary of Genevieve Wilson

September 15, 1985
 I'm feeling nostalgic about the sinking these days. It's to be expected since researchers have just found the *Titanic* in the Atlantic Ocean. I felt so many emotions when I heard about it before realizing that I had no one to share it with, not in any meaningful fashion. All of my friends from those days are dead: Nana, Margaret, Madeleine, Harry. My son was there for me; I love that about him. But even he can't imagine all the feelings I went through. Where to begin with what has happened since those days?

 I had my son, of course; he was the most beautiful child you could imagine. Everyone loved him. True to his word, Harry stuck around in our lives. It was good to have a father figure in Victor's life, to see that family can come in different forms. Victor and Jakey were friends for many years of their lives; it gave Madeleine and me great heart to see the two of them bond. It reminded us of the happy days on the *Titanic*. But I think the days after the *Titanic* wore hard on Madeleine.

She married two times after Jack, having more children. I suspect some part of her was happy. However, as Jakey—I still think of him as a small child—Jacob reached an older age, he was unhappy with the money left to him by Jack, wanting more, reopening more wounds related to a situation Madeleine never wanted to remember. She was alone for the last two years of her life, living in Florida. We saw each other regularly, but I think it got harder for her to see how Victor and I had a loving bond. She was a true friend when I needed her; she was so supportive of my relationship. I will miss her always.

Margaret had a very colorful life after the disaster. Her heroics in the lifeboats earned her the name the Unsinkable Molly Brown. She was the most famous person to emerge from the tragedy. More people were recognized—either favorably or unfavorably—but if I told anyone I was on the *Titanic*, they would always say, "You must know Molly Brown!" I always answered she was a good friend, which always brought a smile to their faces.

But Margaret was more than just a name; she was a legend. A grand majority of the *Titanic* survivors, myself included, gave Captain Rostron a gold cup as a token of our appreciation for saving us; the effort was spearheaded by Margaret. He was always a tough one, but I think he appreciated this more than most would have. Moreover, Margaret ran for the Colorado senate in 1914. Although she didn't get elected, I'm sure it gave the nation a thrill to see her do more for this country.

After that she moved to New Hampshire, where she was involved in a group focused on women's empowerment. I was happy to join whenever I could; it helped Victor to see his mother be a strong advocate for women finding appropriate husbands. Those were a few good years. But nothing lasts forever.

Margaret, that champion of people, had helped the French Legion in World War I and was getting a medal of honor for her achievements. The ceremony was to be held in New York; we were having a jolly time at dinner. She didn't seem sick or even under the weather. But the following day, we received the news: Margaret Brown had passed away in her hotel room. We were so shocked we didn't even cry. Remember when she always got seasick on the *Titanic*? Maybe it wasn't seasickness at all. The autopsy confirmed she had had brain tumors.

It's most troubling to think that she could have had this condition for a very long time. But my tale of woe isn't finished.

They say trouble comes in three; that came true when I lost the three most influential women in my life. It shouldn't have surprised me since Nana was old. I was just happy in the fact she had met her great-grandson and had a lasting friendship with him for most of his childhood. She was always looking out for me—us—but I never took her love for granted. She did worry about what would happen to the two of us after she left. I didn't want her to worry about such things in her old age, and I had a conversation with Harry about the whole thing.

"You know my grandmother is getting old; she worries about how Victor and I will fare once she's gone. I don't love you in that way, but you are a good friend. I wonder if it would be too rash to wonder if we could marry, so Nana doesn't worry further?" I asked him one day.

"I've always cared for you, Genevieve; if this is a way to ensure that you and your son are secured in a happy future, I would be happy to marry you," he said.

"Thank you," I whispered, knowing this was a hard decision for him. But I also made sure to tell Victor the truth about what was happening.

"It doesn't mean that I don't love your father anymore; he is still the man for me. But your great-grandmother worries about us once she—she leaves this place," I said.

"It's OK, Mother. I understand," he said. My sweet boy, always so attentive to others. He gets that from his father.

While I didn't love Harry in the most traditional sense, we still cared for one another and for Victor for the rest of Harry's life. It warmed Nana's heart to see that we were secure in life, which helped her have a good rest of her life; she died five years after Margaret. It was hard for Nana after Margaret died, for she lost most of her friends after that event.

Now that I'm an old woman, without the friendship of those from the *Titanic*, I understand how she felt. I keep on living for Victor, but I know that one day soon, I, too, will go into the great beyond to be reunited with those I love.

After Margaret and Madeleine died, I didn't feel the need to hide secrets about those fateful days we had on the *Titanic*, so when an author came forward wanting our tales of what had happened, I told him as much as I could. I wasn't featured much in the book, but I appreciated the effort anyway. It must have been hard for Mr. Lord to write a comprehensive text with many people's opinions or ideas about what happened. Many movies about the *Titanic* have come out; while they never utilize my Victor well, they are always entertaining, if painful, to watch.

But Mr. Lord was not the only person to write a book, for dear Colonel Gracie—that poor man—started researching a book after we all returned to New York. When he came to Nana's house after Harry and I had returned from Ireland, I was surprised when he called on us to ask us what we thought had happened during the disaster. I couldn't lie to that poor, sweet man.

"Colonel Gracie, do you remember when you asked Harry about his source at Jack's funeral?" I asked him over tea.

"Yes. He was a good man to keep that source secret. I might have been too hasty to ask such a thing," he said.

"Well, I was his source," I said.

He looked surprised.

"I always thought it was a crew member, but I do remember you and Thomas Andrews having a good friendship on board. Yes, that makes sense," Colonel Gracie said.

"I've kept this secret for so long from people, but I think if anybody can make sure that discretion is upheld, it's you," I said, divulging everything that happened on that trip to me. "I hope not everything will be revealed, but my honor is in your hands."

"My dear, sweet Miss Wilson. I told you before that I wanted to make sure everyone was safe. Your secret is safe with me," he said.

"Thank you," I whispered.

Colonel Gracie published his book, but everyone could see how obsessed he was with finding the truth about the *Titanic*. He even went frequently on the sister ship, the *Olympic*, to conduct more research. But not long after our conversation, he died. Not everyone who made it on the *Carpathia* survived—at least

not in any way that counted. My only regret is that my son did not get to meet this amazing man who hoped to save as many people as he could.

My son grew up to be an amazing man. He always reminded me of his father. Once he was old enough, Harry and I told him about Clyde, how he had separated me from my family, how he had tried to kill me many times, how he was not a man to follow. Victor took it to heart, marrying a wonderful woman. They had two children, which made my heart whole. It also gave me a chuckle knowing that I was now Nana Wilson, in a way. Victor also knew this for a fact, always making sure his children were a part of my life. A good man, all the way through.

But there are more aspects of being a good man, aren't there? Years after the sinking, after Harry and I married, a man came to our house. How he knew where I lived, I never asked, for when I heard his story, I knew it was his duty to come here to tell his tale. But I was shocked when Allison—dear, sweet Allison—told me I had a guest that day. He took off his hat when I walked into the foyer.

"How may I help you?" I asked.

"You don't know me, ma'am, but my name is Louis Stewart," he said.

"Am I supposed to know you?" I asked him.

"I suspect not. We never met before the *Titanic*, but your husband—that is, conniving husband—used to be one of my friends," he said.

I paused as I processed this information. "He was?" I asked cautiously.

"Yes, ma'am. He could always spin a tale back in those days." Louis shook his head at the thought. "I was the reason he was on the *Titanic*, ma'am. He said he wanted you back, but if I had known he would go berserk, try to kill you on that last night, I would never have helped him. Not to brag, but I was one of the reasons your beloved and Thomas Andrews were able to find you in time. The last thing I told your husband was to not follow me out of the kitchen, or I would do something less than legal to him."

"I thank you so much, Mr. Stewart. So many men on that ship were perfect gentlemen to the end; I can add you to that list," I said. "I suspect life was hard for you once you reached the shore. I only wish you had approached me on the *Carpathia*. I would have repaid you for your kindness."

"I appreciate that, ma'am, but all I needed to know was that you were safe from Clyde and his abuses. Life was hard, but I found a good woman, then made honest work with my life. I'm a different man than Clyde; I don't know if I would have ever achieved that without your braveness in moving on from him," Louis said before taking his leave.

I was touched by his sentiment. I always wanted to be an inspiration for women everywhere, but to know that I could be one for men as well was a tall order. Louis was a remarkable man. I never saw him again, but I wished him the best of luck in life, wherever it took him. He was like Benjamin Guggenheim: a faithful ally until the very end.

Seeing my life in words, it seems blander than what it truly was. Perhaps one day someone will see this diary page, write my life truthfully for what it was, maybe make it into a play, series, or movie. Perhaps Victor and I will see one last day in the sun. Or maybe nothing will come of this at all; maybe it will remain a pleasant memory for my son and his family after I pass on.

But I don't fear death anymore, not as I did on that night fifteen hundred people went into the frigid water. In fact, I embrace it now, knowing that I'll be reunited with all of my friends: those who died and those who survived that night. I appreciate my son and his family and love them with all my heart. But I also know that the day is coming when I will see Nana, Margaret, Colonel Gracie, Thomas, Benjamin, Jack, Madeleine, Harry, and my Victor once more. He loved me when no one else did, and that's all you can ask for in a man.

The End

Acknowledgments

This book would not be possible without all the knowledge of previous researchers. This includes Colonel Archibald Gracie! While a good portion of this book is purely fiction, Colonel Gracie was the very first researcher of the *Titanic* disaster. Thank you, Colonel Gracie, for paving the way for researchers of *Titanic*.

It can be hard to write about real people; what would they be okay about writing about their lives? What would their families think? If you are related to someone mentioned in this book, I hope that what I wrote is true to their nature while they were living. I do not want to disrespect anyone who went through this tragedy. Anyone who might be related to Bruce Ismay, I just wanted to convey what he went through in life.

My sincere thanks to everyone at Palmetto Publishing. This is a dream come true. To Kathrine, Savannah, and the cover design team, thank you for helping me helping me to accomplish this project. To the editors, Nicholas and Gregg, thank you for reading through my manuscript to help elevate the story. Special thanks to Gregg who knew special aspects about the Astors life pre-*Titanic*. You've helped me ensure that Jack and Madeleine were properly memorialized.

To my friends: your friendship means everything to me, and I'd like to believe we make our own little group like Genevieve, Madeleine, and Margaret.

May we each find our own Victor, someone who loves and respects us in every way, shape, and form.

And finally, to you, reader. I hope that you loved the journey you've just been on. Please don't think I know everything about *Titanic*; if you feel so inclined, start your own research! No one will ever know the complete story about what happened, but we seem to find new information. Who knows? Maybe you will find the next piece of the puzzle.

CPSIA information can be obtained
at www.ICGtesting.com
Printed in the USA
BVHW050207090223
658191BV00031B/1069